e

A Century of Olympic Posters

First published by V&A Publishing, 2008
V&A Publishing
Victoria and Albert Museum
South Kensington
London SW7 2RL

With assistance from the International Olympic Committee, Lausanne

Distributed in North America by Harry N. Abrams, Inc., New York

Paperback edition
ISBN 978 1 85177 538 5

Library of Congress Control number 2007935516

10 9 8 7 6 5 4 3 2 1
2012 2011 2010 2009 2008

Designer: willwebb.co.uk
Copy-editor: Lesley Levene
Indexer: Vicki Robinson

New V&A photography by Paul Robins, V&A Photographic Studio

Front cover illustration: Cortina d'Ampezzo 1956 (plate 50)
Back cover illustration: London 1948 (plate 39)
Frontispiece: Los Angeles 1984 (plate 103)

Printed in Italy

Mixed Sources
Product group from well-managed
forests and other controlled sources
www.fsc.org Cert no. CQ-COC-000012
© 1996 Forest Stewardship Council

V&A Publishing
Victoria and Albert Museum
South Kensington
London SW7 2RL

A Century of Olympic Posters

MARGARET TIMMERS

V&A PUBLISHING

Contents

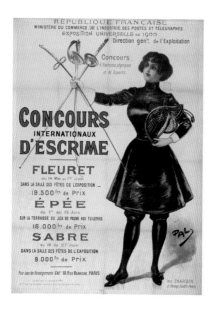

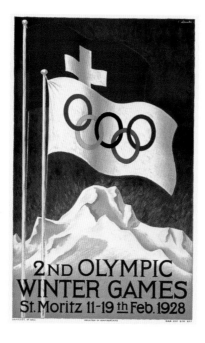

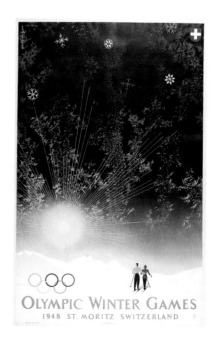

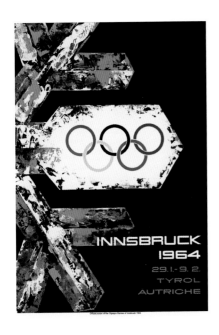

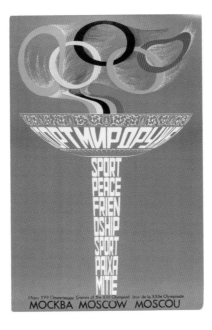

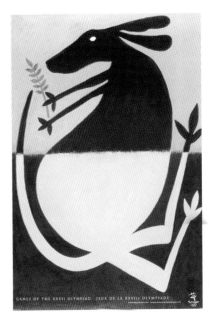

Los Angeles 1984 Olympic Games

This publication is conceived as an accompaniment to the Victoria and Albert Museum's touring exhibition 'A Century of Olympic Posters', and the posters illustrated are a selection drawn largely from the collections of the V&A. Thanks to the generosity of the Olympic Museum Lausanne Collections, and of individual lenders, these are supplemented with additional images to illuminate the narrative. This work presents the evolving story of Olympic Games posters in the context of the Games that they announce and celebrate, and it is hoped that it will serve to stimulate further interest, research and debate.

Introduction

For the modern Olympic Games, posters have been a prime means of visual communication since the early twentieth century. With their broad popular appeal and ability to relay messages through eye-catching and memorable imagery, they are effective both as announcements and as metaphors, whetting our appetite and shaping our expectations of the Games that are to come. They offer Olympic venues an opportunity to project to an international audience images that advertise, identify and define the event, and favourably influence how the venues themselves are perceived.

While various posters were issued in association with early modern Olympiads, it was the pioneering Stockholm Games of 1912 that first realized the potential of an official Olympic poster as a medium for international publicity. Before an age of instant communication, posters became a vital means of advertisement for the Games, and continued to play a major role in publicity during the inter-war years as interest in the event burgeoned. In the second half of the twentieth century, with the increasing professionalization of graphic design, they became a key element in sophisticated visual identity programmes that covered every aspect of the Games' presentation. Even today, with diverse means of instant communication, posters still play an important part in establishing the look and feel (the 'brand') of an Olympic Games; indeed, since practical information such as precise dates and location can be relayed via other media, they are increasingly free to project more intangible messages, such as the chosen values and ideals of a Games, in telling graphic shorthand.

Viewed from a historical perspective, Olympic Games posters provide a fascinating record of our world. As periodic snapshots through time, they offer a means by which we can explore links between sport and art, politics and place, commerce and culture. They also reveal the evolving iconography of the modern Games, ranging from emblems of civic and national pride to those of aspirant internationalism, and from official Olympic symbols (adopted to enhance the status and tradition of the Games) to the identity of specific Games. The sporadic and uneven nature of their production is also an intriguing factor. During the first half of the twentieth century, it was normal practice for the Olympic organizing committee of each host venue to issue one or occasionally two official posters. Although since the 1960s the number of posters officially generated per Games has proliferated, on the whole it has remained customary for one poster to be designated as, or to take on the status of, 'the' official poster. Since the commissioning of official posters is ultimately the responsibility of individual organizing committees, their aesthetic quality may vary greatly from one Games to another, and the degree to which they synchronize with contemporary art movements is arbitrary. So too is their representation of different national cultures: before the 1950s, the Games were held in either European or American venues, but subsequently have taken place in locations as far apart as Melbourne, Tokyo, Mexico City, Moscow, Seoul, Sydney and Beijing, yielding a richer diversity of imagery in the latter part of their history.

The posters and ephemera illustrated in this book, drawn largely from the V&A's own collections, give a pictorial insight into the Olympic Games from their late nineteenth-century origins to the present day. Officially generated posters advertising both Olympic and Olympic Winter Games provide the main theme, supplemented by examples of other kinds of poster inspired by or reacting to the event. These include promotion associated with the early modern Games and posters for some cancelled, alternative or unofficial Games. One outstanding initiative has been the commissioning by various organizing committees since the 1970s of thematic poster series in celebration of particular Games, to which distinguished artists and designers have contributed. This has enhanced the cultural dimension of the Games and inspired a new genre of sports-associated poster art, with many significant

– and highly collectable – works produced as a result.

Baron Pierre de Coubertin is acknowledged as the architect of the modern Olympic Games, which he conceived with the aims of fostering national and international understanding through sport and of inspiring excellence – physical, moral and aesthetic – in society at large. Born in Paris to an aristocratic family, he decided at the age of 24 that his future lay in education, and in particular physical education, believing it to be a vital part of the personal development of young people. He studied educational systems in the United Kingdom and America, admiring those that embraced as part of their curriculum sport and athleticism, which he saw as applications of one of the chief principles of Greek civilization – 'To make the muscles be chief factor in the work of moral education'.[1] However, his researches into the state of sport during the late 1880s and early 1890s convinced him of the danger that it might degenerate through excessive specialization and the influence of a 'mercantile spirit'.[2] As a philhellene, his solution was

> the establishment of a periodical contest, to which sporting societies of all nationalities would be invited to send their representatives, and to place these meetings under the only patronage which could throw over them a hallow of greatness and glory: 'The patronage of Classical Antiquity'! To do that, was to re-establish the 'Olympic Games'.[3]

To foster support for his plans he organized an international congress on the subject of sport at the Sorbonne in Paris in June 1894, and here the proposal to revive the Olympic Games was unanimously agreed. Athens was to be their first home in 1896, followed by Paris in 1900, and then to be held at four-yearly intervals 'in every large capital of the world in turn'.[4] An International Olympic Committee (IOC) was formed to carry out the decisions of the congress, with Demetrius Vikelas as president, to be succeeded in 1896 by De Coubertin himself.

The creation of a modern Olympic Games was not a new idea. In England, for example, the Cotswold Olimpick Games, an annual sporting Games which honoured the ancient Games of Greece, had been taking place near Chipping Campden since the early seventeenth century, originally under the direction of a lawyer, Robert Dover:

> Olimpus mount, that (even to this day) fills
> The world with fame, shall to thy Cotswold-Hills
> Give place and honour; ...[5]

The earliest activities included horse-racing, coursing and several field events, as well as trials of skill and strength, such as jumping, wrestling, shin-kicking, sword-play and cudgel-play, and throwing the hammer and bar. Yellow favours were awarded for arts such as singing and dancing. Printed bills from the nineteenth century (the printed notices and advertisements of the seventeenth, eighteenth and early nineteenth centuries were among the forerunners of the pictorial poster that evolved in the 1880s) record a later phase of the Games (plate 1), which by 1852 had come to an end. However, they were revived in 1966 and are held annually on Dover's Hill on the Friday of the Spring Bank Holiday week.

DOVER'S MEETING, 1851.

It is now Two Hundred and Thirty-nine years since that noble, generous, and heroic gentleman, MR. ROBERT DOVER, instituted the highly celebrated and renowned Olimpic Games, for which this true and distinguished Festival claims precedence of all others, and which are now patronized by Church and State, and esteemed by all brave, true and free, spirited Britons, who admire those ancient and manly exercises for which this kingdom is so justly famed.

On Thursday in the Whitsun Week,

The good old times will be revived with a spirit of hilarity, and a generous subscription for the amusement of Her Majesty's subjects, commencing at TWO o'clock, with

TWO DOZEN OF BELTS
TO BE
WRESTLED FOR,

To contend for which, Dons of high Blood and Metal are required to be on the Turf,

The Sports of the day will conclude with DANCING FOR RIBBONS, JUMPING IN SACKS, JINGLING MATCH, and various other Amusements, too numerous to praticularize.

ON FRIDAY AT TWO o'CLOCK,
The Sports will commence with

WRESTLING for BELTS,
AFTER WHICH, A

HURDLE RACE

For a Handsome Silver Cup, of the value of £5., or in Specie.

Heats twice round Dover's Hill, over five flights of fair hunting hurdles to carry eleven stone each. Enterance One Pound each. A winner of any Race in 1851, to carry 7lbs. extra; Horses under fifteen hands high to be allowed 7lbs. for every inch, the horses to be entered at Mr. Wm. Drury's, Swan Inn, Campden, before twelve o'clock on the day of the Race. Open to horses of all denominations. Three to start or no Race. The winner to pay 5s. for scales and weights.

A GRAND DISPLAY OF BACKSWORDS.

The Silent Evening will be ushered in by a MERRY DANCE, to commence at Nine o'clock.

GOD SAVE THE QUEEN!!!

EXCELLENT BANDS OF MUSIC WILL ATTEND EACH DAY. No Person will be permitted to erect a Booth upon the Hill, for the Sale of any sort of Liquors or Ale, without paying £4. before Monday the 9th of June, or £1. extra will be charged (which will free him from any other demand;) to be paid to MR. DRURY, Swan Inn, Campden. All Stalls for Cakes, Oranges, &c. to be paid for according to size. A Person will be appointed to conduct the Sports, and his decision shall be final, or whom he may appoint.

[Pearce. Pr. Evesham.]

In Athens in 1859, a series of modern Greek Olympiads was founded by the philanthropist Evangelis (Evangelos) Zappas. Zappas himself had been inspired by the writings of the Greek poet Panagiotis Soutsos, who, from 1833, had promoted the idea of a revival as a means of helping modern Greece, recently established as a sovereign state, to return to her ancient pre-eminence in Europe. Excavations at Olympia, begun in May 1829 by French archaeologists and restarted in 1875 by German ones, fostered further public interest in the project.

An English pioneer for the revival of the Games (and a supporter of the Zappas Olympiads) was the surgeon William Penny Brookes of Much Wenlock, Shropshire. He founded the Wenlock Olympian Games there in 1850 (plate 2) and in 1865 contributed to the formation of the National Olympian Association, whose first British Olympiad was held at Crystal Palace in 1866, attracting over 10,000 spectators. Brookes's campaign for physical education to be made compulsory in schools brought him into contact with Baron de Coubertin, whom he invited to the Wenlock Olympian Games and with whom he maintained a correspondence thereafter. De Coubertin was fascinated by the mix of athletics and traditional local sports, preceded by a procession with flag bearers, competitors and officials, and when he returned to France in 1890 he wrote an enthusiastic article in *La Revue Athlétique* about Brookes's initiative in inaugurating the Games.[6]

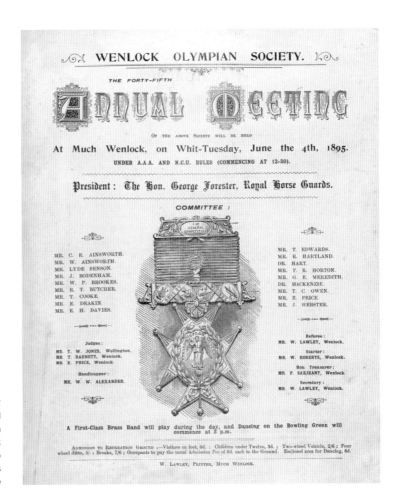

RÉPUBLIQUE FRANÇAISE
MINISTÈRE DU COMMERCE, DE L'INDUSTRIE, DES POSTES ET TÉLÉGRAPHES
EXPOSITION UNIVERSELLE DE 1900
Direction gén.^{le} de l'Exploitation

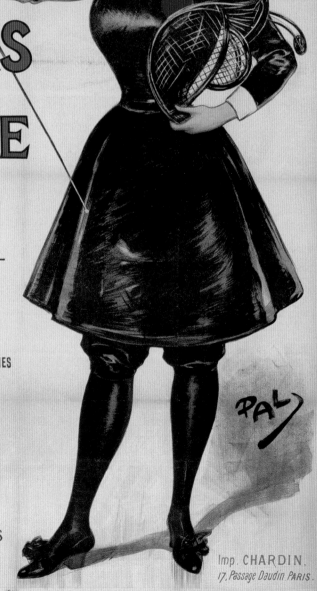

Concours
d'Exercices physiques
et de Sports.

CONCOURS
INTERNATIONAUX
D'ESCRIME

FLEURET
du 14 Mai au 1.er Juin
DANS LA SALLE DES FÊTES DE L'EXPOSITION .-
19.500 frs de Prix
ÉPÉE
du 1.er au 15 Juin
SUR LA TERRASSE DU JEU DE PAUME AUX TUILERIES
16.000 frs de Prix
SABRE
du 18 au 27 Juin
DANS LA SALLE DES FÊTES DE L'EXPOSITION
9.000 frs de Prix

Pour tous les Renseignements : S'Ad.r 10, Rue Blanche, PARIS.

Exposition Universelle de 1900
Dir.tion Gén.le de l'Exploitation - Concours d'Exercices physiques & de Sports.

Imp. CHARDIN.
17, Passage Daudin PARIS.

Early Images

The first modern Olympic Games, the Games of the I Olympiad, were held in Athens from 6 to 15 April 1896. They attracted athletes from 14 nations – low attendance by current standards, but then the largest international sporting gathering to date. Many athletes entered privately – some were in Athens on holiday or through work – and all had to find their own accommodation. Events included athletics, field events, cycling, fencing, gymnastics, shooting, swimming, lawn tennis, weight-lifting and wrestling, while the marathon and throwing the discus were introduced as a deliberate link with the ancient Games.

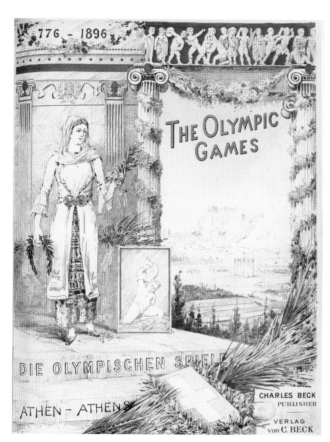 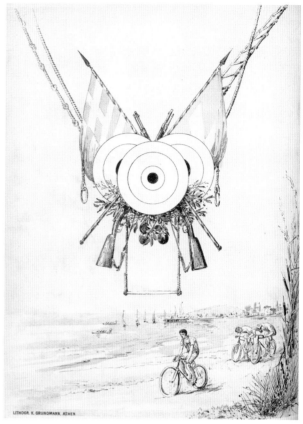

Plate 4
Athens 1896
Front and back cover illustrations
from S.P. Lampros et al.,
*The Olympic Games:
B.C. 776–A.D. 1896*
(Athens, 1896–7)
Printed by K. Grundmann, Athens
Lithograph with litho-tint
V&A: L.529–1896

An American team of college students arriving only a day before the opening of the Games won 11 medals, while Greece achieved 10. The discus-throwing event was described 50 years later by an American studying at the American School in Athens at the time. He recalled that as preparation for the competition several Greek athletes 'had been practicing all winter, going through the graceful motions suggested by the pose of the Discobolus of Myron'. This was all to no avail, as the winning throw was by the American captain of the Princeton team, who 'simply stood up there and *heaved* it by main strength'.[7] No known official poster was produced for the Athens Games, but the front cover illustration to the two-part publication *The Olympic Games: B.C. 776–A.D. 1896* has become an image emblematic of the Games (plate 4).[8] Making an obvious association between the Games of antiquity and those of the modern era, the lithograph portrays the goddess Athena holding an olive branch and a victor's wreath, standing before a view of the Acropolis and the newly restored horseshoe-shaped Panathinaiko (Panathenaic) Stadium. This stadium, originally built in the fourth century BC and restored for the 1896 Games through the benefaction of Greek businessman George Averoff, witnessed the most emotional moment of the Games when thousands rose to acclaim the triumphal entry of a Greek runner, Spyridon (Spiridon) Louis, who was victorious in the marathon. The 1896 Games proved a success with the Greek public, who had contributed to their funding, and there were calls for all future Olympiads to be held in Athens; but by then the next Games had already been planned for Paris, where they were to be held alongside the Exposition Universelle of 1900.

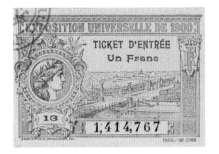

Plate 5
Paris 1900
Entry ticket to the Exposition
Universelle, Paris, 1900
Executed by Daniel Dupuis and
Georges Duval; printed by Chaix,
Paris, 1900
Line-block printed in blue
V&A: E.222-2006

Plate 6
St Louis 1904
Poster by Alphonse Mucha advertising
the French presence at the
St Louis World's Fair, USA
Printed by Champenois, Paris, c.1903
Colour lithograph
Poster Photo Archives
Poster Please Inc., New York

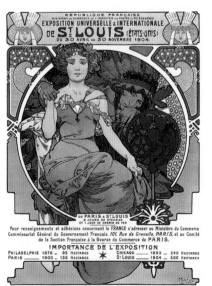

De Coubertin believed that the revival of the Olympic Games was a 'logical consequence of the great cosmopolitan tendencies of our times'[9] and that the awakening international taste for athletics went with increased global communication, made possible by the great inventions of the age. He saw universal exhibitions as one manifestation of mankind's desire to compare their powers and achievements in the fields of art, industry and science, and similarly he believed that it was natural for sportsmen to wish to meet together on common ground in international competition.[10] Indeed, for the next three Olympiads – Paris 1900, St Louis 1904 and London 1908 – the Olympic Games were held in unison with international exhibitions or world fairs.

An enormous variety of international sporting competitions and events were organized alongside the Exposition Universelle in Paris in 1900, with around 1,000 competitors participating. The Exposition, under the directorship of Commissioner General Alfred Picard, was attended by more than 50 million people – a world record at the time – as progressively recorded by the issue of numbered tickets (plate 5). In contemporary reports the sporting events were rarely described as 'Olympic', and in the official reports the Games were designated 'Concours Internationaux d'Exercices Physiques et de Sports'.[11] The contests, which took place over five months at scattered venues including the Vélodrome de Vincennes, the Bois de Boulogne, the track of the Racing Club of France and the Seine at Asnières, seemed lost among the main attractions of the Exposition. For the first time, however, posters were created for several of the individual sports competitions, among others for athletics, rowing, fencing and gymnastics. To publicize the rowing, 6,000 posters were placed on the walls of Paris and surrounding districts, and on advertising vehicles criss-crossing the capital for two days, indicating the date and location of the regattas.[12] For the prestigious fencing competition (held in a field near the cutlery exhibition), the artist Jean de Paleologu ('Pal'), known for his commercial posters and illustrations in magazines such as *Vanity Fair*, designed a poster portraying a female fencer in protective costume, bearing foil, épée and sabre (plate 3). In the context of sporting history, the focus on a female athlete at this time was unusual – and ironically women did not take part in the fencing competition until 1924 – whereas in contemporary French commercial posters the depiction of an alluring female posed beside the product was the norm. The poster's text bore no reference to the word 'Olympic', and indeed the Olympic eligibility of certain of the Paris sports (including cricket, football, golf, polo, rugby and tennis) was only subsequently confirmed. Many athletes were unaware that they had even participated in the second modern Olympiad.

A somewhat similar situation prevailed at the World Fair held in St Louis, Missouri, in 1904, where the Games were integrated within the formally titled Louisiana Purchase Exhibition[13] and the sporting events were spread over a number of months. The high cost of travel meant that very few nations competed in addition to the USA and Canada. The Games nevertheless merited their own official programmes of events, and 'Olympic Games' were also listed among the attractions in the Fair's separate daily official programmes – in one edition alongside 'Organ

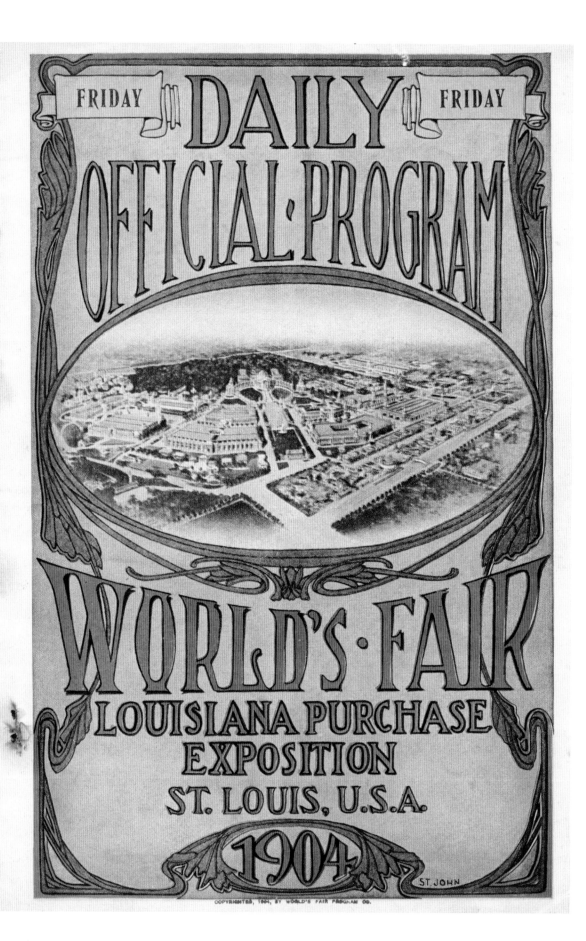

FRIDAY FRIDAY

DAILY OFFICIAL·PROGRAM

WORLD'S·FAIR

LOUISIANA PURCHASE EXPOSITION
ST. LOUIS, U.S.A.
1904

ST.JOHN

Plate 7
St Louis 1904
Official programme for the 1904
St Louis World's Fair, USA:
cover signed 'St. John'
Published by the World's Fair Program
Company of St Louis, 1904
Colour half-tone
V&A: E.223–2006

Plate 8
London 1908
'Londres, via Ostende–Douvres.
Franco-British Exhibition 1908/Fourth
International Olympiad'. Travel poster
designed by Alfred Edwin Johnson
illustration by Noel Pocock, 1908
Colour lithograph and letterpress
Olympic Museum Lausanne Collections

Plate 9
London 1908
Programme for the
1908 Olympic Games
Printed by Hudson & Kearns, Ltd,
London; published by British Olympic
Council, London, 1908
Colour half-tone
V&A: E.332–2006

Recitals' and 'Military Events'. The illustration for the programmes' front covers (plate 7), which has become a recognized image for the St Louis Games, was in the Art Nouveau style, incorporating a view of the city of St Louis within an oval cartouche surrounded by swirling decorative motifs and integrated lettering. This was the style supremely exemplified by Alphonse Mucha, who designed a poster advertising the French presence at the World Fair itself (plate 6) – just as formerly he had created a poster for the Austrian section of the Paris 1900 Exposition Universelle.

Following an intermediate Games held in Athens in 1906, the London 1908 Games helped to establish the competition in its now-familiar format. A code of rules was drawn up for the participating sports and entrants were obliged to compete as members of national teams rather than as individuals, marching into the stadium behind their national flags. Officially known as the Games of the IV Olympiad, they made the transition between the two preceding competitions, where they had been incorporated into world exhibitions, and the future Games, where they would take on their own identity. The 1908 Olympiad had been originally scheduled for Rome, but domestic problems and the eruption of Vesuvius in April 1906 caused the Italians to withdraw and the British IOC members to offer London as an alternative. Once this was accepted, the British Olympic Council expediently cooperated with the executive committee of the Franco-British Exhibition – a celebration of British and French industry, culture and empire – which was coincidentally scheduled for

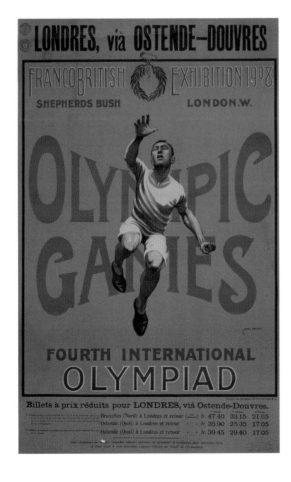

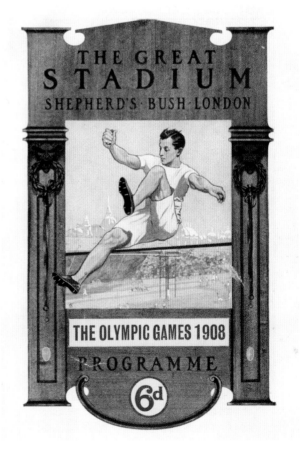

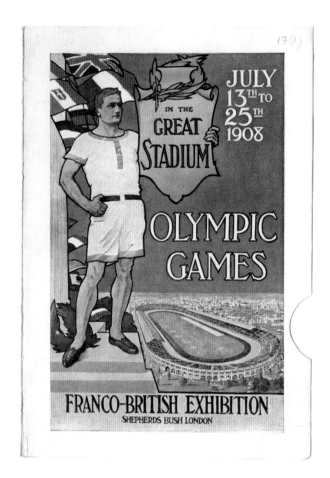

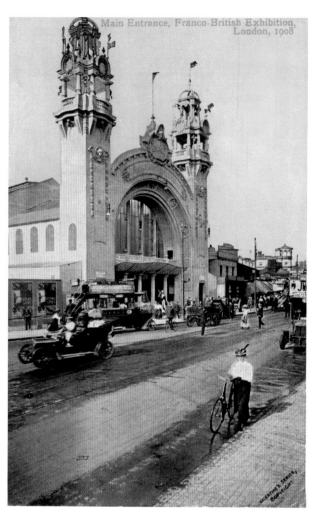

London in 1908 and happily included a sports ground in its plans.[14] And so within the exhibition's site at White City in Shepherd's Bush, an oval sports arena ('The Great Stadium') was built in just 10 months especially for the Games; with its stand accommodating nearly 70,000 spectators and large swathes of terracing, it was considered a great technological achievement. The defining moment of the Games came when the Italian Dorando Pietri reached the stadium first in the marathon (the distance extended to the now-statutory 26 miles 385 yards to accommodate the decision to start the race at Windsor Castle) but fell five times trying to complete his last lap of the track. When well-meaning race officials helped him to finish, they thereby brought about his disqualification, but he survived his collapse to become the most fêted athlete of the Games. In addition to posters specifically advertising the Franco-British Exhibition, one unusual poster, featuring an illustration by Noel Pocock, promoted rail travel to both events (plate 8). The Olympic Games were also publicized in their own right by a poster, the design of which, according to the minutes of the British Olympic Council, was chosen by means of competition, and approved on 17 June 1908.[15] This design, featuring an athlete on a podium bedecked with flags and victory wreaths, overlooking the Great Stadium, also appeared on a leaflet advertising the Games (plate 10). A contemporary postcard

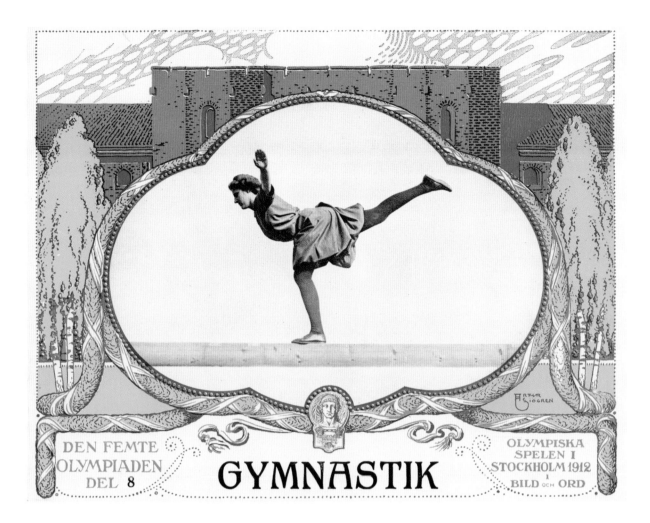

DEN FEMTE
OLYMPIADEN
DEL 8

GYMNASTIK

OLYMPISKA
SPELEN I
STOCKHOLM 1912
BILD och ORD

Plate 12
Stockholm 1912
Souvenir publication *Den Femte
Olympiaden: Gymnastik* (*The Fifth
Olympiad: Gymnastics*):
cover illustration by Artur Sjögren.
From a series of 24 souvenir
publications for the Games
Printed by Jacob Bagges Söners
A.-B., Stockholm; published by Åhlen
& Åkerlunds Förlag, Göteborg, 1912
Half-tone and colour line-block
V&A: E.369–2006

showed the poster displayed in situ to the left of the main entrance to the Franco-British Exhibition (plate 11). Meanwhile the programme cover for the Games (plate 9), featuring an athlete of the schoolboy-hero type leaping through a classically inspired frame, also depicted the sports stadium and the domes of the white-clad exhibition buildings from which White City got its name.

Following the recommendations of a consultative conference held at the Comédie Française in Paris in May 1906, these 1908 Games introduced the concept of art competitions for original works directly inspired by sport. The Paris conference had proposed contests in the disciplines of architecture, sculpture, music, painting and literature, a 'Pentathlon of the Muses', taking forward De Coubertin's long-held desire that art competitions should be an integral part of each Olympiad.[16] For the London 1908 Games, a committee of eminent Royal Academicians under RA president Sir Edward Poynter drew up regulations for the art competitions. In the event, the lead-in time for submitting entries was so short that the attempt was abandoned. Nevertheless, guiding principles were now established for the succeeding Games of 1912.[17]

The first official poster to make a major impact was created for the Stockholm Games of 1912, after the city had been chosen to host the V Olympiad at a meeting of the IOC in Berlin in 1909. The Games, the first at which each

OLYMPIC GAMES
ᕦ STOCKHOLM 1912 ᕤ
JUNE 29 th — JULY 22 nd.

A. Börtzells Tr. A.B. Stockholm

of the five continents was represented, were planned with model efficiency. A purpose-built horseshoe-shaped stadium accommodating 20,000 spectators (the Stockholms Olympiastadion) was designed by Torben Grut, and innovations such as a public address system and electrical time-recording were introduced. Another advance was the increased participation of women: they were allowed to take part in gymnastic displays (plate 12), and their representation in tennis and swimming events increased from 36 in London 1908 to 57.

Similarly, the design of the poster (plate 13) was seen as an opportunity to present Sweden in a positive light to an international audience. It was conceived as an important part of a well-organized and energetic advertising programme, with other printed matter including photographs, tourist literature, picture postcards and a special brochure. The means of the poster's selection, production and distribution were thoroughly described in the official report, providing useful precedents for the future.[18] The choice of image was determined by the Swedish Olympic Committee (SOC), as in future years it would rest in the hands of various Olympic organizing committees, and, prefiguring the elaborate poster competitions of later Olympiads, there was a contest for the best design. Having scrutinized the sketches submitted and conferred with a number of prominent Swedish artists, the SOC agreed in June 1911 upon a design by Olle Hjortzberg.[19] A member of the Swedish Royal Academy, Hjortzberg was a decorative painter well known for his murals for church interiors; he had designed colour lithographic posters in the Art Nouveau style from as early as 1895 and belonged to an 'Artistic Posters' society which aimed to show that posters were more effective when art was applied to advertising. His composition represented a parade of nations, each athlete bearing a billowing flag – with Sweden's at the forefront – and marching towards the common goal of the Olympic Games. It was also a celebration of the nude male body as an ideal, a symbol of athletic perfection in the classical tradition – though slight alterations were made to his original design in order to mask the nudity by some strategic repositioning of flags and streamers.[20] A design by Thorsten Schonberg (known for his drawings of sport) representing the entrance of a marathon runner into the stadium came second, while Axel Törneman's poster, a javelin thrower with the stadium in the background, came third.

Hjortzberg's daring design, in a contemporary interpretation of Art Nouveau, immediately brought ancient *mores* into conflict with twentieth-century notions of propriety, the poster contravening the moral code in several countries. It was forbidden from exhibition in certain public sites, such as hotels, while in China it was banned from display as being 'offensive to Chinese ideas of decency'. In Holland it was withdrawn in one instance from a railway station as being 'in the highest degree immoral'.[21] On the diplomatic front, the order of precedence of the flags depicted also caused some offence, resulting in reluctance in certain quarters to display the poster.[22]

The printing of the seven-colour lithograph was entrusted to A. Börtzell's printing company, Stockholm, which submitted a proof in mid-October 1911 and completed the bulk of the order over the next three months. Such was the demand, in spite of the reservations described above, that additional copies were immediately

Plate 13
Stockholm 1912
'Olympic Games Stockholm 1912'.
Official poster by Olle Hjortzberg
Printed by A. Börtzell, Stockholm, 1911
Colour lithograph
V&A: E.705–1912

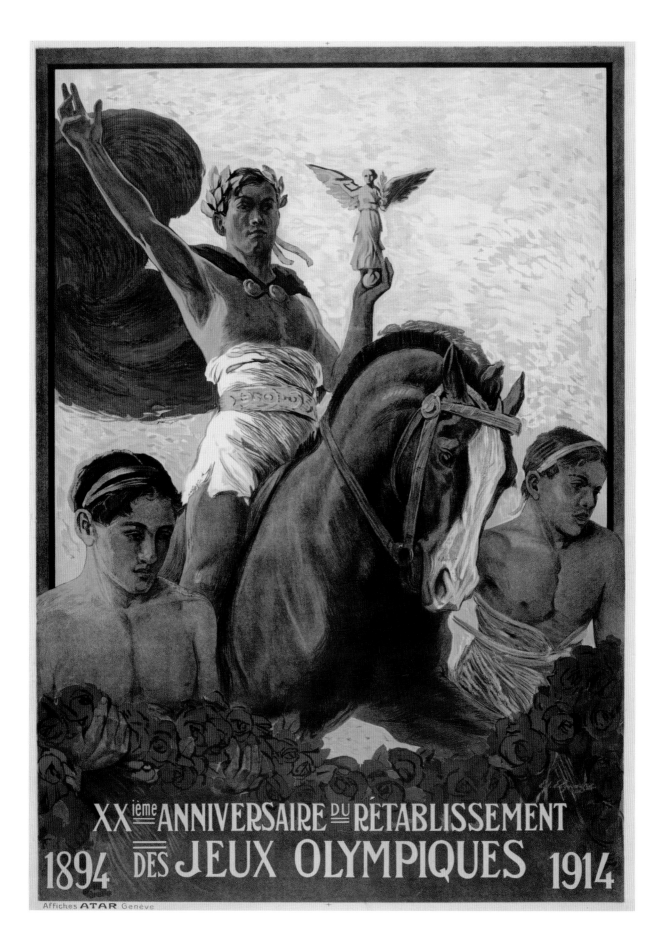

XXième ANNIVERSAIRE DU RÉTABLISSEMENT
DES JEUX OLYMPIQUES
1894 1914

Affiches ATAR Genève

required and, because of the tight production schedule, distribution took place in great haste. At first, 79,950 copies of the poster were printed, in eight different editions, each in a different language, but in response to repeated demands from further interested countries, the number of languages had to be doubled, so that eventually 88,350 copies were produced, with the text in 16 languages (including Chinese, Hungarian, Japanese, Russian and Turkish).[23] The production of the poster in the various language formats set yet another precedent, as did the making of a reduced facsimile as an advertising stamp for postal communications, which proved immensely popular.

Despite its pioneering commission of an official poster, the SOC's promotion of the Olympic art competitions dear to the heart of Pierre de Coubertin was decidedly less enthusiastic.[24] Indeed, as Richard Stanton describes in *The Forgotten Olympic Art Competitions*,[25] the committee's resistance to the competition in favour of an art exhibition incurred the wrath of De Coubertin, who wrote to its secretary, Kristian Hellström, on 31 January 1911:

> How could you think for an instant that I am going to sacrifice my work of twenty years and what is in my eyes the essential thing of the Olympiad – that is to say the alliance of Sports, Literature and the Arts … It will therefore be war … No, Sir, it must not be reckoned that we shall yield, and I repeat, we shall not yield. Deprived of the aureole of the Art Competitions, the Olympic Games are only world championships and for my part, I should no longer be able to support them.[26]

Although the organizing committee eventually submitted to De Coubertin's will, its support remained lacklustre and arrangements for the Concours d'Art for architecture, literature, music, painting and graphic arts, and sculpture were passed to the IOC. With awards of gold, silver and bronze medals available in every category, De Coubertin personally intervened to advertise the competitions and solicit entries. He even submitted an impassioned 'Ode to Sport', under the pseudonyms George Hohrod and Martin Eschbach, which won a gold medal in the literature category; his verses apostrophized Sport as 'Gift of the Gods, Elixir of Life … Beauty … Justice … Courage … Honour … Joy … Fertility'.[27]

On the eve of the First World War, the twentieth anniversary of the 1894 resolution to re-establish the Olympic Games was formally celebrated on 17 June 1914, during the IOC's Sixth Olympic Congress in Paris.[28] Marking the same event was the poster 'XXième Anniversaire du Rétablissement des Jeux Olympiques 1894–1914' (plate 14), designed by the Swiss painter, engraver and illustrator Edouard Elzingre and printed by Affiches Atar, Geneva. Elzingre, who had studied in Paris at the Académie Julian and the Académie des Beaux-Arts, worked in Paris as an illustrator before moving in 1906 to Geneva, where he worked regularly for the printing house of Atar. He was known for his circus, equestrian and history scenes, and among the many posters he created were those advertising horse shows in

Plate 14
'XXième Anniversaire du Rétablissement des Jeux Olympiques 1894–1914'. Anniversary poster by Edouard Elzingre celebrating the decision in 1894 to re-establish the Olympic Games
Printed by Affiches Atar, Geneva, 1914
Colour lithograph
V&A: E.228–2006

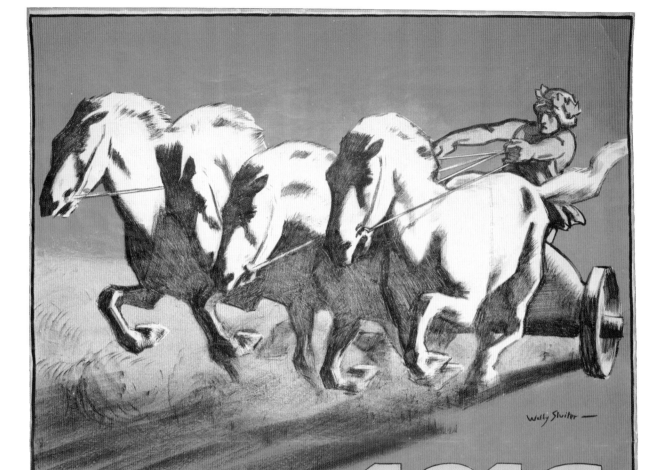

1916
OLYMPISCHE
SPELEN
AMSTERDAM STADION 31 AUG.-3 SEPT.

Plate 15
'1916 Olympische Spelen' (1916
Olympic Games). Poster by Willy
(Jan Willem) Sluiter for the Dutch
National Olympic Games organized in
Amsterdam, 1916
Printed by Drukkerij Senefelder,
Amsterdam
Colour lithograph
V&A: E.47–2008

Geneva. His vividly coloured Olympic anniversary poster conjures up the triumph of an equestrian victor of an ancient Games, crowned with laurels and holding a statue of winged Victory.

The outbreak of the First World War dealt a devastating blow to the VI Olympiad, planned for Berlin in 1916: the Allied Entente of Britain, France and Russia (later joined by Italy and the United States) was at war with the Central Powers of Germany and Austria-Hungary, supported by the Ottoman Empire and Bulgaria. De Coubertin was reluctant to abort the Games, still seeing them as a potential force for world peace. He gave an interview to the Italian newspaper *La Stampa* on 13 February 1915 in which he was reported as saying, 'As regards future Olympic Games, the outlook is quite promising; the strength and, what is more, the harmony of the International Committee have been in no way impaired by the fearful struggle in which Europe is involved at present.' In fact, his stance did strain the harmony of the IOC and eventually he was forced to abandon his attempts at what he saw as a latter-day *ekecheiria* or Olympic truce. Equally, his proposal to count the Berlin Olympic Games officially, in spite of their cancellation, was rejected, and instead they were renamed the VI 'Non Olympic' Games.

In spite of their annulment, one poster (plate 15) acts as a reminder of the phantom Olympiad. On the initiative of Baron F.W.C.H. Van Tuijll van Serooskerken, known as the 'father of Dutch sport' and a member of the IOC since 1898, National Olympic Games were organized in Amsterdam in 1916 to stimulate sports in the Netherlands and to keep the Olympic Movement alive. They started on the very day that the opening ceremony would have taken place in Berlin; the poster of a toga-clad charioteer by the Dutch painter, caricaturist and poster designer Willy (Jan Willem) Sluiter, entitled '1916 Olympische Spelen' (Olympic Games), promoted the event.[29] In terms of sports activities and organization, the Dutch 1916 Games were a great success, although bad weather resulted in poor attendance and they ended in financial deficit.[30]

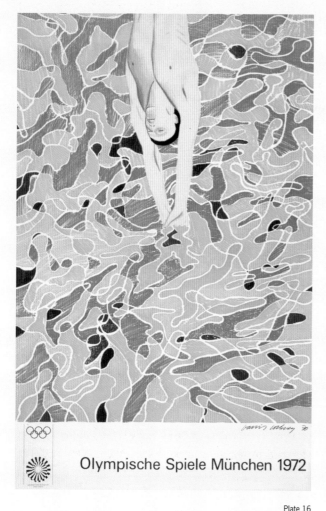

up to the Second World War pay homage to physical beauty, notably Hjortzberg's glorification of the male nude in his design for the Stockholm Games of 1912 (plate 13), and several present the human (always masculine) figure in ways that associate it with classical antiquity and the ancient Games.

As the twentieth century progressed, an awareness of the healthy body and an enthusiasm for sports and athleticism developed yet further. Jean Droit's image of a group of male athletes for the Paris 1924 Olympic poster (plate 21) expressed modernism's preoccupation with physicality and its emphasis on collective fitness as a source of patriotic pride and strength. However, the worship of the body was subject to exploitation by theories of racial supremacy, as evidenced by the posters for the German Games of 1936: Hohlwein's rendition of a skier for the Garmisch-Partenkirchen poster (plate 29) asserts admiration for a supposed Aryan ideal of physical beauty, while Würbel's dominant image for the Berlin Games suggests kinship between the contemporary German male and a heroic classical ideal.

References to classical antiquity continued in posters designed in the post-war years – for example, an image of a Roman marble copy of *Discobolus*, the sculpture which captures the discus thrower in perfect harmony and balance, featured on the poster for the London 1948 Games. In contrast, Kamekura's posters for Tokyo 1964 broke new

Body Beautiful

The human body is naturally the subject of many Olympic Games posters, usually presented as an ideal of physical perfection according to contemporary values. The revival of the Games was one manifestation of late nineteenth-century preoccupations with physical culture, and ancient Greek ideals of physical beauty were fundamental to Pierre de Coubertin's vision of the Olympic Movement. He wrote, 'Sport must be seen as producing beauty and an opportunity for beauty. It produces beauty because it creates the athlete, who is a living sculpture ...'* A number of official Olympic posters created

Plate 13 (p.20), detail
Stockholm 1912

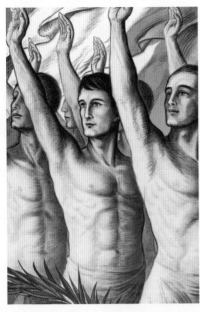

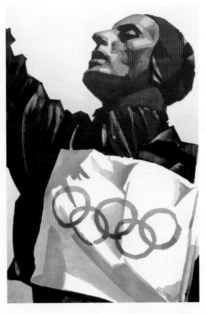

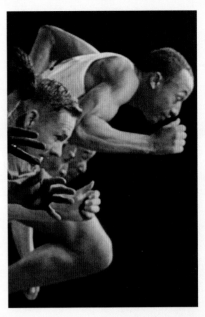

Plate 21 (p.34), detail
Paris 1924

Plate 29 (p.43), detail
Garmisch-Partenkirchen 1936

Plate 60 (p.73), detail
Tokyo 1964

ground: his 'Start of the Sprinters' Dash' (plate 60) used the medium of photography to convey the physical perfection, yet also the psychological drama, of contemporary athletes striving in the reality of fierce competition.

Some of the most inspired interpretations of the human figure in the context of Olympic sport have been those by artists contributing to poster series specially commissioned to celebrate particular Games. Hockney's view of a diver captured at the perfect point of entry (plate 16), Kitaj's startling observation of a swimmer fragmented by water (plate 78) (both for Munich's 'Edition Olympia 1972' series), and Warhol's depiction of a speed skater in motion (for Sarajevo's 'Art and Sports' set) are among the artistic statements offering new insights – portraying the human body as a metaphor for the spirit of human endeavour rather than as literal representation.

In some of the most recent official posters, graphic designers have rendered the human body in emblematic form – a deconstructed figure made up of three bold strokes for Barcelona 1992, the 'Millennium Man' composed of boomerang shapes for Sydney 2000 (plate 131) and the dancing human figure resembling the Chinese character 'jing' on the emblem poster for Beijing 2008. These figures,

conceived as elements within a whole visual programme, are designed to appeal to a universal contemporary audience more familiar with the graphic vocabulary of branding and identity than notions of Hellenistic beauty.

* Quoted in Jean Durry, 'Pierre de Coubertin: sport and aesthetics', *Olympic Review* (July 1986), no.225, p.392

Plate 131 (p.124), detail
Sydney 2000

2ND OLYMPIC
WINTER GAMES
St. Moritz 11-19 th Feb. 1928

SEITZ & Cᵒ, ST. GALL. PRINTED IN SWITZERLAND S.B.B. C.F.F. S.F.R. S.F.F.

Evolving Symbolism

Bids to host the VII Olympiad in 1920 had been entered as far back as 1912, when the Belgian and Dutch Olympic Committees had submitted their proposals to an IOC meeting held in Basel in March of that year. At that point, Belgium's proposed city might have been either Brussels or Antwerp, but thanks to the championship of a group of sportsmen and members of the latter's urban elite, Antwerp eventually won the day, with the Beerschot Stadium approved as the centre for athletic events.[31]

In a shrewd effort to increase its chances of winning the Games for their city, and especially to gain the favour of Baron de Coubertin (president of the IOC since 1896), the Antwerp Provisional Committee issued a publication in 1914 entitled 'Aurons-nous la VIIième Olympiade à Anvers en 1920?' ('Shall we have the VIIth Olympiad in Antwerp in 1920?'), highlighting the city's artistic heritage and emphasizing its desire and ability to organize the Olympic art competitions – a promise that was to be fulfilled. By the Olympic Congress of 1914, the IOC's range of choices had expanded to include Budapest and Rome, but its deliberations were halted by the outbreak of war and it was not until a meeting of the IOC in Lausanne in April 1919 that Antwerp was finally pronounced the 1920 host city, barely 16 months before the event. By that time, the decision was viewed by some on the provisional committee as a cause for alarm rather than for celebration, as Belgium sought to cope with the ravages of war and financial chaos. However, the intervention of the Belgian prime minister and the mayor of Antwerp, and a pledge by the Belgian Olympic Committee of one million Belgian francs, helped to overcome opposition, as Antwerp rose to meet the challenge.

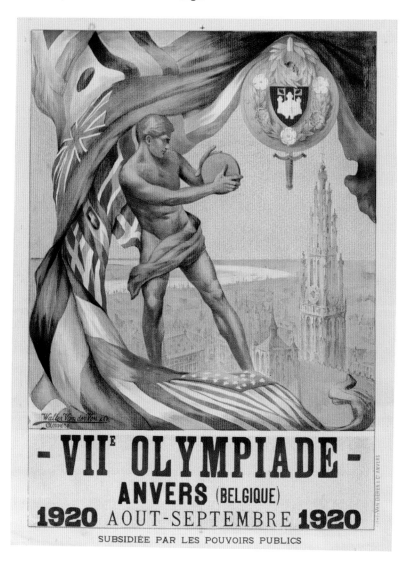

Plate 18
Antwerp 1920
'VIIe Olympiade Anvers [Antwerp] 1920'.
Official poster by Martha Van Kuyck and
Walter Van der Ven & Co., Antwerp
Printed by Van Dieren & Co., Antwerp
Colour lithograph
V&A: E.229–2006

The official poster for the Antwerp 1920 Games (plate 18) was executed by Walter Van der Ven, who ran a small printing company in Antwerp specializing in photogravure, though its concept is attributed to Van der Ven's wife, Martha Van Kuyck. A version of the image had previously been chosen by the provisional committee for the cover illustration of its 1914 brochure, thus explaining the poster's slightly old-fashioned concept.[32] It featured a discus thrower in the foreground, enveloped in a swirl of the flags of participating nations (a theme already developed in the Stockholm 1912 poster), with the Belgian flag prominent to the left and the coat of arms of Antwerp displayed top right. A panoramic view of the city, showing the majestic towers of the Gothic cathedral of Our Lady, the Grote Markt and old City Hall, reinforced the message that Antwerp's proud cultural heritage justified its selection as the venue for the VII Olympiad – a precursor of the many posters in the years to come that would project patriotic imagery and emblems of civic identity. Some 90,000 copies of the poster were produced in 17 different languages, as well as a bilingual series (French/Flemish) for distribution within Belgium, and 40,000 smaller-scale variants of the design. Unfortunately, the VII Olympiad ended in a mountain of debt and a liquidation committee had to resolve the deficit.

At the same time as the official Olympic Games were evolving, a significant workers' sports movement was emerging. Economic and social changes at the end of the nineteenth century, allied to the calls of labour movements for better hours and wages, brought about greater leisure opportunities and preconditions for the rise of mass sport. Workers' sports clubs were formed in the 1890s for the collective enjoyment of pursuits such as cycling, gymnastics, hiking and swimming. The original emphasis on less competitive sports was an aspect of the workers' sports movement's desire to provide what Professor Robert F. Wheeler summarized as 'a humanistic alternative to the excesses of "bourgeois" athletic competition'.[33] During the 1920s and 1930s, the movement supported a marked shift towards team sports and competition, partly in response to grass-roots pressure and partly to combat the opposing ideological and commercial interests vested in organized sport. Membership of workers' sports organizations soared, notably in Germany, Austria, Czechoslovakia, Belgium and France. An outstanding feature of the international labour sports movement was the organization of Workers' Olympiads, seen as a democratic expression of working-class solidarity – of socialist internationalism. Official Workers' Olympiads were held in Frankfurt (1925), Vienna (1931) and Antwerp (1937). Other large-scale Olympiads were organized by the Workers' Gymnastics Association in Prague in 1921, 1927 and 1934.[34] (The early twentieth-century enthusiasm for group gymnastics was also harnessed and encouraged by other organizations, such as the German Turnverein (gymnastics club) and the Czechoslovakian Sokol (Falcon) movement.) In the 1921 Prague Olympiad, 22,314 gymnasts participated, being allowed to enter (unlike at the official post-war Games) irrespective of their nation's allegiance in the First World War. A magnificent colour lithograph (plate 19) by the Prague-born Václav Čutta, a painter and prolific poster designer and illustrator, announced the event. The figure of the heroic male athlete, executed in the socialist-realist style associated with nineteenth-century

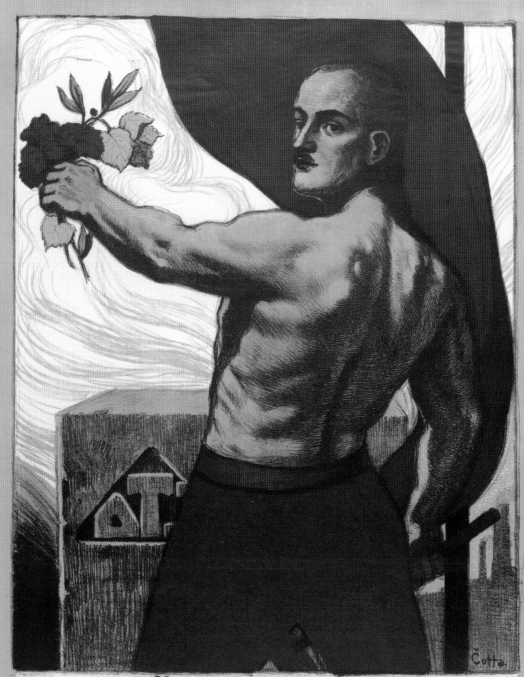

DĚLNICKÁ OLYMPIADA
V PRAZE * 1921 * ČERVEN

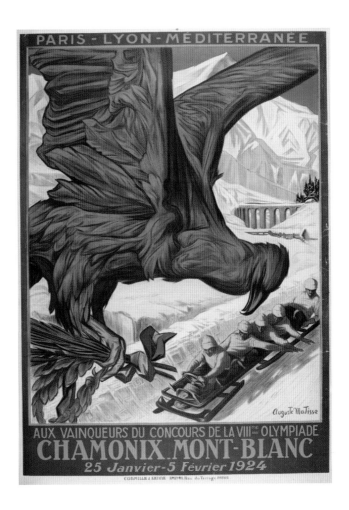

socialism, is posed against a swirling red flag and industrial architectural forms, his musculature echoed in the flowing shapes of the freely drawn sky. Eschewing chauvinistic symbols and references to classical iconography, the poster extols the personal fulfilment of the worker athlete in his contemporary industrial world, suggesting also the solidarity of workers reaching across national borders.

At the 1921 Olympic Congress held in Lausanne (established in 1915 as the permanent headquarters of the IOC), Baron de Coubertin expressed his wish for the VIII Olympiad to be held in Paris in 1924 on the thirtieth anniversary of the founding congress. He wanted the Paris Games (his last as IOC president) to be the living embodiment of his long-held Olympic ideals, including the organization of art competitions. The decision was taken and, at the same time, the congress voted to organize winter sports in Chamonix in 1924 in celebration of that year's Olympiad, though not at the time to be an integral part of its programme. For Chamonix, the decision triggered a period of frenzied construction as rail and road links and hotel development opened up the area to international tourism. And it is a travel poster, 'Chamonix Mont-Blanc' (plate 20), issued by the Paris–Lyon–Méditerranée Railways and designed by the French painter and decorative designer Auguste Matisse, that heralded the Olympic Winter Games and paid tribute to the official Olympiad. Railway companies were important patrons of the poster in the first half of the twentieth century and developed a special relationship with the Olympic Games, since they

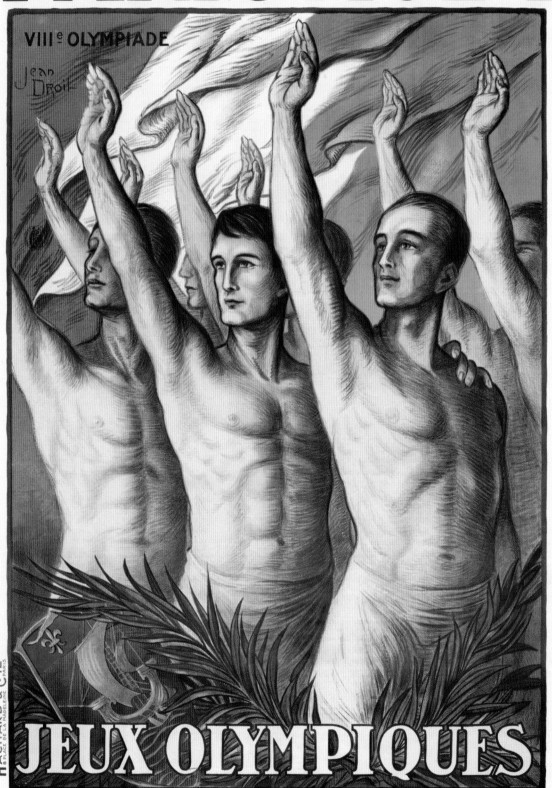

Plate 21
Paris 1924
'Paris – 1924 Jeux Olympiques'.
Official poster by Jean Droit
Printed by Hachard et Cie,
Paris
Colour lithograph
V&A: E.329–2006

were a means both of distributing and displaying the posters that promoted the events and also of transporting visitors to and from the venues. In Matisse's somewhat menacing image, a golden eagle (a species found around Chamonix) hovers above a bobsleigh team, grasping in its talons a palm and wreath of victory tied with the French colours. About 5,000 copies of the poster were issued – in line with the normal production numbers for contemporary railway posters. These successful Games were retrospectively recognized at the 1925 IOC Congress in Prague as the first Olympic Winter Games.

A poster of a completely different order was the design by Jean Droit for the Paris Games of 1924 (plate 21). The revival of the Olympic Games in 1896 had been one manifestation of the late nineteenth-century preoccupation with physical culture and ancient Greek ideals of physical beauty; by the early twentieth century an awareness of the healthy body and an enthusiasm for sports and physical prowess had developed yet further. It found particular expression in modernism, in which an emphasis on the active and perfectible body, and on individual and collective fitness, was crucial to the movement's social agenda.[35] The espousal of mass physical culture became a source of national pride and strength, as perfectly exemplified in Jean Droit's image: the group of male athletes, right arms raised in a demonstration of unity and heroic endeavour, is pictured amid laurels of victory, the red, white and blue of the Tricolour and the Paris coat of arms. Droit was a French painter, illustrator, poster artist and designer, and also a supporter of the Scout movement, the aims of which included the encouragement of young people in their physical, mental and spiritual development. Two designs were selected by the French Olympic Committee from the 150 submitted – that by Jean Droit and another by the prolific poster designer Orsi – and 10,000 copies of each were printed. Altogether 12,000 were sent abroad and distributed with the help of the national Olympic committees, sporting federations and Olympic associations, while in France the posters were spread by sporting organizations and theatre and travel agencies, among other means.

Plate 22
Film still from *Chariots of Fire* (1981),
directed by Hugh Hudson, showing
Ian Holm as Sam Mussabini, Harold
Abrahams's coach, in front of the
1924 Paris Olympic Games poster
Twentieth Century Fox Film Corporation

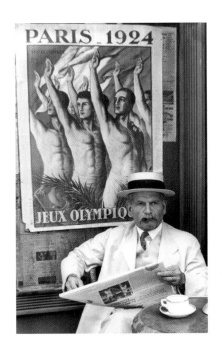

De Coubertin's desire for the Paris Games to symbolize his classical ideals through '*la présence de génies nationaux, la collaboration des muses, la culte de la beauté* …'[36] was met at least in part by the raised status at these Games of the Olympic art competitions, which attracted 238 entries. There was also an architectural competition by invitation of the Comité Olympique Français for the design of different sports stadiums. None of the projects was realized, the remodelled Stade de Colombes becoming the main site for the Games. This was the setting for the Olympic triumphs of British track athletes Harold Abrahams and Eric Liddell that inspired the film *Chariots of Fire* (1981), in which Jean Droit's poster was used as a 'prop' (plate 22). Other stars of the Games, which attracted 3,092 athletes from 44 nations, were the Finnish runner Paavo Nurmi, who won five gold medals, and American swimmer Johnny Weissmuller, who won three gold medals and later went on to star as Tarzan in Hollywood films. For the first time, events could be followed by live radio transmission.

The second Olympic Winter Games were held at St Moritz in 1928 and,

as at Chamonix four years earlier, the venue provided all the amenities of a well-established ski resort – although an unseasonable thaw affected events such as the speed skating, bobsleigh and Nordic skiing. Norway's Sonja Henie became the star attraction, winning the women's figure skating event at the age of only 15. Unlike the 1924 precedent, the St Moritz Games were held in a different country (Switzerland) from the Olympic Games the same year (the Netherlands). The official St Moritz poster (plate 17) by Hugo Laubi, of which 12,000 copies were produced, featured the Swiss and Olympic flags (on which the rings symbol made its first poster appearance) against a backdrop of the pristine snow-capped heights of the Engadin Mountains. Laubi, known for his commercial lithography work and St Moritz tourist posters, was a popular artist of the contemporary Swiss poster school, a genre characterized by a simplification of form and a controlled orchestration of space and colour.

In 1928 Amsterdam was at long last awarded the Olympic Games. Having organized national Games in 1916 in order to keep the Olympic spirit alive, and having bid for the previous two Olympiads, losing out to Antwerp in 1920 and Paris in 1924, Amsterdam triumphed over Los Angeles – the only other contender – for the prize of the IX Olympiad. For the first time, the Games were funded entirely through private donations rather than with government support. Other 'firsts' were the lighting of the Olympic flame on top of the mighty tower of the Olympisch Stadion and the order of precedence in the parade of nations, with the Greek contingent, representing the founding nation of the ancient Games, at the head and the host nation at the rear; this established a custom for all future Games. Also for the first time, women were allowed to compete in gymnastics and athletics. The Games were held largely in an atmosphere of peace and harmony, and the action of Australian rower Henry 'Bobby' Pearce, who stopped midway through his quarter-final to allow a flotilla of ducks to swim by in front of his boat, passed into Olympic legend. In spite of this interruption, Pearce won the race and later the gold medal too.

Sensitive to the long-held views of the 65-year-old Baron de Coubertin, whose ill-heath prevented him from attending the Games in person (he listened to news of them by radio), the Netherlands Olympic Committee made a special effort to raise the profile of the art competitions and to integrate them into the Games. Originally the committee even planned to construct a special building close to the Olympic Stadium to make the dream of integration a reality, although in the event the venue was the Stedelijk Museum. An art section was created representing the fields of Dutch painting, sculpture, architecture, music and literature, and entries were encouraged from both the Netherlands and abroad. The end result was the greatest participation in the competitions to that date, one notable winner being the Dutch architect Jan Wils, whose functionalist-influenced design for the Olympic Stadium itself won the gold medal in the architecture category.

The Netherlands Olympic Committee also set great store by their choice of official poster, which was 'intended to draw worldwide attention to the coming Olympic Games', and privately approached several Dutch artists to submit entries.[37] The design chosen from a shortlist of four was by Joseph Johannes (Jos) Rovers,

Plate 23
Amsterdam 1928
Official brochure for the IX Olympiad:
cover illustration by
Joseph Johannes (Jos) Rovers
Published by Joh. Enschedé en Zonen,
Haarlem, 1928
Colour lithograph
V&A: E.4–2007

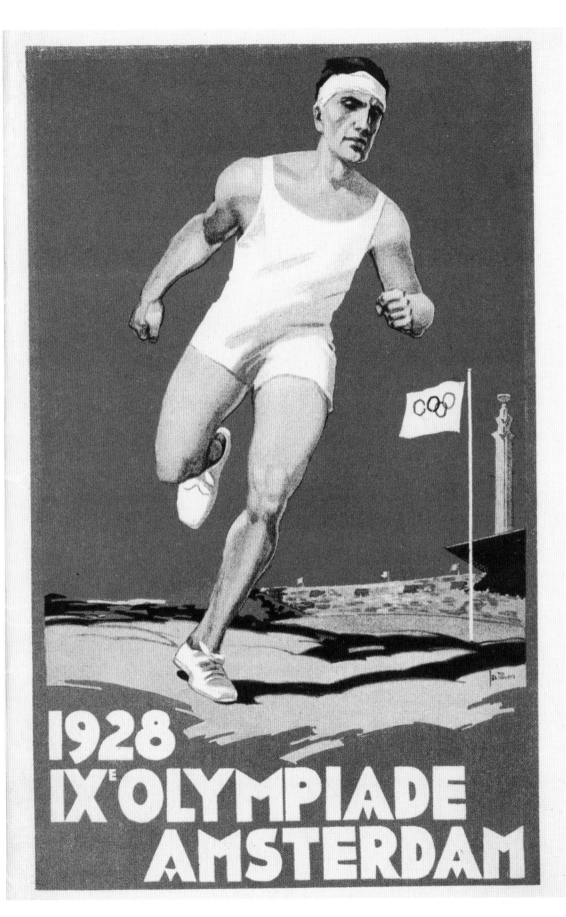

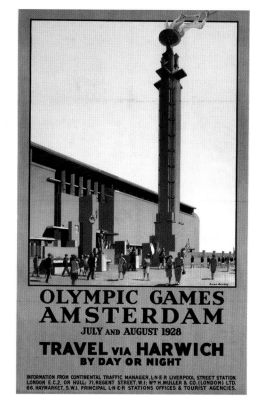

OLYMPIC GAMES
AMSTERDAM
JULY AND AUGUST 1928
TRAVEL VIA HARWICH
BY DAY OR NIGHT
INFORMATION FROM CONTINENTAL TRAFFIC MANAGER, L.N·E·R LIVERPOOL STREET STATION,
LONDON E.C.2, OR HULL; 71, REGENT STREET, W.I; W™ H. MULLER & CO. (LONDON) LTD.
66, HAYMARKET, S.W.I, PRINCIPAL L·N·E·R STATIONS OFFICES & TOURIST AGENCIES.

Plate 24
Amsterdam 1928
'Olympic Games Amsterdam'. Railway
poster by Anton van Anrooy, depicting
the Olympic flame burning in the
bowl of the Marathon tower of the
Amsterdam Olympisch Stadion
Issued by the London and North
Eastern Railway; printed by Vincent
Brooks, Day & Son Ltd, London, 1928
Colour lithograph
National Railway Museum, York

a painter, etcher and designer who lived and worked in Amsterdam and Haarlem,
and who had previously studied at the Academy of Fine Art in Antwerp. He received
500 guilders voted for the purpose. A realistic portrayal of a lone runner, Rovers's
design also featured the Olympic flag and, in the background, a view of the stadium
tower. After some modifications to the original design, the poster was produced in
two sizes, 10,000 copies issued in the large size (100 x 62cm) and 45,000 copies
in the small (24 x 39cm). A number of the posters that were to be distributed by
the Netherlands Railways were lettered with the railway's name in the language
of the country to which they were to be sent. Within the Netherlands, the posters
were hung in railway stations and distributed by sporting organizations, travel and
tourist offices, hotels and various municipalities. Abroad, they were distributed by
the national Olympic committees, international travel offices and the International
Federation of Hotel Keepers. In a conscious move to strike a relationship between
the various forms of printed propaganda, Rovers's design was also reproduced on
a smaller scale on the cover of the publicity booklet (plate 23) and on letter seals
and postcards.

The poster by Rovers makes an interesting comparison with the railway
poster 'Olympic Games Amsterdam' (plate 24) by the painter Anton van Anrooy,
issued by the London and North Eastern Railway (LNER) in 1928 and advertising
travel to the Games via Harwich. The former focuses on an intense sporting
moment, while the latter, in the customary manner of travel posters, entices the
would-be voyager with a scenic view of the Olympic Stadium seen from the visitor's
perspective. Van Anrooy was well placed to execute this commission, having been
born in the Netherlands and studied art in The Hague before moving to London and

acquiring British citizenship; he designed posters for the Great Western Railway as well as the LNER.

Until 1932, each Olympiad had taken place in Europe. Now, for the first time, the venue for both winter and summer Games was to be America. The third Olympic Winter Games, in 1932, were held in Lake Placid, in the Adirondack Mountains of New York State, a town with fewer than 4,000 inhabitants. To publicize the venue, photographs of Lake Placid winter scenes and sports facilities were distributed abroad, and the poster by Witold Gordon (plate 25) helpfully pinpointed Lake Placid on a map of the USA. Gordon was a Polish-born illustrator, designer and muralist, and his Olympic design featuring the pared-down silhouette of a ski jumper was in

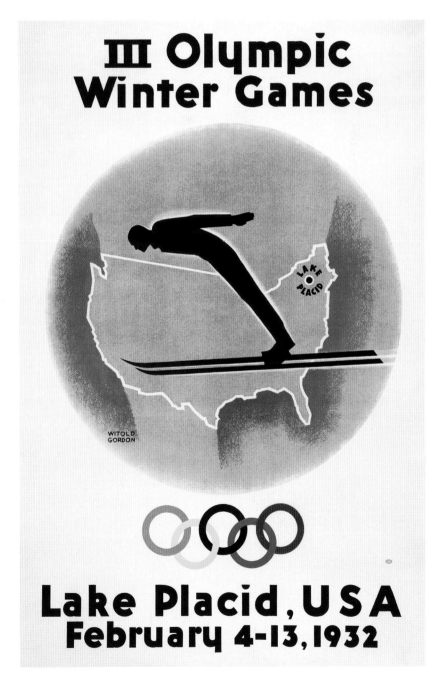

Plate 25
Lake Placid 1932
'III Olympic Winter Games Lake Placid, USA, February 4–13, 1932'. Official poster by Witold Gordon
Printed in USA, 1930
Colour lithograph
Olympic Museum Lausanne Collections

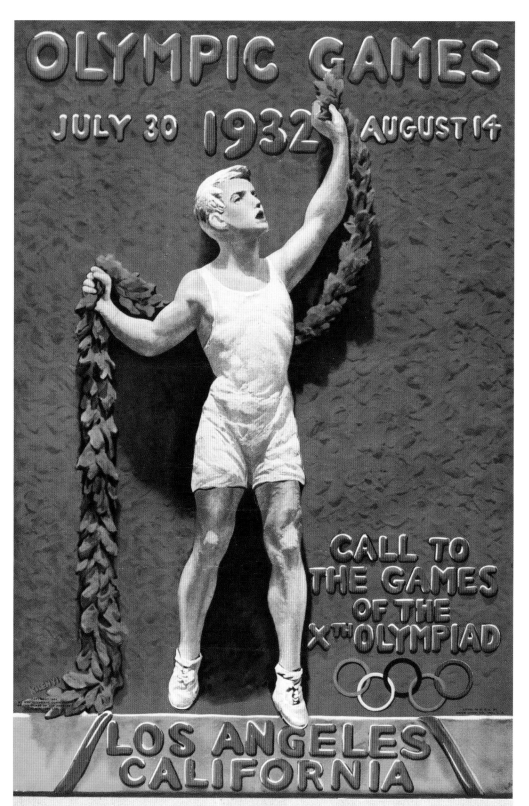

OLYMPIC GAMES

JULY 30 1932 AUGUST 14

CALL TO THE GAMES OF THE XTH OLYMPIAD

LOS ANGELES CALIFORNIA

◀ Send Name and Address to Ticket Department, Olympic Games, Eighth and Spring Streets, Los Angeles, for Program of Events and Ticket Reservation Form. ▶

Plate 26
Los Angeles 1932
'Olympic Games July 30 - August 14
1932, Los Angeles California'. Variant
of official poster by Julio Kilenyi, 1931
Colour lithograph
V&A: E.421–2007

the modern, simplified style to be found in contemporary advertising posters. It was used for the poster and as the emblem of the Games. Publicity material prepared for 1930, including approximately 15,000 copies of the poster printed in English, French and German, preliminary programmes, information booklets and sticker stamps, was distributed abroad, mainly to Europe, with the aid of the American Express Company, Thomas Cook & Son, Olympic committees, sports federations and steamship and railway lines.[38] A subsequent phase of distribution in 1931, mainly to the USA and Canada, included an anonymously designed second poster featuring a bobsleigh team in action. Unfortunately, the Games were held in the midst of a worldwide depression and many countries were unable to send well-prepared and equipped teams. In the end only 17 nations competed, and over half the 252 athletes were from the USA or Canada. In spite of this, and the mild weather conditions that turned ice and snow to slush, Lake Placid proved an exciting venue, with its new Olympic Stadium and a thrillingly fast bobsleigh run – the first ever in North America – created on Mount Van Hoevenberg.

The Great Depression continued to cast its shadow over the 1932 Games of the X Olympiad held in Los Angeles, California (the only bidder for these Games). There were domestic protests demanding 'Groceries Not Games'[39] and abroad many nations decided that they could not afford to send teams; the number of participants was less than half that for Amsterdam. Nevertheless, the standard of competition was very high and record crowds attended, with over 100,000 present at the opening ceremony. Over the 16 days of the competition – which has remained 15 to 18 days long ever since – 18 world records were broken or equalled. Mildred 'Babe' Didrikson struck a blow for women when she won the javelin and the high hurdles, and finished second in the high jump, to become the most successful athlete of the Games – this at a time when women were restricted to competing in only three individual events in track and field. A popular cultural component was the exhibition of art staged at the Los Angeles Museum of History, Science and Art in Olympic Park (opposite the Olympic Stadium), which was held concurrently with the art competitions and attracted over 384,000 visitors. The awards for the art competitions themselves – gold, silver and bronze medals for architecture, literature, music, painting and graphic art, and sculpture – were ceremonially announced in the Olympic Stadium, in the same manner as for the sports victories.[40]

Plate 27
Los Angeles 1932
Official programme for the Olympic
Games 1932, Los Angeles, California:
cover image by Julio Kilenyi
Printed by Times–Mirror Printing &
Binding House, Los Angeles
Colour half-tone and lineblock
V&A: E.224–2006

Because of the distance from Los Angeles to the majority of participating Olympic countries, press and promotion took on a newly important role for the X Olympiad. The official poster was conceived by the American-Hungarian sculptor Julio Kilenyi and, according to the official report, 'depicted the ancient Greek custom of sending a youthful athlete out to announce the forthcoming celebration of the Games'.[41] The Los Angeles Organizing Committee chose the design believing it to be sufficiently novel and attractive to retain its appeal over the period of many months during which it would be displayed. An adaptation of the poster (plate 26) had additional text advertising the ticketing arrangements, while the same image was also used on the cover of the official programme (plate 27). Kilenyi was born in Hungary and first studied at the Royal Fine Arts School in Budapest, continuing his

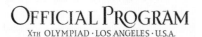

Official Program
XTH OLYMPIAD · LOS ANGELES · U.S.A.

OLYMPIC PARK 10c SUNDAY AUGUST 7, 1932

Plate 28
Berlin 1936
Cover and detail of p.10 of Official
Tages-Programm (*Daily Programme*)
for the Berlin Olympic Games,
2 August 1936, listing the 100-metre
heat won by Jesse Owens
Printed by Reichssportverlag
GmbH, Berlin; published by
Organisationskomitee der XI.
Olympischen Spiele, Berlin, 1936
Cover: half-tone
V&A: E.225–2006

Plate 29
Garmisch-Partenkirchen 1936
'Deutschland 1936. IV Olympische
Winterspiele Garmisch-Partenkirchen
6.–16. Februar 1936'. Official poster
by Ludwig Hohlwein
Published by the Reichsbahnzentrale
für den deutschen Reiseverkehr
(German Railway Publicity Bureau),
Berlin, 1934
Colour lithograph
V&A: E.370–2006

training in Germany and France. After working in Europe, he went to South America and spent several years in Buenos Aires, where he established a high reputation as a portrait sculptor. He moved to the United States in about 1918 and became celebrated for his medal portraits of well-known figures, including Benjamin Franklin, Woodrow Wilson, General Pershing, Thomas A. Edison, Mark Twain and Charles Lindbergh. He also executed numerous commemorative medals, including that for the Los Angeles 1932 Games. For the Los Angeles poster, Kilenyi first modelled the design in clay, then a photograph of this model was coloured and reproduced by colour lithography, giving a three-dimensional effect.

The Olympic Games of 1936, both held on German soil, were among the most controversial of the twentieth century and took place in an atmosphere of increasing international rivalry. Two decades after her original plans to host the 1916 Games had been aborted by the First World War, and having been readmitted to the Games in 1928 after post-war ostracism, Germany outbid the rival claim of Barcelona to host the 1936 Olympiad. The decision was announced by the IOC on 13 May 1931, at a time when Germany, though beset by economic crisis and political extremism, was still under the government of the democratically elected Weimar Republic. Two years later, however, as the organizing committee began its preparations, Hitler was offered the chancellorship of Germany by President Hindenburg and, through his leadership of the Nazi Party, proceeded to acquire dictatorial powers, assuming the title of Führer of the Third Reich on Hindenburg's death in 1934. Sport as a strengthening collective activity was high on the Nazi political agenda by now, and it was also seen as a means of underscoring their belief in the innate superiority of the Aryan race. By extension, the forthcoming Games were viewed as an opportunity to present German sporting mastery and organizational expertise to the world. In reality, of course, the hero of the Olympiad would prove to be the African-American track and field athlete Jesse Owens, who won gold medals in the 100 and 200 metres, the long jump and the relay. The marked-up pages of daily programmes (plate 28) provide an on-the-spot record of his astounding feats.

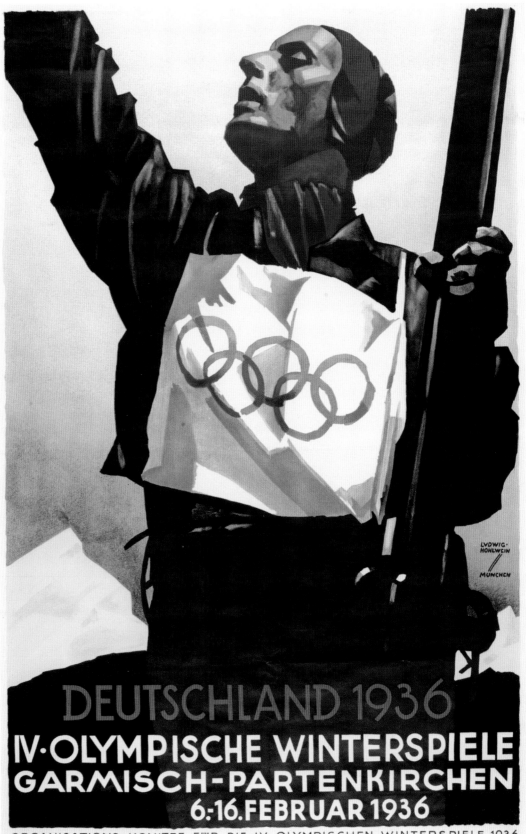

Plate 30
A show window in London.
From p.357 of *The XIth Olympic
Games Berlin, 1936,
Official Report* (Berlin, 1937), Vol.1

To publicize the Olympiad in Germany and abroad, a publicity commission for the Olympic Games was established on 15 January 1934, beginning a regular campaign to make the Games the outstanding international event of 1936. The latest publicity methods were used in order to make the world 'Olympic-conscious', with special initiatives aimed at countries where 'for political reasons a wave of opposition began to make headway'.[42] The commission carried out its foreign campaign through the international organization of the Reichsbahnzentrale für den deutschen Reiseverkehr (RDV), the German Railway Publicity Bureau, which by the start of the Games had 44 foreign offices in 40 different countries. It arranged posters, pamphlets, the RDV press service, radio talks, postcards and special seals, publicity badges, exhibition and show window material (plate 30), advertisements, Olympic receptions and celebrity lecture tours.[43]

The 1936 IV Olympic Winter Games, officially opened by Hitler on 6 February, were held in the twin Bavarian towns of Garmisch and Partenkirchen and featured an uneasy mix of pageantry and militaristic display. About 650,000 spectators attended as the sporting drama unfolded at the newly built bobsleigh run, ski jump, skating rink and stadium.[44] Only German photographers were allowed to record the events and pictures were vetted before being made available for international distribution. The poster advertising the Games was by Ludwig Hohlwein, one of the twentieth century's most distinguished poster designers (plate 29). Born in Wiesbaden and originally trained as an architect at the Munich Polytechnic, Hohlwein took up poster design in 1906 and for the next 40 years, in Munich and the USA, conceived a masterly series of posters for a wide range of clients. Influenced by the distinguished British poster artists The Beggarstaffs[45] and by contemporary art movements in France and England, he created a style characterized by asymmetry, block-like interlocking shapes, high tonal contrasts and bold lettering. Hohlwein was employed by the

German government during the First World War to produce propaganda posters, and after Joseph Goebbels had formed the Reichsministerium für Volksaufklärung und Propaganda (Ministry for People's Enlightenment and Propaganda) in 1933, he signed up to the Nazi cause. The poster for the Garmisch-Partenkirchen Games depicting an Olympic skier exemplified his facility for rendering the body in idealized sculptural form: the figure's chiselled features and athletic stance presented the would-be Aryan archetype of physical strength and perfection, his right arm raised in what could be interpreted as a Nazi salute. Some 106,150 copies in large format were produced in 13 languages and 22,450 small copies in German. Photographs showing massed versions of the image displayed in RDV tourist offices windows in Spain (plate 31), the Netherlands and Sweden were used as illustrations in the Games' official report.[46]

The 1936 Berlin Games offered Hitler a supreme opportunity to promote his regime's prestige on a world stage through Olympic spectacle and ritualistic display: not only to invest the Third Reich with the pomp and glamour of the modern Games but, by appropriating and inventing images from antiquity, to associate it symbolically with the grandeur of the Roman Empire and the glories of the classical world. Constructed from 1933, the vast sports complex of the Reichssportfeld was the centrepiece for the Games. This encompassed the monumental Olympiastadion designed by Werner March, with its last-minute addition of a neo-classical façade by Albert Speer, consciously evoking comparison with Rome's Colosseum, the huge Maifeld for massed gatherings and displays, the Waldbühne amphitheatre, and other buildings for specialist sports. Ceremonial highlights of the Games included a triumphal torch relay from Olympia to Berlin (a 'tradition' invented by Carl Diem, secretary general of the Berlin Organizing Committee), the climactic lighting of the Olympic flame in the Marathontor (Marathon Gate) and the solemn procession of a massive 9.5 tonne 'Olympic Bell' to the high Glockenturm (Bell Tower) in the Maifeld. Leni Riefenstahl's ground-breaking film *Olympia* (1938), the first documentary of an Olympic Games ever made, paid long visual homage to the cult of the body beautiful and the links with classical Greece. Meanwhile, an ambitious exhibition, *Sport in Hellenic Times*, drawing on sport-related artworks from German museums and elsewhere, heightened associations with antiquity.

Heroic realism was the style approved by Hitler, and the official poster (plate 32) by the Berlin painter and graphic artist Franz Würbel was designed to dominate and impress. It was printed in two formats, with a total of 243,710 copies produced in 19 languages. The publicity committee for the XI Olympiad had announced a competition for the official poster in June 1934, but the results were unsatisfactory: of the 59 posters submitted by 49 leading German graphic artists, none was held to meet the threefold objective of indicating the importance of the Olympiad, proclaiming Berlin as the host city and publicizing the Games in an effective and internationally understandable manner.[47] The five allocated prizes were nevertheless awarded, the first prize going to Willy Petzold, whose design was adapted to advertise the art competitions. After this false start, the publicity committee responsible for advertising the Games actively commissioned a number

Plate 31
A show window in Spain displaying the German Railway Publicity Bureau's publicity for the 1936 Olympic Winter Games. From p.145 of *IV Winterspiele Garmisch-Partenkirchen. Amtlicher Bericht* (Berlin, 1936)

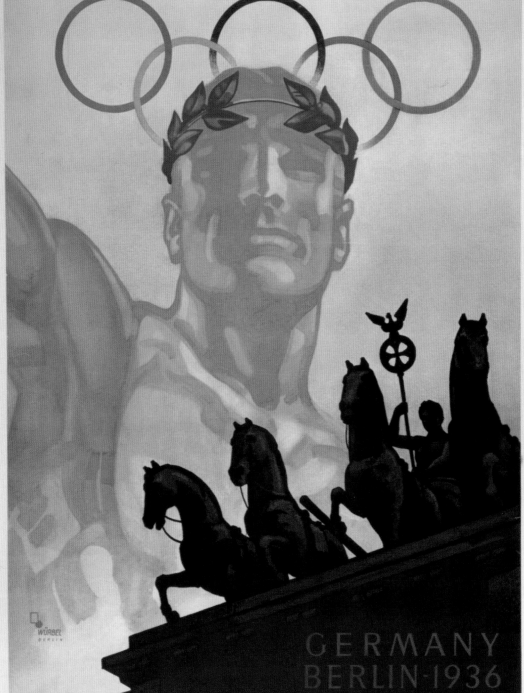

GERMANY
BERLIN · 1936
1–16ᵗʰ AUGUST

OLYMPIC GAMES

Plate 32
Berlin 1936
'Germany Berlin 1936 Olympic
Games'. Official poster by
Franz Würbel
Published by the Reichsbahnzentrale
für den deutschen Reiseverkehr
(German Railway Publicity Bureau),
Berlin, 1935
Colour lithograph
V&A: E.2905–1980

Plate 33
'Olimpiada Popular Barcelona 19–26
Julio 1936' (People's Olympiad
Barcelona, 19–26 July 1936)
Poster by F. Lewy ('LY'), 1936
Colour lithograph
Courtesy of Jordi Carulla

of artists to create designs for the official poster and Würbel was finally selected. His composition combined symbols of the Olympic Games (a wreathed victor 'with his arm raised in Olympic greeting' and the Olympic rings) with an image of the quadriga of the landmark Brandenburg Gate (denoting Berlin) and text about the Games clearly lettered across the architecture.[48]

This poster makes a fascinating comparison with the modern populist appeal of 'Olimpiada Popular' (plate 33), which promoted the People's Olympiad planned for Barcelona in 1936 as a protest against the Berlin Games under Nazi rule. Whereas Würbel's design is a forceful expression of German nationalism, the Barcelona image promoted ideals of socialist internationalism. When the Popular Front of Spain was voted into government in February 1936, they decided to boycott the Berlin Games and invite the nations of the world to their alternative Games, to be held from 19 to 26 July, six days before the official event. Barcelona had bid to be the official 1936 summer venue, so plans were already drawn up. Some 6,000 athletes from 22 nations registered for the Games, with many sent by trade unions, workers' clubs and associations, socialist and communist parties and left-wing groups. However, the Spanish Civil War broke out just as things were about to get under way and the Games were abruptly cancelled. In an extraordinary turn of events, many athletes took part in the fighting the following day alongside the workers, while around 200

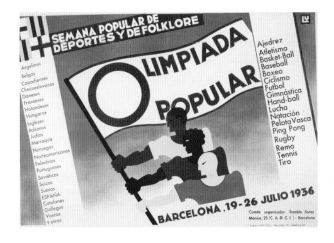

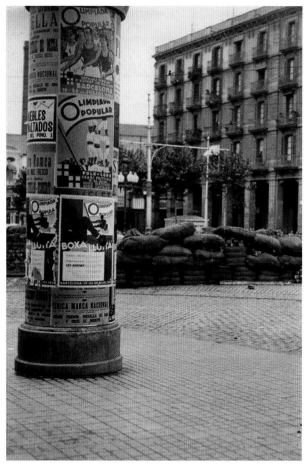

Plate 34
'Barricada al Paral.lel, 19 July 1936'.
Photograph by Pérez de Rozas
Taken in central Barcelona, shortly
after the outbreak of the Spanish Civil
War, showing posters for the aborted
People's Olympiad displayed in front
of a sandbag barricade
Courtesy of Arxiu Fotogràfic de l'Arxiu
Històric de la Ciutat de Barcelona

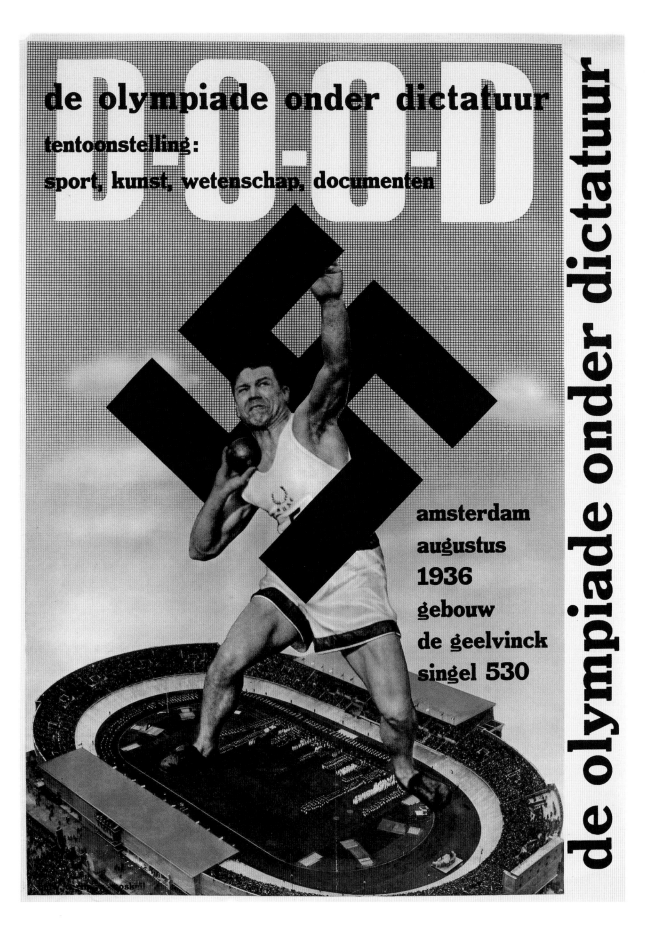

later joined the militia columns that were battling to defend the Spanish Republic.[49] A photograph taken in a Barcelona street on 19 July (plate 34) shows posters for the Olimpiada Popular incongruously displayed before a barricade of sandbags.

A repudiation of the political values espoused by the Berlin Games was also expressed in an exhibition organized in Amsterdam in August 1936, *D-O-O-D/de olympiade onder dictatuur* (*The Olympiad under Dictatorship*). The exhibition committee called for artists and intellectuals from the Netherlands and abroad to contribute works in defence of the cultural values of civilization and in protest against Nazi bias against certain artists on grounds of race or belief in international (including Olympic) art competitions.[50] Its poster (plate 35), a powerful photomontage of a shot putter in the vice-like grip of a swastika, with photography by Cas Oorthuys, was conceived by the exhibition secretary, Dutch artist Johan Jacob Voskuil. Contributors, who included Robert Capa and Max Ernst, sent in a total of 256 works, and as well as paintings, drawings, prints, graphics, sculpture and photomontage, there was also a documentation section. The German consul complained, causing the withdrawal of many artworks from the Amsterdam showing. Part of the exhibition then moved to Rotterdam, where after a few days it was closed completely, due to further German protests.

In turbulent times, the Olympic Games planned for 1940 were to be the victim of events. The XII Olympiad was originally scheduled for Tokyo, which would have made it the first Games to be held in Asia and provided an opportunity for Japan to display not only her sporting facilities but also, by organizing the Olympic art competitions, her commitment to the arts. The Olympic Winter Games of the same year were planned for Sapporo, on the most northern island of Japan. Although preparations got under way immediately after the Berlin Games, Japan's action in invading China in 1937 rang alarm bells within the IOC, and in July 1938 the Japanese government ended the controversy by forfeiting its right to host the Games. St Moritz was revisited as an alternative site, but a dispute about ski instructors led the Swiss also to withdraw and instead in July 1939 Germany made a repeat offer of Garmisch-Partenkirchen. Meanwhile, the IOC accepted an offer put forward by the Finnish IOC representative to make Helsinki the substitute summer venue. Encouraged by the great victories of their athletes, Finnish sports leaders had dreamed since the 1920s of organizing an Olympic Games: the Helsinki Olympic Stadium, a landmark piece of functionalist architecture designed by the architects Yrjö Lindegren and Toivo Jäntti and built in 1934–40, was to be the inspirational setting. Planning, advertising and construction began, but once again war intervened. Germany invaded Poland on 3 September 1939, triggering the start of the Second World War – and leading to the demise of Garmisch-Partenkirchen as the substitute host for the 1940 Olympic Winter Games. On 30 November 1939 the Soviet Union attacked Finland and on 2 May 1940 the Games of the XII Olympiad were cancelled altogether.

A magnificent poster, designed by the Finnish artist Ilmari Sysimetsä and printed by F. Tilgmann of Finland, reminds us of the Helsinki 1940 Games that might have been (plate 36). The image is based on a bronze statue of the Finnish runner

Plate 35
'D-O-O-D de olympiade onder dictatuur' (The Olympiad under Dictatorship). Poster by Johan Jacob Voskuil, photographer Cas Oorthuys, advertising the exhibition held in Amsterdam, August 1936
Rotogravure, letterpress
Courtesy of Merrill C. Berman

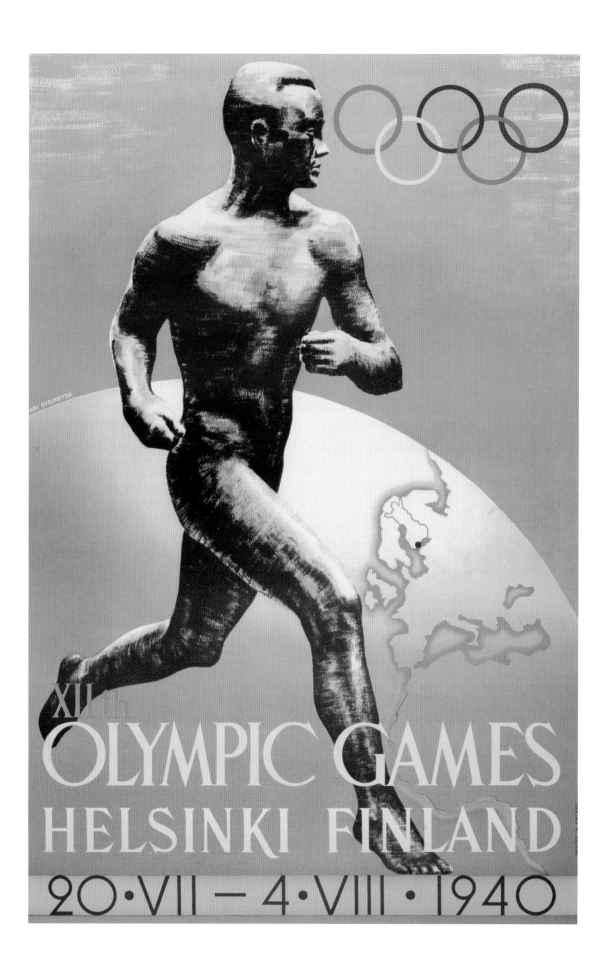

Plate 36
Helsinki 1940 (cancelled)
'XIIth Olympic Games Helsinki Finland
20.VII–4.VIII.1940'.
Poster by Ilmari Sysimetsä for the
cancelled Helsinki 1940 Games
Printed by F. Tilgmann, 1939
Colour lithograph
V&A: E.301–2006

Paavo Nurmi ('The Flying Finn') by Finnish sculptor Wäinö Aaltonen. The choice of subject is an early example of the cult of heroes that later became a feature of sporting posters. Nurmi was one of the greatest runners of all time and his athletic feats in the 1920s helped put Finland on the world map after she had declared her independence from Russia in 1917. Significantly, his image is superimposed over a section of the globe that shows Finland prominently outlined in orange. It was after Nurmi had won his five gold medals at the Paris Games in 1924 that the Finnish government commissioned the statue by Aaltonen; a copy, cast in 1952, stands at the entrance to the Helsinki Olympic Stadium. Driven by the love of running and with an iron will to succeed, Nurmi dominated middle- and long-distance running, and in total won nine gold and three silver Olympic medals Martti Jukola, a leading Finnish sports journalist, wrote in 1935, 'There was something inhumanly stern and cruel about him, but he conquered the world by pure means: with a will that had supernatural power.'[51]

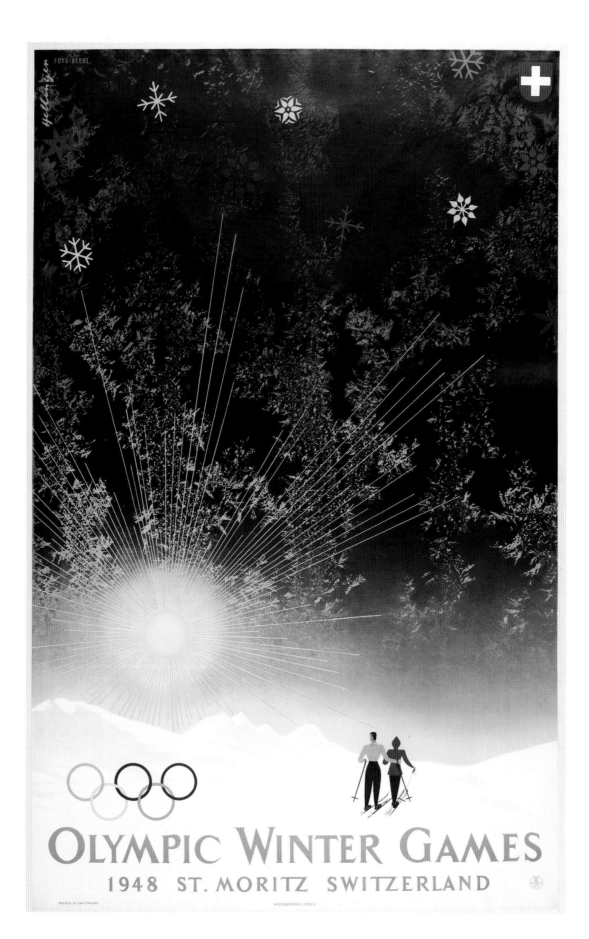

Post-war Design

Ten years after the Berlin Games of 1936, and in the climate of a new world order established at the end of the Second World War, the IOC meeting in September 1946 decided that the first post-war Olympic Winter Games should be held in St Moritz. This resort, the second alternative for the 1940 winter venue, and with previous experience of hosting the 1928 Games, needed only to modernize its facilities, rather than to build anew.

Plate 38
London 1948
Olympic relay torch designed by
Ralph Lavers, ARIBA, 1947
Made by EMI Factories Ltd,
London, 1948
Aluminium and steel
V&A: M.3:1&2–2006

'Jeux Olympiques d'Hiver', the radiant image by Swiss poster designer Fritz Hellinger chosen as one of the posters for the Games (plate 37), seems to symbolize a world free once again to enjoy sport in surroundings of natural beauty. It can equally be read as a straightforward travel poster, and indeed a variant of the design lettered 'Vacances en Suisse' was issued by the Swiss National Tourist Office (a patron of the Swiss winter sports poster) in the same year. In the event, participation was limited by post-war restrictions on sports equipment, currency and travel, and St Moritz hoteliers suffered as a result. In sporting terms, Alpine skiing was now raised to the same level as Nordic skiing, with slalom and downhill events for both men and women included for the first time: a surprise victor was the American skier Gretchen Fraser, who sensationally won the gold medal in the women's slalom.

The Games of the XIII Olympiad had been awarded in 1939 to London and would have been held there in 1944, on the fiftieth anniversary of the founding of the modern Games, had not the Second World War caused their cancellation. London remained a viable option for 1948 and was eventually chosen by a postal ballot of the IOC membership as the host of the first post-war Games. Although much of London was scarred by wartime bomb damage, many of the city's sporting facilities remained functioning and the Empire Stadium at Wembley in north-west London became the principal venue for the Games. After an interval of 12 years, the Olympic flame was once again relayed by torch (plate 38) from Olympia to the host city, though political factors, including the unsettled situation in Greece, caused considerable diversions from the direct route. One planned detour was to Lausanne, where the flame was dipped in salute before the tomb of Baron de Coubertin, who had died in 1937. Enthusiastic crowds gathered all along the route through Italy, Switzerland, France, Luxembourg, Belgium and south-east England. The official report recording the torch relay's 'astonishing success' surmised, 'After long years of apparently almost unending national and international strain and stress, here was a gleam of light ... which lit the path to a brighter future for the youth of the world.'[52]

At the inaugural ceremony in Wembley Stadium, attended by 85,000 spectators, the stadium scoreboard was emblazoned with Baron de Coubertin's belief that 'The most important thing in the Olympic Games is not winning but taking part. The essential thing in life is not conquering but fighting well.'[53] This established the prevailing spirit of the Games. In all, 4,099 athletes from 59 countries participated, although Germany and Japan (former wartime Axis Powers) were excluded. The outstanding performer of the Games was Fanny Blankers-Koen, the Dutch mother-of-two ('The Flying Housewife'), who at the age of 30 won four athletics gold medals in sprints, relay and hurdles. These Games were held in a climate of austerity, with post-war housing shortages and rationing still in place, but were a triumph of ingenuity and 'making do': male competitors were housed in barrack blocks and camp hutments, and women in schools and colleges, while restricted foodstuffs were eked out by a special 'Olympic scale' ration, supplemented by brought-in and donated supplies.[54]

As there was not time to organize a competition for the official poster, the choice rested between a few designs submitted to the executive committee of

Plate 39
London 1948
'Olympic Games London
29 July–14 August 1948'.
Official poster by Walter Herz of
Heros Publicity Studios Ltd
Printed by McCorquodale & Co. Ltd,
London, c.1947-8
Colour lithograph
V&A: E.331–2006

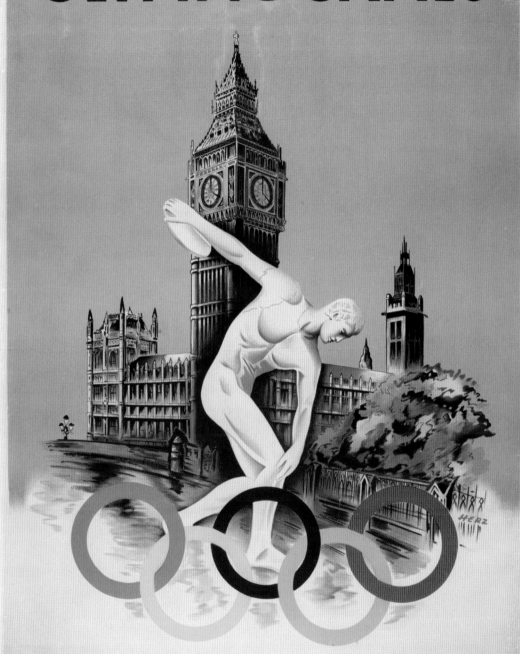

the Organizing Committee. The one selected (plate 39) was by Walter Herz, chief artist at Heros Publicity Studios Ltd, a firm of commercial artists in London.[55] Herz superimposed an image based on a marble statue of the discus thrower *Discobolus*[56] and another of the Olympic symbol over a view of the Houses of Parliament, thus allying classical and modern symbols of the Games with an image of one of London's most potent landmarks. The hands on the clockface of Big Ben stand at four o'clock, the time that the Games were officially proclaimed open by King George VI. The poster was printed by McCorquodale & Co. Ltd, London, with 100,000 copies produced in three traditional paper sizes: 50,000 double crown (30 x 20in/76.2 x 50.8cm), 25,000 crown (15 x 20in/38.1 x 50.8cm) and 25,000 double royal (40 x 25in/101.6 x 63.5cm). Free distribution was arranged through the Organizing Committee's Press Department, and various bodies were approached to accept and deliver large quantities: the governing bodies in Great Britain of the 17 Olympic sports, all travel and tourist agencies with offices in London, and all airlines operating to and from Britain. The town clerks of nearly 300 UK towns and cities were contacted, as were the directors of education of all counties. The response was excellent, with only three towns failing to cooperate and a large majority promising to display the posters on buses and trams, in schools and sports pavilions, and in public places in their areas. Every London borough was covered and each area with an Olympic venue was given special attention. Ultimately all 100,000 posters were distributed.

Plates 40 – 44
London 1948
Official programmes for the London Olympic Games, 1948
Printed by McCorquodale & Co. Ltd, London, 1948; published by the Organizing Committee for the XIV Olympiad London
Line-block
V&A: NAL.802.AH.0021.g,i,b,f,h

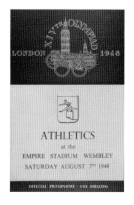
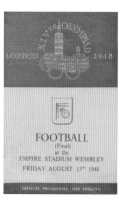
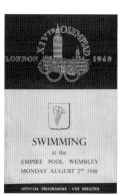
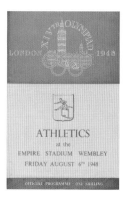
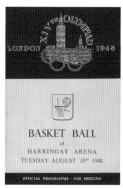

An important graphic innovation, to be variously developed in future Games, was the concept of a system of pictorial symbols to denote the various sports and events; applied to tickets and programmes, which were colour-coded according to the day (plates 40–44), these provided a means of instant visual recognition, important in an international gathering of such magnitude. One symbol was for the arts, showing the significance that the organizing committee attached to the art competitions and exhibition that were organized for the XIV Olympiad. For these, a distinguished fine arts committee was established (for example, Sir Arnold Bax chaired the music sub-committee), and artworks in the categories of architecture, painting, graphic art (now given its own category), sculpture, literature and music were solicited. Entries had to be by living artists, produced since 1 January 1944,

Plate 45
London 1948
'Sport in Art Exhibition'. Poster
designed and printed by Oliver
Burridge & Co. Ltd, London WC1,
advertising an exhibition organized by
the Organizing Committee for the XIV
Olympiad London 1948, held at the
Victoria and Albert Museum, London,
15 July–14 August 1948
Lithograph,
Olympic Museum Lausanne Collections

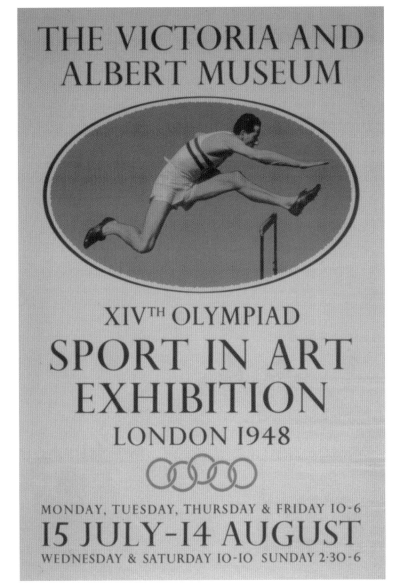

Plate 46
London 1948
'Bienvenue A Londres/Welcome to
London/Bien Venidos A Londres'.
Anonymous poster issued by London
Transport and British Railways
Printed by the Baynard Press,
London
Colour lithograph
V&A: E.2287–1948

related to sports or games, and nominated through the national Olympic committees. An international jury selected the works to be exhibited, which were displayed at a 'Sport in Art' exhibition staged at the Victoria and Albert Museum from 15 July to 14 August 1948 (plate 45).[57] Names of prize winners were announced during the victory ceremonies at Wembley Stadium on 29 July, and medals and diplomas awarded to the successful competitors at the V&A on 15 August.

The opportunities afforded by the London Games were naturally also seized upon by the travel and transport industry. London Transport and British Railways, acknowledged patrons of the twentieth-century poster, jointly issued a design bearing the direct and simple message 'Welcome to London' (plate 46). With its caption in English, French and Spanish, this was aimed at an audience of international visitors, some perhaps negotiating the British transport system for the first time en route for the Games. A surrealist poster by Abram Games for British European Airways (plate 47), depicting an airborne athlete running on the nose of an aircraft marked up in the

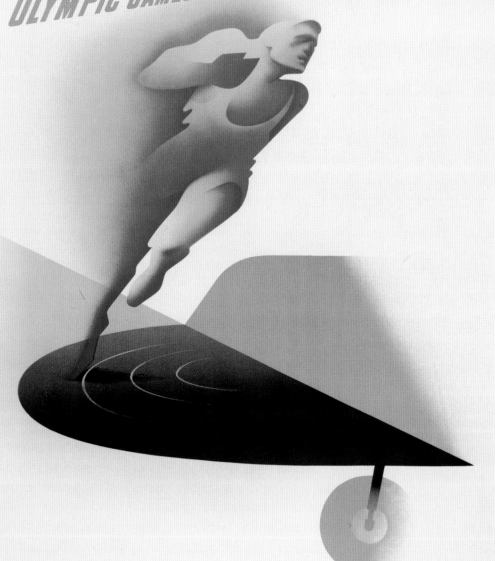

BEA

OLYMPIC GAMES · LONDON · JULY 29 - AUG. 14 · 1948

BRITISH EUROPEAN AIRWAYS

BEA

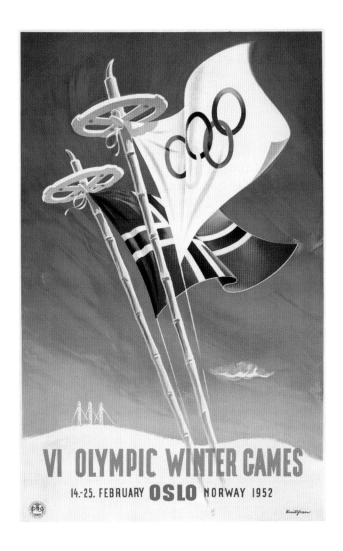

pattern of a racetrack, wittily linked the airline with an announcement of the sporting event. Games also designed the commemorative stamps for the 1948 Olympiad, thereby acquiring himself the nickname 'Olympic Games'.

In 1952 the Games returned to Scandinavia: the XV Olympic Games finally went to Helsinki, 12 years after the aborted Games of 1940, and the VI Olympic Winter Games to Oslo (it was here that Germany and Japan were readmitted to the competition). Norway, where skiing and skating were once traditional means of winter travel, was formed by nature for winter sports and interest in the forthcoming Games was keen. The main poster (plate 48), by Knut Yran – a Norwegian designer who went on to a career in industrial design and corporate identity within Royal Philips Electronics of the Netherlands – set the scene with a crisp image of the Olympic and Norwegian flags raised on a pair of ski poles, flying side by side against a brilliant winter-blue sky. His design was selected by competition, for which the brief stipulated that the poster must show the Olympic rings in colour and place the title text (which would have to be translated into various languages) away from the central image.[58] More than 30,000 copies of this poster were produced in seven different languages for use on billboards and bulletin boards, while 12,000 copies of a smaller poster by Yran, showing a Norwegian skier raising the Olympic flag, were

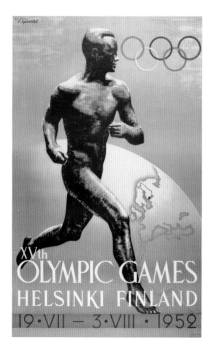

distributed for small display windows, travel bureaux, hotels and ships. The choice of posters and the identifying emblem for the Games was the responsibility of a separate emblem and poster committee. The Games were notable for their efficient organization (existing sporting facilities were quickly improved or added to with a view to their future sustainability) and for pioneering the first Olympic Winter Games torch relay, in which a pine-wood torch was lit at Morgedal, home of Norway's early skiing pioneer Sondre Norheim, and relayed to Oslo's Bislett Stadium.

Just as the choice of Helsinki to host the 1952 Olympic Games was the long-awaited fulfilment of plans first made for 1940, so too was the choice of official poster the ultimate accolade for Ilmari Sysimetsä's original design. A new competition in 1950 elicited 277 designs, but none could compete with the 'Paavo Nurmi' image, which needed only minor design modifications to modernize it (plate 49).[59] The dates were altered from 20.VII–4.VIII 1940 to 19.VII–3.VIII 1952, and significantly the outline of the map of Finland was changed to show the new borders of the country post-1940 (see plate detail), after certain areas had been ceded to the USSR. The poster was printed in two sizes and 20 different languages (115,000 copies in all), the first appearing in Finnish railway and bus stations, post offices and sports clubs in March 1951, although it was not on general display until the spring of 1952, shortly before the Games. To the ecstasy of the Finnish crowds, the 55-year-old Paavo Nurmi brought the poster to life, as it were, by appearing at the opening ceremony as the final torch bearer in the relay and lighting the Olympic flame in a cauldron on the stadium ground. The torch was then borne to a second cauldron at the top of the stadium tower, where, in memory of the cancelled 1940 Games, another flame was ignited by the Finns' first great long-distance runner and sporting hero, Hannes Kolehmainen, who was now 62 years old. Appropriately, the hero of the Games was another long-distance runner – the great Czech athlete Emil Zátopek. Politically, the Games were notable for the participation of a team from Russia representing the Soviet Union (Russian athletes, then representing the Tsarist Empire, had last competed in 1912), and for the perceived East–West polarization of teams according to their allegiance to capitalist or communist regimes in the Cold War. In the field of arts, it was decided to hold an art exhibition on its own, instead of organizing art competitions, reflecting a long period of uncertainty within the IOC over the validity of the contests and the advisability of requiring competing artists to have amateur status.[60] This marked the demise of the Olympic art competitions in their original formulation.

A feature of Olympic Games history is the ultimate emergence of venues whose original bids were unsuccessful or became the victims of external events. Cortina d'Ampezzo in Italy had made two previous unsuccessful bids, for the 1944 Olympic Winter Games (abandoned because of the Second World War) and the 1952 competition (outbid by Oslo), before emerging triumphant as the 1956 venue. With the support of various Italian industrial groups and companies, this resort in the Italian Dolomites created a fitting stage for the VII Olympic Winter Games – which for the first time were given live international television coverage, broadcast to Central Europe through Eurovision. The team from the USSR, making its first appearance at

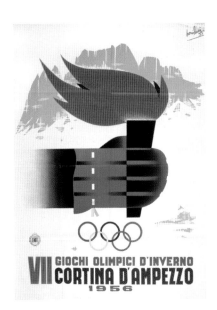

an Olympic Winter Games, won more medals than any other nation, while the United States emerged as a dominant force in figure skating – this winter venue being the last at which figure-skating events were held out of doors. East and West German athletes competed together in a combined team, as they would continue to do until Grenoble 1968, when the teams competed separately.

In order to launch the promotional campaign, the Comitato Olimpico Nazionale Italiano (CONI) held a competition to select the symbol for the Games. From 86 sketches submitted by 79 artists, the first prize was shared between Mario Bonilauri of Genoa and Franco Rondinelli of Milan.[61] Two of Bonilauri's designs were used as posters (one illustrated, plate 50), while Rondinelli's evolved into the official emblem for the Games (plate 51). Prophetically, since much drama at Cortina centred on an initial lack of snow followed by a great abundance, the symbol was an abstract snow crystal encircling a view of the resort topped by CONI's emblem of the Olympic rings and a star.

Plate 50
Cortina d'Ampezzo 1956
'VII Giochi Olimpici D'Inverno Cortina
d'Ampezzo 1956'.
Poster by Mario Bonilauri
Printed by a.g.f., Firenze, 1954-5
Colour offset lithograph,
Olympic Museum Lausanne Collections

Plate 51
Cortina d'Ampezzo 1956
Poster featuring the official emblem
designed by Franco Rondinelli
Printed by Tipografia La Fiaccola, Rome, 1955
Colour offset lithograph,
Olympic Museum Lausanne Collections

XVI OLYMPIADENS
RYTTARTÄVLINGAR
19 ⬯⬯⬯⬯⬯ 56
STOCKHOLM 10-17 JUNI

The Olympic Games of 1956 were to be celebrated in Melbourne, Australia, the first time that they had been held in the southern hemisphere and, because of the reversal of seasons, during the months of November and December. However, the choice of venue and date posed problems of acclimatization and training for many teams from Europe and America. In particular, quarantine problems in Australia caused the equestrian events to be rescheduled to Stockholm in June 1956, in a unique contravention of the Olympic Charter, which stipulated that the Games' various disciplines should be held in a unity of time and place. This decision triggered the production of a striking poster by John (Johan) Sjösvärd of Stockholm (plate 52).[62] Sjösvärd was an expert in drawing horses, a skill he employed on many posters for Westerns. His image of a Greek equestrian sculpture, mounted on a plinth decorated with classical egg-and-dart moulding against a marbled background, again evoked the link between the modern Games and their classical precursors. In Greek equestrian competitions, the riders, as portrayed in this poster, competed without stirrups. Equally, as gloriously exemplified in the Parthenon frieze – which may have inspired Sjösvärd's composition – horsemen were a favourite subject of ancient Greek sculpture. Some 40,000 copies were printed in colour offset lithography, with text in English, French, German or Swedish, and distributed worldwide in the early part of 1955. The same image was also adapted as the emblem of the Games and was used on the obverse of the Olympic medals.

While Sjösvärd's design looked to the past for inspiration, the official poster for Melbourne broke new ground (plate 53). It was an unashamedly modern graphic work by Richard Beck, a British designer who had emigrated to Australia in 1940. Beck aimed to create a clear, succinct and bright design that immediately communicated its message to an international audience. It was selected from designs commissioned from five artists by the fine arts sub-committee of the Melbourne Olympic Organizing Committee in June 1954 and was first intended to be released in the form of a postage stamp in December 1954 to announce the forthcoming Games. Beck had trained at the Slade School of Art in London and the Blocherer School in Munich, and in England established his own freelance design consultancy with commissions executed for London Transport, Shell-Mex Ltd and the Orient Line. When he moved to Australia, he set up Richard Beck Associates, a design consultancy producing packaging, corporate identity design, exhibitions and general advertising work.[63] In the post-war years, posters were increasingly designed by graphic design studios and advertising agencies rather than by freelance poster artists. Beck's background in graphic communication is immediately evident in his approach to the Melbourne poster. The Games are announced through the visual device of a threefold invitation card which opens out towards the viewer: on the front sheet is the symbol of the Olympic rings and, on the back, the coat of arms of Melbourne, the two united in a single composition. With surrealist effect, the white card floats like a paper craft through deep-blue space suggestive of the oceans or heavens that surround the continent of Australia. The clear, open typography reinforces the simple directness of the message. Some 70,000 copies of the colour lithographic poster in two different sizes were printed in 1954–6 and distributed

Plate 52
Stockholm 1956
'XVI Olympiadens Ryttartävlingar [XVI Equestrian Olympic Games] 1956'. Official poster by John Sjösvärd for the Equestrian Games held in Stockholm, 10–17 June 1956, 1955
Colour offset lithograph
V&A: E.414–2007

OLYMPIC GAMES

The Coat of Arms of the City of Melbourne

MELBOURNE

22 NOV–8 DEC
1956

RICHARD BECK

PRINTED IN AUSTRALIA BY CONTAINERS LIMITED, MELBOURNE.

through the well-tested outlets of shipping, railway and airline companies, travel and tourist organizations, banks, sporting bodies and national Olympic committees. Every Australian overseas office acted as a distribution point and, under reciprocal arrangements, the Australian National Travel Association sent 15,000 posters abroad for display on railway hoardings. Through the Australian News and Information Bureau in New York, arrangements were made for thousands of posters to be displayed in American retail stores, while at home in Australia posters reached every post office, as well as retail stores, small shops and municipal sites.[64]

The positive promotion could not prevent a decline in the number of athletes participating (fewer than 3,500 from 67 countries) as the result of boycotts by various countries: Egypt, Lebanon and Iraq because of the Suez crisis; China because of Taiwan's inclusion; and Liechtenstein, the Netherlands, Spain and Switzerland because of the Soviet invasion of Hungary. A final-round water-polo match between Hungary and the USSR on 6 December 1956 became invested with political symbolism when, one month after Soviet troops had crushed the Hungarian uprising, the Hungarian Ervin Zádor emerged from the pool dripping blood after tensions flared (his team dramatically beat the USSR 4–0). Nevertheless, it was at Melbourne that the new custom of athletes marching into the closing ceremonies together, not segregated by nation, was introduced. In the field of fine arts, the first official Olympic arts festival replaced the troubled Olympic art competitions.[65]

Squaw Valley in the Sierra Nevada was a surprising choice for the IX Olympic Winter Games, given that in 1955, when the decision was taken by the IOC, this Lake Tahoe resort was virtually undeveloped. It was, however, blessed with natural assets of spectacular terrain, winter sunshine and some of the deepest snowfall in America. The man primarily responsible for securing these Games was Alexander Cushing, co-founder of the Squaw Valley Development Corporation. His initiative, combined with the entrepreneurial skill of the Squaw Valley Organizing Committee and financial backing from the states of California and Nevada, meant that by 1960 the resort had the necessary sporting facilities and infrastructure to accommodate both the competitors and more than two million visitors. Only the bobsleigh run remained unbuilt, resulting in the omission of both bob competitions. At the opening ceremony, choreographed by pageantry chairman Walt Disney, the Olympic flame was once again relayed from Morgedal in Norway and then lit in front of a symbolic 'Tower of Nations'. Two posters for the Games were produced for international distribution. The first, in 1958 (plates 54 and 55), featured the snowflake emblem designed by the art department of the Knollin Advertising Agency, San Francisco. This was chosen from over 600 designs, partly for its adaptability to both small-scale use (labels, buttons, rings) and larger application (posters, decoration). Within the poster, the geometric emblem, made up of three coloured triangles with the Olympic rings emblazoned on the central triangle, floated and cast shadows over a snow-effect background, achieving a three-dimensional look. There were 57,228 copies produced in five different languages. The second poster appeared late in 1959 with the purpose of showing the location of Squaw Valley in relation to a map of the United States and giving the date of the Games; 36,500 copies were printed.[66]

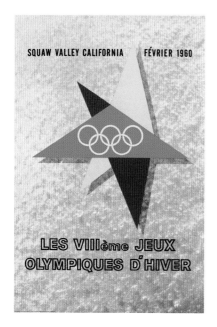

Plate 54
Squaw Valley 1960
'Les VIIIème Jeux Olympiques D'Hiver'.
First official poster designed
by Knollin Advertising Agency,
San Francisco, 1958
Colour offset lithograph
Olympic Museum Lausanne Collections

Plate 55
Squaw Valley 1960
Organizing Committee secretaries
pose with foreign-language editions
of first poster advertising Squaw
Valley Games. From p.15 of the
Organizing Committee's *Final Report*
(Sacramento, 1960).

In 1908 Baron de Coubertin had been keen to block Greek demands for Athens to be the permanent home of the Olympic Games, thinking that they should be internationally based. At his special wish, Rome was chosen as the venue for the 1908 Games, until fate decreed otherwise. Fifty-two years later, in 1960, Rome fulfilled her original destiny in offering a unique historic context for the XVII Olympiad, now matched by up-to-date sporting facilities. While the marathon (won by the barefoot Abebe Bikila of Ethiopia) was run from the Capitoline Hill to the Arch of Constantine, along a route that included the Appian Way, gymnastic competitions were held in the Baths of Caracalla, wrestling in the Basilica of Maxentius and equestrian events in the Villa Borghese Gardens. The main outdoor site was the Stadio Olimpico, built in 1953 on the Foro Italico, north of the city. Hockey preliminaries were held in the Stadio dei Marmi (Marble Stadium), built in 1932 within the Foro Italico sports complex designed by Enrico Del Debbio, which boasted enormous tiers topped by 60 white marble statues commemorating athletes; it was one of the Mussolini-era structures directly inspired by imperial Roman art and architecture and manifesting the ideology of Fascism. Two innovative indoor stadiums were created by the leading Italian architect and engineer, Pier Luigi Nervi. One, the Palazzetto dello Sport, was a concrete domed structure with an impressive ribbed roof span offering a modern, light-filled space for disciplines such as boxing (where the 18-year-old Cassius Clay was to win his first light-heavyweight title).

Advance publicity for the Games issued by CONI reinforced and proclaimed the connection between modern and historic Rome. Posters by Nino Gregori, boldly executed in a style of heightened realism, advertised 'Olympic Days' organized in 1958 and 1959 to promote the Games that would take place in 1960. His 1959 design (plate 56) incorporated an incised 'SPQR' ('Senatus Populusque Romanus'/ 'The Senate and the Roman People'), the initials referring to the government of the ancient Roman Empire, brought into twentieth-century usage by Benito Mussolini. For all events of an artistic nature generated by the Rome Games, an arts committee was established by CONI under the presidency of Professor Guglielmo De Angelis d'Ossat, General Director of Antiquities and Fine Arts of Italy. It considered and advised on questions concerning the official poster, the model of the relay torch, the symbols and medals, and musical matters such as the Olympic hymn, official fanfare and national anthems. On 31 January 1957, it initiated a 'Prize-winning contest between artists of Italian nationality for the poster intended to exalt the Games of the XVII Olympiad'. The brief stipulated that designs should contain three elements: the idea of Olympic sport in Rome; the five Olympic rings; and the wording, according to language, 'Games of the XVII Olympiad – Rome – MCMLX'.[67] A jury was appointed and 249 designs were received from 212 competitors. However, none was deemed to meet the requirements and, on 9 August, a second competition was announced, with 12 artists being personally invited to submit entries. Of the seven who took up the offer, it was Armando Testa whose design was chosen. In Turin in 1946 Testa had founded the Armando Testa SpA graphic design studio, which became a full-service advertising agency in 1956, with clients including Martini & Rossi, Pirelli and San Pellegrino. Throughout his career he aimed to create

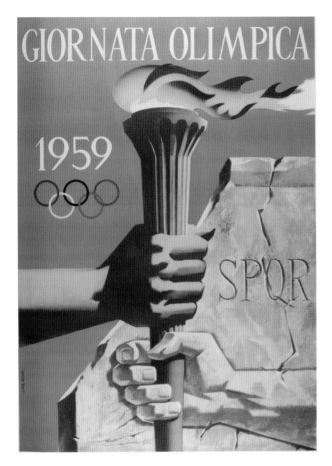

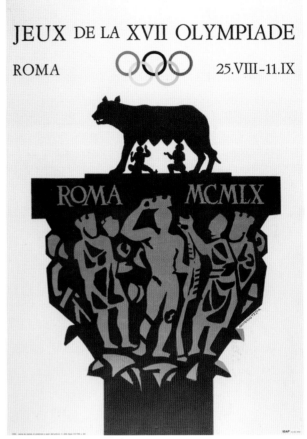

Plate 56
Rome 1960
'Giornata Olimpica 1959'
(Olympic Day 1959).
Poster by Nino Gregori
Printed by Vecchioni and Guadagno,
Rome, 1959
Colour offset lithograph
V&A: E.340–2006

Plate 57
Rome 1960
'Jeux de la XVII Olympiade'.
Official poster by Armando Testa
Printed by IGAP, Milan, Rome, c.1957
Colour lithograph
V&A: E.303–2006

simple, clear and striking messages, stating in 1992, 'Synthesis was the law of my whole life both in my works and in my words.'[68] To meet a revised brief, his poster combined an image of the Capitoline wolf suckling twins Romulus and Remus with his adaptation of a Roman capital showing a victorious athlete holding a palm, both set beneath the Olympic symbol and the text (plate 57).[69] Perhaps surprisingly, given 'design by committee' interventions, his message was remarkable for its clarity and effectiveness, stamping the forthcoming Games with Rome's unique cultural 'brand'. Some 290,000 copies of the poster were produced in 11 languages and distributed by CONI's Press Services Section.

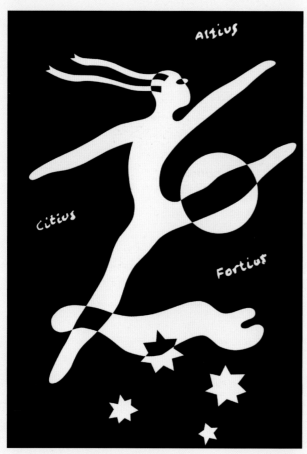

Plate 132 (p.125), detail
Sydney 2000

Plate 62 (p.75), detail
Grenoble 1968

Symbols and Identity

Over the past century, official Olympic posters have played a major role in communicating the evolving iconography of the modern Games. Their graphic form – made for the swift delivery of visual messages – has offered an ideal field for displaying and promoting a range of pictorial symbols, including official Olympic symbols, emblems of national and civic pride, and the identity of specific Games.

Invented or coopted over time, the 'official' symbols are used to identify and validate the aspirations of the Olympic

Movement, and to build up a tradition that includes the Olympic rings, flag, motto, flame, oath, hymn and fanfare. The famous Olympic symbol of the five interlocking rings is now generally interpreted as the five continents of the world united in Olympic competition. Conceived by Pierre de Coubertin, it was first described in 1913 as representing 'the five parts of the world', with the colours combined on the five rings – blue, yellow, black, green and red – representing those found on the national flags of all nations. It was De Coubertin's idea to apply the symbol to an Olympic flag with a white background, which he presented to the twentieth-anniversary Olympic Congress in Paris in 1914, and to envisage its successful application

to various other surfaces.* The flag first flew at the Antwerp Games of 1920, but did not feature on an official poster until the Olympic Winter Games at St Moritz in 1928. The symbol on its own appeared on posters from 1932 and has been a continuous presence ever since, acquiring significance with repetition and constantly reinvented as a design motif (plate 62). Nowadays the use of the rings is subject to strict graphic standards set by the IOC.

The Olympic motto, '*Citius, Altius, Fortius*' ('Faster, Higher, Stronger'), was proposed by De Coubertin for the creation of the IOC in 1894, signifying his belief that sport should be a field of endeavour.[†] It was given exuberant graphic form in Barrie Tucker's poster for the Sydney Games of 2000 (plate 132).

A theme that runs through a number of the posters is that of the Olympic flame and the torch relay. The custom of bearing the flame from Olympia to the host venue in commemoration of the ancient Games was instigated by Carl Diem, secretary general of the Berlin Organizing Committee for the Games of 1936, and the lighting of the flame at the opening ceremony has become a famous piece of ritual. For the official poster of the Seoul Games of 1988, the artist combined an image of radiant Olympic rings with that of an Olympic torch bearer whose onward stride symbolized mankind's progress (plate 112).

While the official Olympic symbols can be perceived as promoting ideals of internationalism, another distinct genre establishes national and civic identity. Incorporated into the main composition, depictions of national flags and emblems, cities' coats of arms, famous landmarks and cultural artefacts

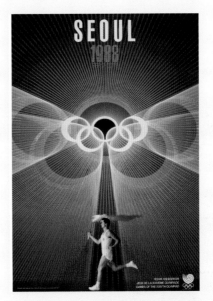

Plate 112 (p.108), **Seoul 1988**

are inescapable statements that promote the host venue to the world. In the Antwerp 1920 poster the Belgian flag is prominent, while Antwerp's coat of arms, garlanded with roses and laurel leaves, hangs above a panoramic view of the city (plate 18). This may be seen as a forerunner of the many patriotic images projected in the years to come: the Brandenburg Gate (Berlin 1936), the Houses of Parliament (London 1948), Romulus and Remus (Rome 1960) and the Sydney Opera House (Sydney 2000).

The use of pictographic emblems to symbolize individual Olympiads has provided one of the key pictorial elements of posters – as either a main or a subordinate motif. Memorable examples are Yusaku Kamekura's emblem for the Tokyo Games of 1964, showing the rising sun of Japan echoed by the rings of the Olympic symbol, and the Athens 2004 emblem of a *kotinos*, evoking the ancient Greek Games, when victors were crowned with olive wreaths. In both these cases, the chosen image was extensively applied to a whole graphic identity programme.

* See 'L'emblème et le drapeau de 1914', *Revue Olympique* (August 1913), no.92, pp.119–20, text not signed but attributed to De Coubertin.

† The motto is believed to have been formulated by a confidant of De Coubertin, Henri Didon, a French Dominican writer, preacher and educator.

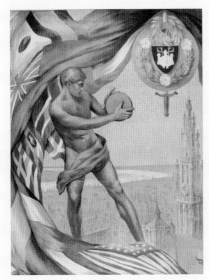

Plate 18 (p.30), detail
Antwerp 1920

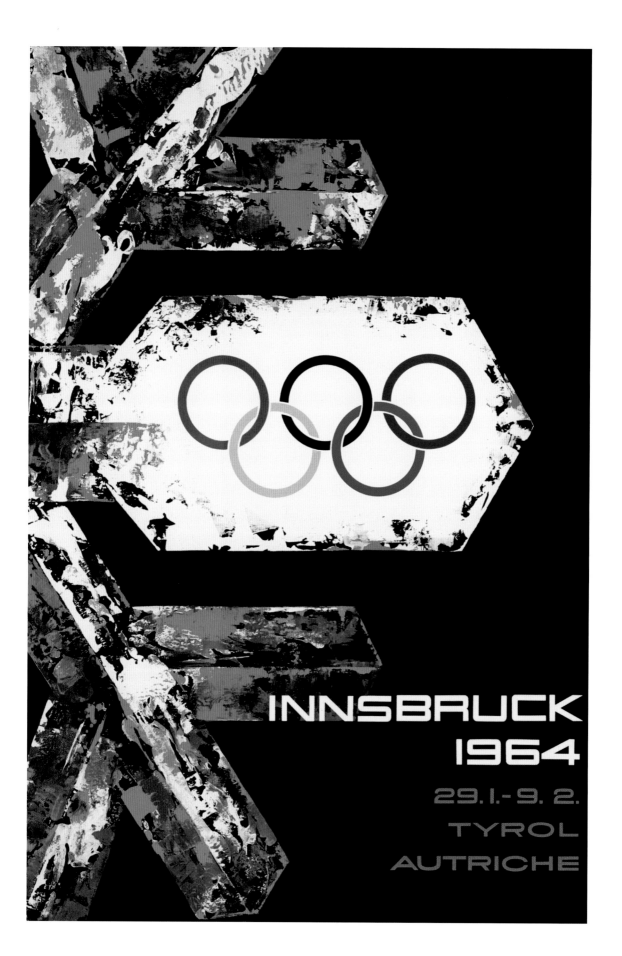

INNSBRUCK
1964
29.1.- 9. 2.
TYROL
AUTRICHE

Plate 58
Innsbruck 1964
'Innsbruck 1964'.
Official poster by Wilhelm Jaruska
Printed in Austria by
Wagnersche, Innsbruck, *c.*1963
Colour offset lithograph
Olympic Museum Lausanne Collections

New Identities

Heralding the Games through a single dynamic image was the aim of Wilhelm Jaruska in his poster for the IX Olympic Winter Games held in Innsbruck in 1964. Jaruska was a freelance designer and illustrator who taught at the Federal Institute of Graphic Art, Teaching and Research in Vienna from 1954 to 1976 and was one of 12 Austrian artists who had been invited to enter designs in a national competition.[70]

There were 56,695 copies of his poster (plate 58) produced in 10 different languages. Ironically, since Jaruska's subject was a detail of a magnified ice crystal figuring the Olympic symbol, Innsbruck became the victim of unseasonably warm weather, and the resort found itself short of ice and snow. The situation was saved only by the heroic efforts of the Austrian army, who hewed, transported and laid 20,000 ice bricks and 40,000 cubic metres of snow from nearby higher mountains and snowfields. Innsbruck was therefore still able to organize a record number of 34 events, which attracted another record number of over 1,000 competitors from 36 nations. Luge (sledding feet first) was introduced and bobsleigh returned after its banishment at Lake Placid. Stars of these Winter Games were the graceful Soviet figure skaters Ludmilla Belousova and Oleg Protopopov, and the Soviet speed skater Lidia Skoblikova, who won a clean sweep of four gold medals.

Tokyo had bid to host the Olympic Games in 1940 and again in 1960, so when she was finally successful in 1964 it was a historic decision: for the first time the Games would be held in Asia. It also publicly signalled Japan's successful post-war reconstruction. The Games were officially opened by the Emperor Hirohito and symbolically the final torch bearer in the relay was Yoshinori Sakai, born in Hiroshima on the day that that city was destroyed by an atomic bomb. About 5,000 athletes participated, representing 93 countries, but South Africa was banned as a result of her government's policy of apartheid. In many ways this was a modernizing Olympic Games, with state-of-the-art sports facilities at the National Stadium (the main venue, which had been completed in time for the Asian Games of 1958), the Yoyogi National Gymnasium (a work of architectural modernism designed by Kenzo Tange) for gymnastics and diving events, and the Nippon Budokan (modelled on the style of a traditional Japanese temple) for judo events, as well as improvements to the infrastructure of a city of 10 million inhabitants. There were other innovations, such as the first use of computers to keep results and Syncom 3, a novel geostationary satellite which telecast the Games to the United States – the first television programme to cross the Pacific Ocean.

The Tokyo Games were the first to produce a set of official posters, all designed by Yusaku Kamekura, who was also selected to create the emblem for the Games. Kamekura, a pioneer of post-war Japanese graphic design, was one of a generation that brought a new Japanese aesthetic to the attention of an international audience. His influences lay in European modernism, which he brought into harmony with the fundamentally Japanese quality of his vision – a fusion of East–West sources made manifest in his designs for posters, books, packaging, typography and trademarks. His design for the symbol was selected in 1960 from many submissions. Showing the sun emblem from Japan's national flag rising triumphantly above the Olympic rings and the boldly lettered text 'Tokyo 1964', it was a work of dynamic simplicity in tune with the mood of Japan's post-war revitalization. Kamekura himself believed that 'The most important element is the pictogram, a universal element for communication.'[71] His symbol was consistently applied by the design committee to posters, printed matter, venues, signage and memorabilia, as part of a strong visual identity programme.[72]

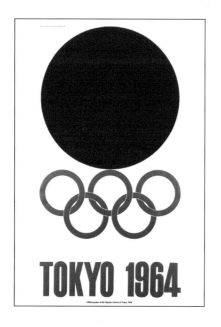

Plate 59
Tokyo 1964
'The Rising Sun and the Olympic Emblem'. First of four official posters by Yusaku Kamekura
Printed by Toppan Printing Co. Ltd, Tokyo, 1961
Colour photogravure
Olympic Museum Lausanne Collections

It became the subject of Kamekura's first official poster, 'The Rising Sun and the Olympic Emblem' (1961), of which 100,000 copies were produced and distributed before the Games (plate 59). It was also incorporated as a design element into the other three posters in his set, each of which broke new ground by focusing on the psychological drama of individuals striving for personal goals in an 'actual' event. This was achieved through photography – the first time that the medium had been used in official Olympic posters to transmit the immediacy and excitement of the Games to a contemporary audience. The photographs were taken by Osamu Hayasaki, with photo direction by Jo Murakoshi. 'The Start of the Sprinters' Dash' (1962) (plate 60) captured athletes powering away from the blocks purportedly in the men's 100-metre event – though in fact the photograph had been taken on a wintry night in February 1962 and featured amateur Japanese athletes and athletes from the American Forces stationed at the Tachikawa Air Base. Some 90,000

Plate 60
Tokyo 1964
'"The Start of the Sprinters' Dash".
Tokyo 1964'. Official poster by
Yusaku Kamekura (art director);
Osamu Hayasaki (photographer);
Jo Murakoshi (photo direction)
Printed by Toppan Printing Co. Ltd,
Tokyo, 1962
Colour photogravure
V&A: E.341–2006

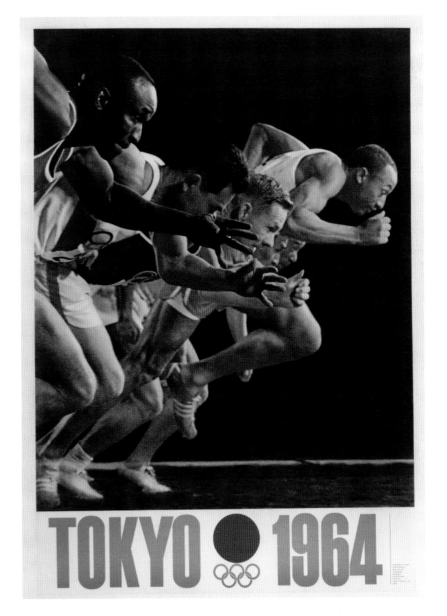

Plate 61
Tokyo 1964
'"An Olympic Torch Runner". Tokyo
1964 XVIII Olympic Games'.
Official poster by
Yusaku Kamekura (art director);
Osamu Hayasaki (photographer);
Jo Murakoshi (photo direction)
Printed by Toppan Printing Co. Ltd,
Tokyo, 1964
Colour photogravure
V&A: E.304–2006

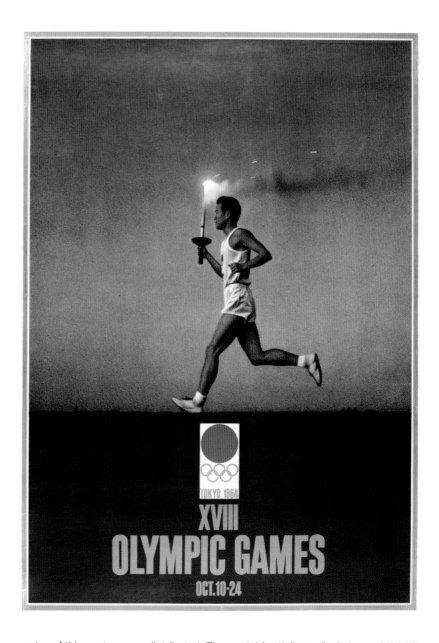

copies of this poster were distributed. The model for 'A Butterfly Swimmer' (1962), viewed mid-stroke, his body cleaving a chasm-like shadow through the water, was Koji Iwamoto of Waseda University, photographed at the Tokyo Metropolitan Indoor Swimming Pool in 1962; 70,000 copies of the poster were issued. 'An Olympic Torch Runner' (1964) (plate 61), the final poster in the set, with 50,000 copies distributed, was based on a photograph taken in early 1964 of the athlete Tanaka of the Juntendo University track and field team, chosen to epitomize the perfection and endurance of an Olympic athlete. These posters were internationally acclaimed, winning various prizes, including the Milan Poster Design Award, and were also praised for their technical accomplishment as photogravures.[73]

Returning to Europe, the X Olympic Winter Games of 1968 were allocated to Grenoble in the Dauphiné region of the French Alps. Large amounts of money were poured into improving the city – but even so the Games had to rely on the facilities

Plate 62
Grenoble 1968
'Xmes Jeux Olympiques D'Hiver
1968 Grenoble'.
Official poster by Jean Brian
Printed by Imprimerie Générale,
Grenoble, 1967
Colour offset lithograph
V&A: E.342–2006

X^{mes} JEUX OLYMPIQUES D'HIVER
6/18 Février 1968 GRENOBLE FRANCE

of outlying areas for a number of competitions, and accommodation for the athletes was spread over seven miniature Olympic Villages. At a ceremony attended by 18,000 people, they were declared open by General de Gaulle, who wanted this to be a spectacular international event for France: the Olympic flame arrived by relay after air transport from Athens to Paris and, at the conclusion, five jets from the Patrouille de France traced coloured Olympic rings in the sky. In effervescent spirit, the official poster (plate 62) by Jean Brian depicted the five interlocking Olympic rings taking on a life of their own and skiing downhill as though in breakneck competition. There were 170,000 copies produced. Brian, an observant caricaturist, illustrator and watercolour artist, had worked in Paris before the war, then afterwards moved to the Dauphiné, setting up his own publicity studio producing commercial posters.[74] In the competition itself, Jean-Claude Killy delighted the French crowd by sweeping the board in the men's Alpine events, winning the downhill, slalom and giant slalom, while ABC broadcast the triumph of the American women's figure skater Peggy Fleming. The Games were also notable for the IOC's introduction of drug and gender testing, and for a controversy over skiers' endorsements that were said to contravene their amateur status. East and West German athletes competed as separate teams for the first time since 1952, united only by their common German Olympic flag and 'Ode to Joy' anthem. The Grenoble Games also made history by being the first Olympic Winter Games to be broadcast by colour television and the first to adopt a mascot, albeit unofficial – 'Shuss', a toy-like skier in the French colours.

In 1963 Mexico City outbid Buenos Aires, Detroit and Lyons to host the XIX Olympiad in 1968, so becoming the first Latin American location for the Games. A total of 5,530 athletes from 112 nations participated in 172 events. The venue was to prove highly charged in both political and sporting terms. With heights of 2,240 metres in the south of Mexico's central plateau, altitude was a contentious issue. In the event, the sprinters and field athletes thrived, breaking numerous world and Olympic records (Bob Beamon set a long-jump record that would last for 22 years and high jumper Dick Fosbury perfected his 'Fosbury Flop' technique); however, apart from the African runners, who trained at high elevations, many distance runners suffered in the thin air. Ten days before the Games opened, protests led by Mexican

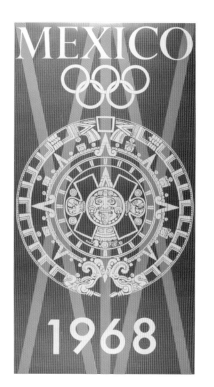

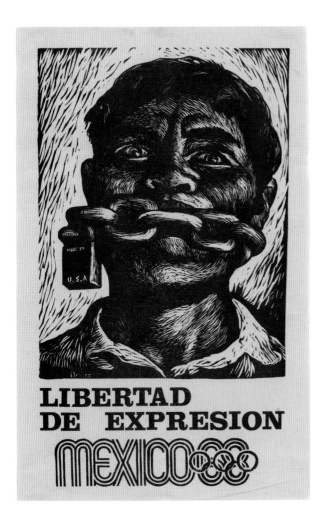

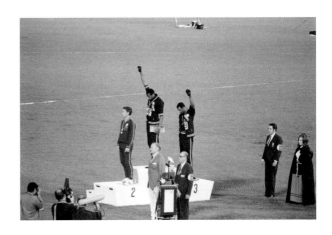

Plate 65
Mexico City 1968
'Libertad de Expresion'
(Liberty of Expression).
Protest poster by Adolfo Mexiac
Lithograph, 1968
(adapted from a design of 1954)
V&A: E.1517–2004

Plate 66
Tommie Smith and John Carlos
giving a Black Power salute. 1968
Photograph
© Bettmann Corbis

students over the government's heavy investment in Olympic facilities rather than in social programmes were harshly quelled by police and army units. A lithograph (plate 65) by the militant Mexican artist Adolfo Mexiac, a prominent member of the Taller de Gráfica Popular, the first self-supporting art workshop in Mexico to create and publish its own work, showed a protester symbolically gagged by a padlocked chain. Mexiac had originally designed 'Libertad de Expresion' ('Liberty of Expression') as a fine art linocut in 1954; the image was later used by the student protest movement in Paris 1968. In sympathy with the Mexican students, the artist adapted his design by adding the 'Mexico 68' logo, making a sarcastic connection between its circles and the links of the imprisoning chain. He handed out 2,000 copies to students, through whom it achieved mass circulation. A demonstration of another kind became an enduring image of the Mexico Games: two black American athletes, Tommie Smith and John Carlos (gold and bronze medallists in the 200 metres), staged a silent protest against racial discrimination in the United States, giving a Black Power salute as the American National Anthem played during the victory ceremony (plate 66). To this day souvenir posters celebrate the iconic moment. Meanwhile, Mexican hurdler Enriqueta Basilio had previously broken the mould by becoming the first woman to light the cauldron at the opening ceremony.

A dazzling Op Art design, the official poster for the Mexico City Games (plate

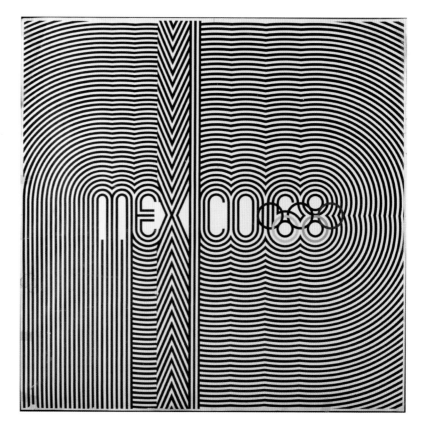

(above right)
Plate 67
Mexico City 1968
'Mexico 68'.
Official poster by Lance Wyman;
Eduardo Terrazas and Pedro Ramírez
Vázquez (art direction), 1967
Colour lithograph
V&A: E.338–2006

(above left)
Plate 68
Mexico City 1968
'Mexico 68'.
Variant of the official poster
Colour screenprint
V&A: E.2819–2007

67) was a triumph of graphic communication. It evolved under the auspices of the Programme of Olympic Identity, established to create the 'Mexico 68' image and project it to the world.[75] This programme was created under the overall leadership of architect Pedro Ramírez Vázquez, chairman of the Organizing Committee for the Mexico City Games, with the architect and designer Eduardo Terrazas as coordinator and director of urban design, and Beatrice Trueblood as director of publications. This team worked together to integrate aspects of design and communication, and as Terrazas and Trueblood wrote in 2006, 'our main object and goal was to use this opportunity to present Mexico's vast and unique culture to the world'.[76]

The graphic design programme, in which the American graphic designer Lance Wyman played a leading role,[77] was fundamental to the Games' identity, and it had a profound and lasting impact on the way that contemporary Mexico City was perceived both by its inhabitants and by the rest of the world. It was, in Wyman's own words, 'a multidimensional integration of logos, typography and color, developed to communicate to a multilingual audience'.[78] It stamped Mexico City with a unique and concise orientation system for the Olympic sports programme, as well as for transport systems and services, and the events generated by the Olympic cultural programme. (In Mexico, the cultural programme took the form of a year-long national and international festival, promoted by a whole sequence of imaginative designs (plate 63). Wyman's 'Mexico 68' logotype for the Games, developed under the direction of Terrazas, was neatly based on geometry. Inspired by the Olympic rings symbol, Wyman developed the five circles into the year number '68', then unified it with the lettering of the word 'Mexico' by means of radiating parallel lines.

It worked both as a dynamic example of 1960s Op Art, related immediately to its time and culture, and as an evocation of the pattern-making imagery of pre-Hispanic Mexican cultures and the folk art of the Huichol Indians.[79] As a brand image it also worked across a range of applications, from interior and exterior design to promotional material and fashion statement (plate 69). The official poster was a development of the logotype. As well as the black and white version used in international contexts, the design was also printed in various vibrant colourways giving the concept another important dimension. It is interesting to compare the official identity with an earlier poster for the Games issued by the organizing committee (plate 64) made before the development of the final graphics programme that evolved around the logotype: in this banner-like design, the numerals 'XIX' form a background pattern (Mexico being the nineteenth Olympiad) and symbols recalling pre-Hispanic art make up the central motif.

So strong was the graphic identity of the logotype that the poster image for the French distribution of Alberto Isaac's documentary feature film *Olimpiada en México* (*Jeux Olympiques Mexico*) (1969) substituted the distinctive 'Mexico' parallel-line lettering for the hurdles seen on the track (plate 70). Its compelling identity had other effects: during a lecture in 2006, Lance Wyman recalled a certain unease at having been a young man working for the Mexican establishment on the Olympic programme at the time of the 1968 Mexican student uprising. Much of the Olympic iconography had been subverted into posters, flyers and anti-government propaganda. However, in 1985 one of those students had reassured him, thanking him for 'creating a language' that they could adapt to their own purpose.[80]

SAPPORO'72

XI OLYMPIC WINTER GAMES

Sapporo, the capital of Hokkaido and Japan's fifth-largest city, had lost the opportunity to host the 1940 and 1968 Olympic Winter Games, but succeeded for 1972, so bringing these Games to Japan for the first time. Seizing the opportunity, the Japanese government invested heavily in the event: an underground railway was built, sports stadiums were newly erected or completely reconstructed, and a swathe of new infrastructure was put in place. Costs were offset by selling television transmission rights. The February dates of the Games fortunately coincided also with the famous annual Sapporo Snow Festival, bringing international attention to the giant snow and ice sculptures on display in Odori Park. Less happily, the Games became embroiled in debates over the questionable amateur status of a number of participating athletes.

Three well-known Japanese designers were invited to create official posters for these Games: Takashi Kono, Yusaku Kamekura and Gan Hosoya.[81] Kono, an innovative designer whose career had matched the evolution of Japanese graphic design in the mid-twentieth century, conceived the first (plate 71) in the series of four which were issued between 1968 and 1971. Known for his book and editorial designs, posters, typography and logos, Kono had famously worked in the design department at Shochiku Film and for the design magazine *Nippon*. He was an advocate of traditional Japanese forms and colours reinterpreted in a modernist aesthetic through a process of distillation. His Sapporo poster incorporated the banner-like emblem for the Games designed by Kazumasa Nagai, which itself combined three symbolic elements: the Rising Sun, stressing the continuity with the Tokyo Games; a snowflake, symbolizing winter; and the Olympic rings with the words 'Sapporo '72'. Kono suspended this emblem over a band of horizontal text, 'XI Olympic Winter Games', and the pure geometric forms of a snow-peaked mountain and the reflection of the sun.

The Munich Games of 1972 took place in a world still rife with political unrest – in the Middle East, Vietnam and elsewhere – but the Games of the XX Olympiad had aims of peaceful coexistence and were intended to present to the world a positive, friendly and optimistic Federal Republic of Germany. They were also consciously understood as a counter to the bombast of the Berlin 1936 Games, the fresh image to be expressed through various aspects of the visual identity programme. With 195 sporting events and 7,173 athletes attending from 121 nations, these Games were the largest yet, and were set fair to fulfil their official motto as 'The Happy Games' ('Die heiteren Spiele') until, on 5 September 1972, eight Arab terrorists stormed the Olympic Village, killing two Israeli athletes and taking nine more as hostages. The subsequent gun battle at Munich airport resulted in further loss of life. In defiance of these horrifying events, IOC president Avery Brundage took the decision that 'The Games must go on!'[82] and, after a day of mourning, the suspended competition continued with the Olympic and national flags flying at half-mast. But forever overlying the sporting images that should have been paramount – of American swimmer Mark Spitz winning his seventh gold medal and of the young Russian gymnast Olga Korbut – were the violent images of tragedy.

The graphic imagery generated by the Munich Games memorably fulfilled

Plate 71
Sapporo 1972
'Sapporo '72 XI Olympic
Winter Games'.
Official poster by Takashi Kono
Printed by Dai Nippon
Printing Co. Ltd, Japan, c.1968
Colour screenprint
V&A: E.343–2006

the promise of a synthesis between sport and art that was an important element in Munich's original bid proposal. A key factor was the cooperation and trust between Willi Daume, president of the organizing committee for the Games of the XX Olympiad, and Otl Aicher, who was appointed head of the committee's visual design group: brilliant networkers, they were at the forefront of a development that deployed art in a relatively new role promoting global public events. From the start, posters were high on the agenda of the organizing committee, and ideas were discussed as early as September 1967 to publish a series of art posters that would 'relate artistic activity to the Olympic Games and engage the best artists to collaborate', and also to commission an internationally known artist for the official poster.[83]

In order to achieve the ambitious aims for the art series, the organizing committee formed a partnership in June 1968 with the well-known publishing house F. Bruckmann KG, Munich, setting up the company Edition Olympia 1972, GmbH. The project – which eventually ran to five series, each made up of seven posters – was to publicize the Games effectively worldwide and promote 'artistic, cultural, political and commercial aims'.[84] From the sale of the posters, the organizing committee would receive two-thirds of the profits (they got nearly two million DM towards the funding of the Games) and F. Bruckmann would keep a third. With the collectors' market in mind, three grades of poster were produced in a hierarchy of values: original graphics printed on high-quality paper in numbered editions of 200, each impression signed by the artist; original posters on slightly lower-quality paper in editions not exceeding 4,000, with signatures printed within the design; and unlimited commercial editions printed on poster paper. Artists were free to choose their themes, but were encouraged to incorporate a relationship with the Olympic idea and the contemporary Olympic Games in the present time. The choice of artists was entrusted to an art commission, with the original criteria that the artists' 'high artistic quality had to be world famous' and that 'Established and avant-garde trends in art ought to be represented.'[85] The series included abstract compositions by Josef Albers (plate 72), known for his style of superimposed rectangles and squares of colour, Max Bill (plate 74), whose work engaged with modern science and mathematics, and Richard Smith (plate 81), whose expressionistic geometric structuring, inspired by packaging, was here applied to track and podium. A work of Op Art by Victor Vasarely evoked notions of strength, unity and confidence in its perfect geometry (plate 83). Other abstract works by Eduardo Chillida (plate 75) and Pierre Soulages (plate 82) suggested the dynamic forces of the human body in action. There were contributions by Pop artists Tom Wesselmann, whose portrayal of a monumental foot had a powerful, slightly humorous, impact (plate 84), and Peter Phillips, whose layered imagery suggested both a multiplicity of sporting events and competitive endeavour (plate 80). In his surreal composition, Horst Antes's trademark 'cephalopod' figure appeared unsettled by challenges of victory (plate 73), while Alfonso Hüppi's split, puppet-like figure conveyed at once both high jumper and diver, upward thrust and downward trajectory (plate 76). The human figure was explored by a number of the artists: David Hockney played on a favourite swimming-pool theme, with a diver in conjunction with the play of light on water (plate

16), while Allen Jones, combining the figurative with the abstract, focused on two pairs of athletes' legs, apparently fused together yet in dynamic opposition (plate 77). R.B. Kitaj's fragmented swimmer suggested the excruciating demands the Games places on the human frame (plate 78), as did the image by Jacob Lawrence (notable for his epic narratives of black history) capturing the agonizing heroism of runners striving for the line (plate 79). Taking an architectural subject, Gerd Winner, known for his artistic exploration of urban structures, focused on the powerful engineering behind the tented roof of the Munich Olympic Stadium (plate 87).

This inspirational project, in which artists were invited to submit their interpretations of the Olympic ideal, unshackled by many of the customary constraints of the 'official poster', may be seen as an expression of De Coubertin's wish that the Games should result in aesthetic as well as sporting excellence. The first series was issued in 1969–70, and as four more series were produced from 1970 to 1972, younger and less well-known artists were introduced. (For the full list, see Appendix A, p.138.) It also pioneered the idea of commissioning editions of posters unified by concept or theme and linked to particular Games. In practical terms, since the 'Edition Olympia' posters were intended to appeal primarily to people with artistic interests, and to promote the cultural image of the Games, the sites chosen for their display were universities, schools, Goethe Institutes and other cultural institutions, museums and galleries, embassies and tourist trade centres.

Numerous other posters were produced for the Munich Games, including a distinguished series for the 21 Olympic sports and another for the cultural programme. As the organizing committee recognized, 'The opportunity to reach as many people as possible increases in places where there are crowds – this is the domain of posters. And since posters by their essence are also visual means of information about the Olympic Games, thus once again they are part of the overall image.'[86] Posters were prominent features in a total graphic identity programme developed for the Games under the inspired design leadership of Otl Aicher, one of Germany's leading graphic designers and a pioneer in the development of visual identity systems. A founder member of the Hochschule für Gestaltung (School of Design) in Ulm, Aicher was acknowledged for his corporate branding and logo designs, such as the iconic visual identity he and his student development team created for Lufthansa in 1964.[87] He relished the opportunities offered by his commission for the Munich Olympiad to project Germany's new positive image and to develop a distinct graphic language that could communicate with a multicultural, multilingual audience. The visual design group's concept extended to posters, forms, documents, booklets, plans, tickets, uniforms and signage systems, as well as city graphics and the interior decoration of buildings.[88] Key elements of the visual identity for the posters were the flexible but coherent application of a basic format and grid, a palette composed of a range of chosen colours (white, light blue, green, orange, silver), the use of Univers typeface and the incorporation of the official emblem.[89] To add impact, the sports posters were displayed on customized wall sites in the locations where the events were held, displayed in pairs of contrasting colours to give a 'flicker' effect.[90]

Munich 1972:
Posters from
Edition Olympia 1972

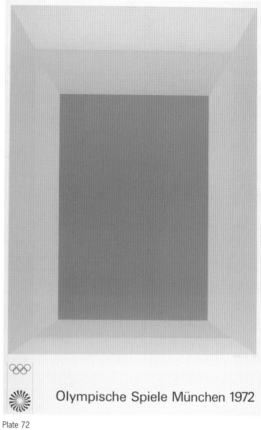

Olympische Spiele München 1972

Plate 72

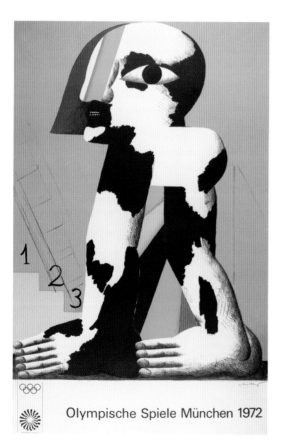

Olympische Spiele München 1972

Plate 73

Olympische Spiele München 1972

Plate 74

Olympische Spiele München 1972

Plate 75

München
Olympia
1972

Plate 76

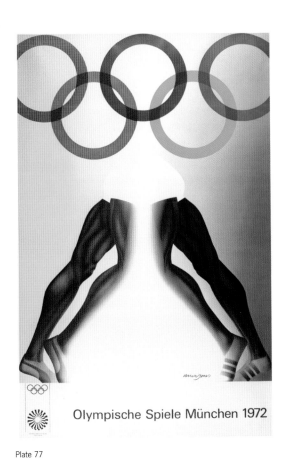

Olympische Spiele München 1972

Plate 77

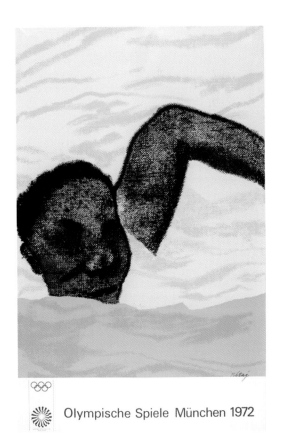

Olympische Spiele München 1972

Plate 78

Olympische Spiele München 1972

Plate 79

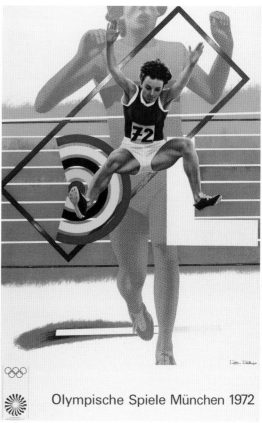

Olympische Spiele München 1972

Plate 80

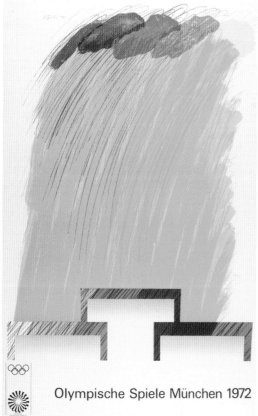

Olympische Spiele München 1972

Plate 81

Olympische Spiele München 1972

Plate 82

Olympische Spiele München 1972

Plate 83

Olympische Spiele München 1972

Plate 84

Plate 72
Munich 1972
'Olympische Spiele München 1972'.
Poster by Josef Albers from Edition
Olympia 1972, third series, 1971
Colour offset lithograph
V&A: E.362–1972

Plate 73
Munich 1972
'Olympische Spiele München 1972'.
Poster by Horst Antes from Edition
Olympia 1972, second series, 1970
Colour offset lithograph
V&A: E.145–1971

Plate 74
Munich 1972
'Olympische Spiele München 1972'.
Poster by Max Bill from Edition
Olympia 1972, third series, 1971
Colour offset lithograph
V&A: E.363–1971

Plate 75
Munich 1972
'Olympische Spiele München 1972'.
Poster by Eduardo Chillida
from Edition Olympia 1972,
second series, 1970
Colour offset lithograph
V&A: E.147–1971

Plate 76
Munich 1972
'München Olympia'. Poster by Alfonso
Hüppi from Edition Olympia 1972,
fifth series, 1972
Colour offset lithograph
V&A: E.399–1972

Plate 77
Munich 1972
'Olympische Spiele München 1972'.
Poster by Allen Jones from Edition
Olympia 1972, second series, 1970
Colour offset lithograph
V&A: E.149–1971

Plate 78
Munich 1972
'Olympische Spiele München 1972'.
Poster by R.B. (Ronald Brooks) Kitaj
from Edition Olympia 1972,
third series, 1971
Colour offset lithograph
V&A: E.358–1972

Plate 79
Munich 1972
'Olympische Spiele München 1972'.
Poster by Jacob Lawrence
from Edition Olympia 1972,
fourth series, 1972
Colour offset lithograph
V&A: E.367–1972

Plate 80
Munich 1972
'Olympische Spiele München 1972'.
Poster by Peter Phillips from Edition
Olympia 1972, fourth series, 1972
Colour offset lithograph
V&A: E.368–1972

Plate 81
Munich 1972
'Olympische Spiele München 1972'.
Poster by Richard Smith from Edition
Olympia 1972, fourth series, 1972
Colour offset lithograph
V&A: E.369–1972

Plate 82
Munich 1972
'Olympische Spiele München 1972'.
Poster by Pierre Soulages
from Edition Olympia 1972,
second series, 1970
Colour offset lithograph
V&A: E.146–1971

Plate 83
Munich 1972
'Olympische Spiele München 1972'.
Poster by Victor Vasarely from Edition
Olympia 1972, second series, 1970
Colour offset lithograph
V&A: E.151–1971

Plate 84
Munich 1972
'Olympische Spiele München 1972'.
Poster by Tom Wesselmann
from Edition Olympia 1972,
third series, 1971
Colour offset lithograph
V&A: E.360–1972

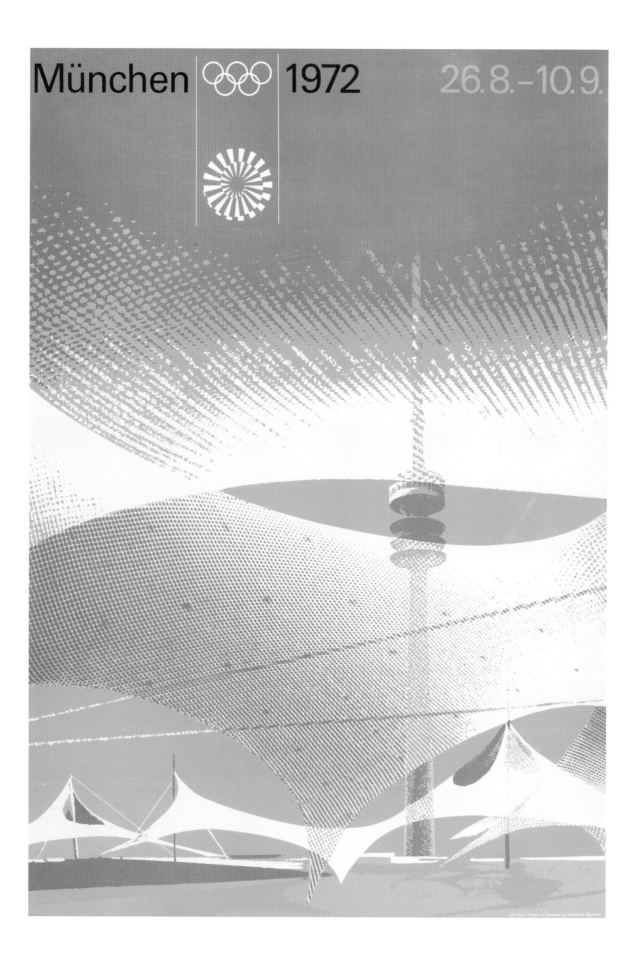

Plate 86
Munich 1972
'Kiel 1972'. Sports series poster
by Otl Aicher and his design team
announcing the
sailing competitions at Kiel
Photograph by Peter Cornelius;
printed by Klein und Volbert,
München, 1970
Colour screenprint
Collection of Peter Jacobs

Plate 87
Munich 1972
'Olympia 72 München'.
Poster by Gerd Winner from
Edition Olympia 1972,
fifth series, 1972
Colour offset lithograph
V&A: E.393–1972

For the important official poster, intended to project the positive overall image desired for the Games, 11 international graphic artists were invited on 10 July 1969 to submit designs anonymously. The poster was to conform to the graphic vocabulary described above – the chosen range of colours, the official emblem and the Univers font (prominent in the text 'München 1972') – and to feature a significant Munich landmark. The competition came full circle when the jury ultimately rejected all the submitted designs and returned to the original concept submitted by Aicher's visual design group, which had stimulated the competition in the first place. The poster image (plate 85) was a photographic modification of the architectural model for the Munich Olympic Stadium designed for the Games by Günther Behnisch & Partner: a nylon mesh was used to simulate the translucent material of Behnisch's huge tented roof structure. It set the style of the subsequent sports series posters in making separations of the tonal values of monochrome photographic images and converting these to the official colours (plate 86).[91] Among other remarkable achievements of Aicher's visual design group were the original concept for the official Munich emblem – a *Strahlenkranz* or radiant garland (later evolved to a radiant spiral) which appeared on the posters; 180 pictograms flagging up the 21 sports activities and various support services (the sports pictograms were a modification of Masaru Katsumie's designs for the Tokyo 1964 Games); and the choice of the striped dachshund 'Waldi' as the first officially named Olympic mascot – which proved a significant marketing device.

(opposite page)
Plate 85
Munich 1972
'München 1972'.
Official poster by Otl Aicher
and his design team
Printed in Germany by Mandruck,
München, 1970
Colour offset lithograph
V&A: E.876–1970

In 1976 Innsbruck made a surprise reappearance as a winter venue, when the people of Colorado, swayed by reasons of cost and supposed damage to their environment, declined to vote for a public funding initiative to support the XII Olympic Winter Games due to be held in Denver. The IOC's second choice for the Games was Whistler in British Columbia, Canada, but following a change of government it too declined. At Innsbruck, which then accepted the invitation, sporting facilities were already in place from the Olympic Winter Games 12 years earlier, so the resort required only some updating of transport and accommodation to prepare itself. At the opening in the main Bergisel Stadium, two flames were lit, to celebrate both Innsbruck Games. In the event, 37 nations participated and, to the delight of the home crowd, Austrian Franz Klammer won the coveted downhill skiing event on the first day and Karl Schnabl the big hill ski jump competition on the last. The official poster (plate 88) by Arthur Zelger, a graphic designer known for his bold Austrian tourist posters, was an abstract composition whose main motif was interpretable as the 'I' of Innsbruck, the blade of a skate or a ski jump, ski run or bobsleigh slide.[92] Peaked swirls in distinctive colours evoke the Tyrolean mountains and the lower two of the Olympic rings, pictorially connected by the main motif, suggested the link between the Innsbruck Games of 1964 and those of 1976. Some 11,000 copies were issued. A further visual link was made through the official emblem, which was a slight modification of the one Zelger had designed for the earlier event.

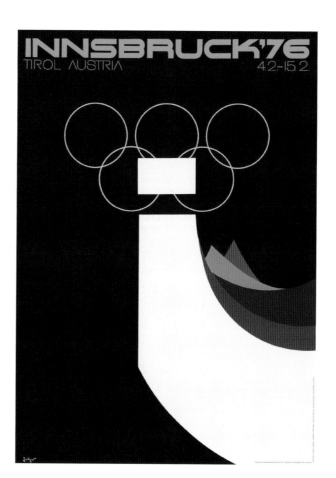

Plate 88
Innsbruck 1976
'Innsbruck '76'.
Official poster by Arthur Zelger
Printed by Alpina Offset, Innsbruck
Colour offset lithograph
Olympic Museum Lausanne Collections

Montréal 1976

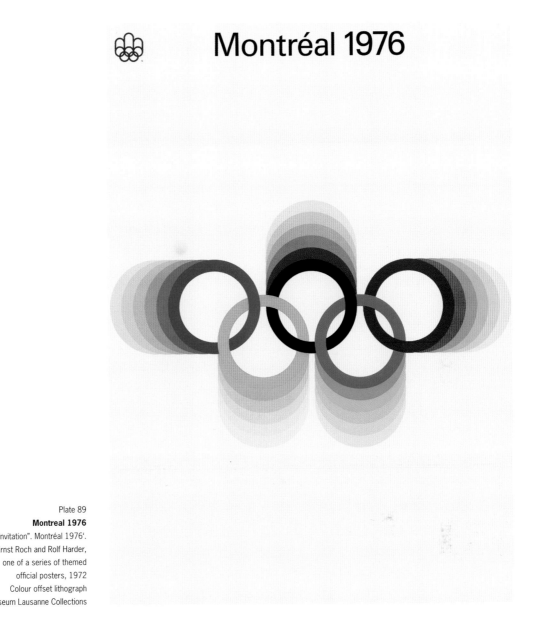

Plate 89
Montreal 1976
'"Invitation". Montréal 1976'.
Poster by Ernst Roch and Rolf Harder,
one of a series of themed
official posters, 1972
Colour offset lithograph
Olympic Museum Lausanne Collections

The Montreal Olympic Games of 1976 were threatened by political, ethical and economic issues, which posed looming problems for the Olympic Movement. There was a mass boycott by African countries protesting against New Zealand's sporting links with apartheid-run South Africa, while Taiwan withdrew because Canada, which officially recognized the People's Republic of China, would not permit Taiwan to be identified as the Republic of China. There were also debates about the suspected use by many athletes of performance-enhancing anabolic steroids, as well as about growing commercial influence on sports in the West and increasing government control over athletes from the Eastern Bloc. And on the economic front, Montreal's descent into debt – vividly symbolized by the cranes of unfinished buildings that dominated the skyline at the opening ceremony – cast doubt over the financial sustainability of the modern Games on their ever-expanding scale. In spite of the boycotts, more than 6,000 athletes representing 92 countries competed,

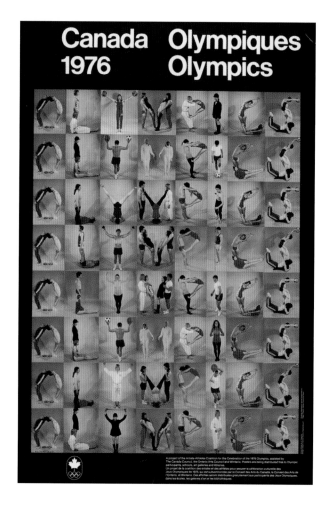

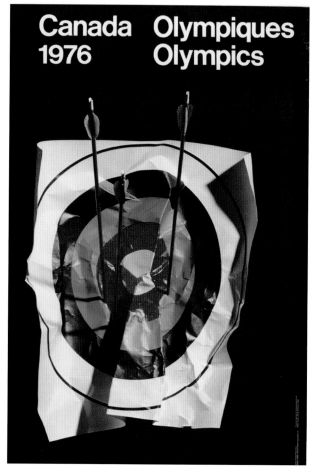

Posters from **'The Artists–Athletes Coalition for the Celebration of the 1976 Olympics'** series

Plate 90
Montreal 1976
'Canada 1976 Olympiques Olympics'.
Poster by N.E.Thing Co.
(artists' collective including Ian Baxter,
Louise Chance and others)
Series design by
Burton Kramer Associates
Colour offset lithograph
V&A: E.48–1977

Plate 91
Montreal 1976
'Canada 1976 Olympiques Olympics'.
Poster by Pierre Ayot
Series design by
Burton Kramer Associates
Colour offset lithograph
V&A: E.45–1977

with outstanding performances from (among others) hurdler Edwin Moses (USA) and gymnasts Nellie Kim (Soviet Union) and Nadia Comaneci (Romania), the 14-year-old who sensationally scored the first-ever perfect 10 awarded to an Olympic gymnast.

In the field of Canadian graphics, the Montreal 1976 Games, like Expo 67 (the 1967 World Fair held in Montreal) before it, provided a stimulus for new design. Le Comité Organisateur des Jeux Olympiques (COJO) recognized the need for an aesthetic unity that would reflect the character of the Games and appointed the Montreal graphic designer Georges Huel, formerly director-general of Expo's graphics and signage programme, as head of COJO's Graphics and Design Directorate, which advised on aspects of the visual identification programme. Huel, who had previously designed Expo's official poster, was also chosen in 1972 to design the distinctive official emblem for the Games: a stylized representation of the Olympic rings topped by a podium, which was also a graphic representation of the letter 'M' for Montreal.

In all, COJO employed eight permanent designers and over 100 freelancers, and as part of an impressive publicity campaign they commissioned two series of thematic posters from the Graphics and Design Directorate. The first set had eight chosen themes: Olympic Stadium, Mascot, Invitation, Flag, International Youth Camp, Olympia and Montreal, Kingston 1976 (site of the sailing competitions) and

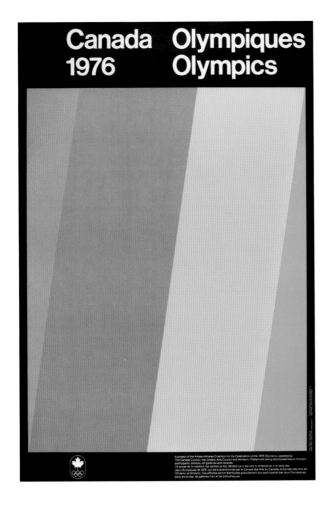

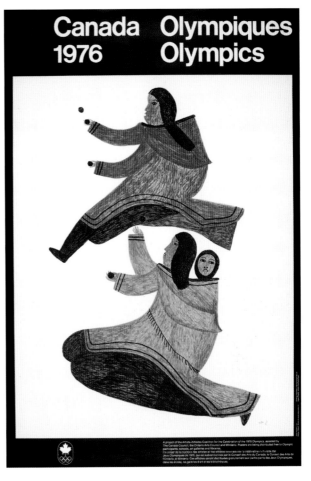

Plate 92
Montreal 1976
'Canada 1976 Olympiques Olympics'.
Poster by Guido Molinari
Series design by
Burton Kramer Associates
Colour offset lithograph
V&A: E.3182–2007

Plate 93
Montreal 1976
'Canada 1976 Olympiques Olympics'.
Poster by Lucy (Lucy Qinnuayuak)
Series design by
Burton Kramer Associates
Colour offset lithograph
V&A: E.3183–2007

the Olympic Flame. The thematic poster 'Invitation' (plate 89) by Ernst Roch and Rolf Harder, co-founders of Design Collaborative, was an optimistic design developing the Olympic rings into sound waves, symbolically inviting athletes from the five continents to the Games. It was one of the Games' few posters to be commercially licensed and became one of the most recognized images. The second set illustrated the 21 sports in the Olympic programme, each design intended to express the action and immediacy of the sport depicted.[93] All COJO's posters were lettered in both French and English, the two official languages of Canada (Canada being the official host of the Games), and used Frutiger's Univers typeface. This font was chosen to give a modernist uniformity to the graphics programme – which also included an Olympic calendar, competition schedule, explanatory brochures and maps of transport systems and venues.

Another poster project, chaired by Canadian academic and Olympian athlete Bruce Kidd, was 'The Artists–Athletes Coalition for the Celebration of the 1976 Olympics'. This was created to educate the Canadian public about De Coubertin's vision of bringing sport and art together, to broaden public support for the Montreal Games and to lobby COJO for an arts and culture festival. More than 300 artists submitted posters to a pan-Canadian competition held for the project in 1974, with 10 designs chosen for printing and distribution. Among the set were works by the

Canadian abstract painter Guido Molinari (plate 92), popular Inuit graphic artist Lucy Qinnuayuak (plate 93), Pierre Ayot (plate 91), known for his poster-like images and installations, and artists' collective N.E.Thing Co. (plate 90), who created many installations and events to do with modes of communication, which they documented with photography or video. Since the funds came from the Canada Council, a federal agency seeking a federal presence in the Games amid the growing aspirations for independence in Montreal and Quebec, a condition of the funding was that the word 'Canada' appeared on the posters.[94] The Artists–Athletes posters were also part of COJO's arts and culture programme and sets were distributed to Olympic participants, schools, universities, art galleries, libraries and sports clubs around the world.

In 1980 Lake Placid was the venue for the Olympic Winter Games for a second time – 48 years after hosting the 1932 event. The official emblem created by Robert Whitney and used for an official poster (plate 94) struck an echo with the earlier Games: its abstract design could be read as a schematized ski jump, but also as a double Olympic cauldron (representing the two Games) from which the Olympic rings issue as flames. There were links in reality too: just as before, warm weather turned the snow to slush, but now, for the first time in Olympic history, artificial snow was used to make good the shortfall. In spite of unpredictable weather conditions and the logistical difficulties of moving vast crowds around the venues by bus, the Games were a sporting triumph. The two superpowers battled it out in the ice hockey competition (the US team won, beating the Soviet Union in the semi-final) and there were stirring individual performances by American speed skater Eric Heiden, who won five gold medals, Swedish slalom and giant slalom champion Ingemar Stenmark, and the Soviet pairs figure skaters Irina Rodnina and Alexander Saizev.

Plate 94
Lake Placid 1980
'XIII Olympic Winter Games
Lake Placid 1980'.
Official poster by Robert Whitney
Printed by George Little Press,
Burlington, Vermont, 1977
Colour offset lithograph
Olympic Museum Lausanne Collections

XIII OLYMPIC WINTER GAMES LAKE PLACID 1980

™

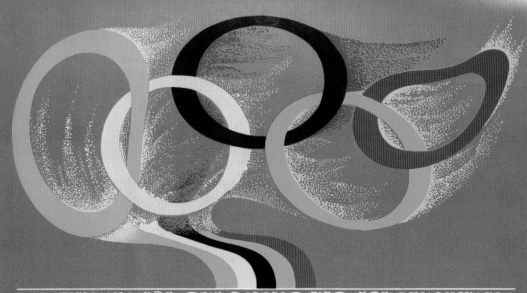

SPORT
PEACE
FRIEN
DSHIP
SPORT
PAIXA
MTIE

Plate 95
Moscow 1980
'Sport Peace Friendship'.
Poster by A. Archipenko
Published by Plakat, Moscow, 1979
Colour offset lithograph
V&A: E.305–2006

Regeneration and Promotion

A shadow had fallen over the Lake Placid Games when, in late December 1979, the Soviet Union sent troops into Afghanistan, causing US president Jimmy Carter to threaten a retaliatory boycott of the 1980 Moscow Games. The Olympic Games held in 1980 and 1984 were to take place against a background of heightened superpower tension when, after a long period of détente, a 'new' or 'second' Cold War developed for which the Soviet intervention in Afghanistan is seen to have been the trigger.

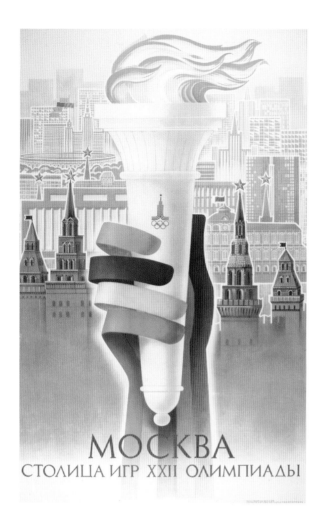

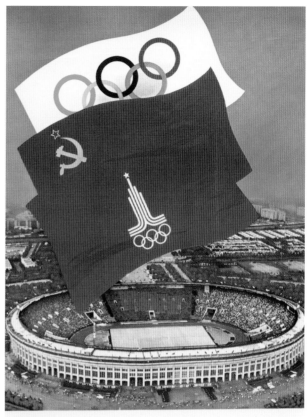

Plate 96
Moscow 1980
'Moscow Capital of the
XXII Olympic Games'.
Poster by S. Pegov
Published by Plakat, Moscow, 1977
Colour offset lithograph
V&A: E.345–2006

Plate 97
Moscow 1980
'The USSR has supported
and will support the
Modern Olympic Movement'.
Poster by V. Vorontsov
Published by Plakat, Moscow, 1978
Colour offset lithograph
V&A: E.344–2006

The XXII Olympiad was the first to be held in a country under communist rule, but the US-led boycott reduced the participating nations to 80 – the lowest number since Melbourne 1956. The political controversy even brought into question the future of the Olympic Movement itself, founded as it was on a premise of international goodwill. Not surprisingly, the Moscow Games (opened by Leonid Brezhnev) were dominated by athletes from the USSR and East Germany, with Soviet gymnast Alexander Ditiatin becoming the first athlete to win eight Olympic medals (three gold, four silver, one bronze) in a single year and Soviet swimmer Vladimir Salnikov winning three gold medals before the home crowd. Defining images of the Games were the dramatic confrontations between British middle-distance runners Steve Ovett and Sebastian Coe, with Ovett winning the 800 metres and Coe the 1,500 metres.

Despite the worsening international situation, the stated aims of the Organizing Committee of the Games of the XXII Olympiad (OCOG-80) were to carry through a set of measures aimed at 'popularizing the forthcoming Games in Moscow' and, in the spirit of the Olympic Movement, 'promoting international contacts, improving mutual understanding and strengthening friendship and peace between nations'.[95] These included publications, press, visual propaganda (exhibitions, posters, etc.),

the cultural programme, design elements, civic decorations and official films. OCOG-80 naturally called upon state organizations to achieve these measures and, in the case of posters, worked jointly with the Plakat publishing house to carry through a programme of poster publication from 1976 to 1980. The first two posters were seen on Soviet television's final broadcast from Montreal. Well-known Soviet artists and photographers were among the designers, but enthusiastic amateurs sent in their sketches too and Plakat also cooperated with Soviet art institutes whose students chose Olympic posters as their semester and diploma work.[96] Though conceived in the long-established tradition of state publicity and propaganda, many of the Moscow Olympic posters were also aimed at an international audience. A. Archipenko's design (plate 95) urging 'Sport Peace Friendship' was lettered in Russian, English and French; 40,000 copies were issued. Another by S. Pegov entitled 'Moskva Stoliza Igri XXII Olimpiady' ('Moscow Capital of the XXII Olympic Games') (plate 96) possibly sought to popularize the Games with a home audience through its portrayal of an Olympic torch against the proud backdrop of Moscow's Kremlin Palace and towers, sports stadium, two of the 'Stalin skyscrapers' and other architectural landmarks; 120,000 copies were produced. In V. Vorontsov's poster (plate 97), 100,000 copies of which were issued, a statement of support by Brezhnev ('the USSR has supported and will support the modern Olympic Movement') is prominently lettered below the image of the Olympic, Soviet and Moscow Olympic flags flying above the Central Lenin Stadium; within the stadium the depicted spectators make a pictorial display with blocks of colourful scarves in the tradition of communist mass rallies. The stadium itself, constructed in 1955–6 during the Khrushchev era, had a spectator capacity of 103,000 and was the chief venue for the Games. An enduring image of the closing ceremony was the spectacle of Misha the Bear, the first sporting mascot to generate large-scale merchandising success, floating away as a balloon into the Moscow night sky.

As well as publishing series of posters on the subjects of Soviet sport and on the sports arenas of Moscow, Tallinn, Leningrad, Kiev and Minsk, OCOG-80 also distributed the poster images as postcards and sold small-format posters as souvenirs during the Games. In all, under OCOG-80's direction, Plakat issued 250 Olympic posters in a total edition of 18,750,000 copies. The official emblem for the Moscow Games, also made into a poster (plate 98), was created by Vladimir Arsentyev, a young Soviet artist from Rezekne in Latvia. The organizing committee had run a competition in 1975 for the design of the symbol, stipulating that it must incorporate the Olympic rings and a design representative of the host city: 8,500 amateur and professional artists entered from across the world. Arsentyev's concept of parallel lines above the Olympic symbol could be interpreted as five sports tracks and the unity of the sports movement, and also as the silhouette of one of Moscow's Kremlin towers topped by a red five-pointed star.

Plate 98
Moscow 1980
'Olympiad 80 Moscow'.
Official poster featuring the
Moscow Games' emblem,
designed by Vladimir Arsentyev
This version lithographed in Canada
Colour lithograph
V&A: E.425–2007

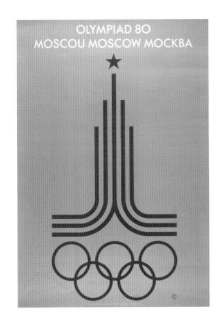

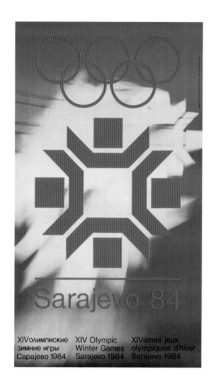

Plate 100
Sarajevo 1984
Poster by Andy Warhol reproducing
'Speed Skater' from 'Art and Sports'
portfolio, 1983
Colour offset lithograph
V&A: E.3185–2007

Plate 99
Sarajevo 1984
'Sarajevo '84'. Official poster featuring
the Games' emblem, designed by
Cedomir Kostovic; poster designed by
Radmila Jovandič and Lora Levi
Photo: Saša Levi
Printed by NIŠRO 'Oslobodenje'
Sarajevo
Colour offset lithograph
Olympic Museum Lausanne
Collections

In 1978 the XIV Olympic Winter Games of 1984 were awarded to Sarajevo (then in the Socialist Federal Republic of Yugoslavia, now the capital of Bosnia and Herzegovina), which trumped the rival bids of Sapporo and Gothenburg. Sarajevo's tradition of winter sports dated back to the days of the Austro-Hungarian Empire, and by raising money through sponsorship, licensing agreements, television rights and advertising, together with domestic initiatives such as an Olympic lottery and the sale of Olympic coins and stamps, the city quickly added extra sports facilities. Infrastructure projects, such as new roads, hotels and a modern airport, were also undertaken – though much would be destroyed in the war that engulfed the city 10 years later. In terms of publicity, the Sarajevo Organizing Committee's aims were primarily 'to present the Sarajevo Games to all countries of the world, and therewith to publicize the tourist-recreational potential of the Sarajevo region and of Bosnia and Herzegovina ...'[97] An official poster (plate 99) incorporated the Games' emblem that had been designed by Cedomir Kostovic: a deconstructed snowflake imitating a traditional embroidery pattern of the Bosnian region. Another important element was a rich programme of cultural activities, one major initiative being the production of an 'Art and Sports' portfolio (1983) to which international artists such as Henry Moore, James Rosenquist, Victor Vasarely and Andy Warhol were invited to contribute. The original prints were produced in a variety of media on special papers and issued in limited editions, but they also appeared in unlimited editions as offset-lithographed posters. For example, Warhol's poster 'Speed Skater' (plate 100), in which the artist overlaps two images (based on a publicity photograph) to convey the distinctive crouched stance and counter-thrusting actions of the skater in motion, was originally produced as a colour screenprint on Arches 88 paper.[98] Sarajevo gained plaudits for its organization and hospitality, and provided a setting for memorable performances, among others by figure skaters Scott Hamilton (USA) and Katarina Witt (East Germany), and by ice dancers Jayne Torvill and Christopher Dean (GB) with their interpretation of Ravel's 'Bolero'.

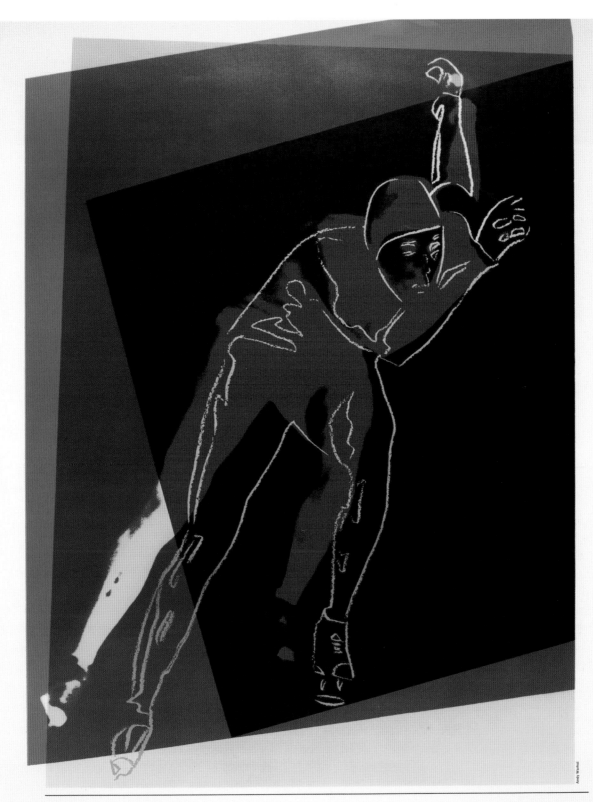

 XIVèmes jeux olympiques d'hiver XIV Olympic Winter Games XIV zimske olimpijske igre
Sarajevo 1984 Sarajevo 1984 Sarajevo 1984

Yougoslavie Yugoslavia Jugoslavija

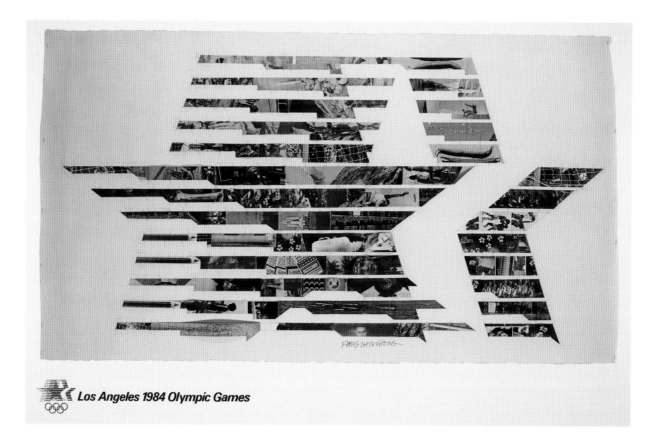

Los Angeles 1984 Olympic Games

Plate 101
Los Angeles 1984
'Los Angeles 1984 Olympic Games'.
Poster by Robert Rauschenberg,
issued in association with the Los
Angeles Olympic Games 1984
Published by Knapp Communications
Corporation, 1982
Colour offset lithograph
V&A: E.3187–2007

Plate 102
Los Angeles 1984
'Los Angeles 1984 Olympic Games'. Poster
by Roy Lichtenstein reproducing one of his
earlier works, 'The Red Horsemen' (1974),
issued in association with the Los Angeles
Olympic Games 1984
Published by Knapp Communications
Corporation, 1982
Colour offset lithograph
V&A: E.346–2006

Undaunted by the Olympic Games' recent history of terrorist attacks, financial disasters and political boycotts, Los Angeles was the only bidder for the XXIII Olympiad. In spite of a boycott by many communist countries, generally viewed as retaliation for the US-led boycott of the Moscow Games, nearly 6,800 athletes representing 140 countries attended, with China participating for the first time since 1952. The loss of athletic representation was offset by feats such as Carl Lewis (USA) taking four gold medals in his track and field events, and Daley Thompson (GB) successfully defending his decathlon title. New events for women included synchronized swimming and the marathon. The Games were conducted in an exuberant spirit of commercialism under the direction of American entrepreneur Peter Ueberroth and were the first to develop the huge potential of corporate sponsorship, with ABC paying 225 million dollars for the exclusive television transmission rights.

In entrepreneurial spirit, the Los Angeles Olympic Organizing Committee (LAOOC) commissioned a series of 15 fine art posters by artists ranging from the internationally famous (such as Richard Diebenkorn, Sam Francis, David Hockney (plate 104) and Robert Rauschenberg) to young emerging talents, with a special emphasis on artists working in Los Angeles.[99] One such was designer April Greiman, who had just moved to Los Angeles and collaborated with photographer Jayme Odgers to create a colourful montage (plate 103) that experimented with dimensions of time and space, reality and imagination. Each poster in the series represented the artist's individual response to the idea of sport or the Olympic Games. Roy Lichtenstein chose to have reproduced an earlier work, 'The Red Horsemen' (1974)

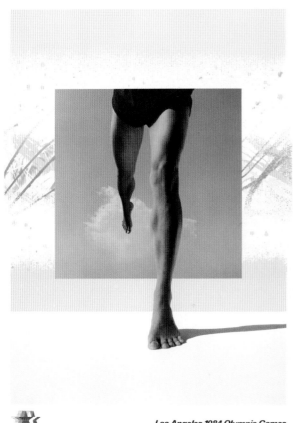

Los Angeles 1984 Olympic Games

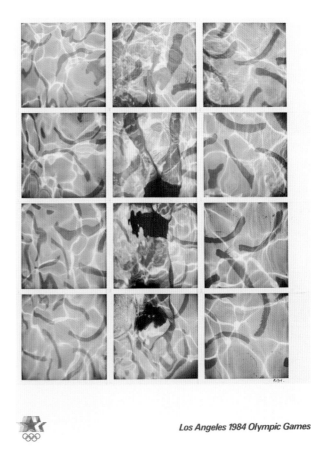

Los Angeles 1984 Olympic Games

Plate 103
Los Angeles 1984
'Los Angeles 1984 Olympic Games'.
Poster by April Greiman and Jayme
Odgers, issued in association with the
Los Angeles Olympic Games 1984
Published by Knapp Communications
Corporation, 1982
Colour offset lithograph
V&A: E.347–2006

Plate 104
Los Angeles 1984
'Los Angeles 1984 Olympic Games'.
Poster by David Hockney, issued
in association with the Los Angeles
Olympic Games 1984
Published by Knapp Communications
Corporation, 1982
Colour offset lithograph
V&A: E.306–2006

(plate 102). Rauschenberg took as the framework for his composition (plate 101) the official Los Angeles 'The Star in Motion' emblem designed by Robert Miles Runyan and Associates, a schematic design of interlocking stars crossed by horizontal stripes that appear to set the stars in motion. He used this pattern as if it were a shutter through which we view another picture: a collage of apparently random snapshots, including several with sporting subjects, that suggests fast-moving and fragmented experience. It exemplified one of the themes that Rauschenberg liked to explore – the multiple reproducibility of images, and the way that this can affect our perception and understanding. Published and marketed by Knapp Communications Corporation in 1982, the images were printed in a signed limited edition of 750, and also as colour offset lithographs in a commercial edition on non-archival paper, each poster printed below with the official emblem.

As part of the 'Design and Look of the Games', the LAOOC commissioned further categories of poster representing the subject of sport from specific artistic viewpoints – a practice that would continue in future Games. A second series reproduced five paintings commissioned by the LAOOC and Los Angeles Area Chamber of Commerce from footballer-turned-artist Ernie Barnes,[100] who drew on his direct experience of sport to create works in a distinctive neo-Mannerist style. As official sports artist, he also acted as spokesman for the Games, encouraging the involvement of inner-city youth. A third series was LAOOC's 'Olympic signature

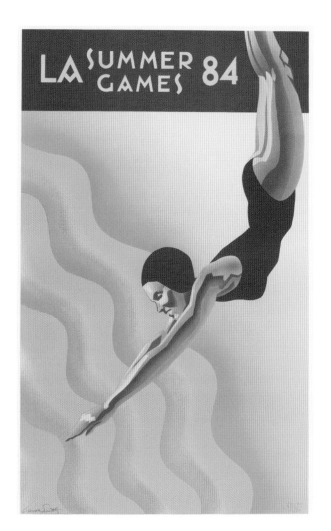

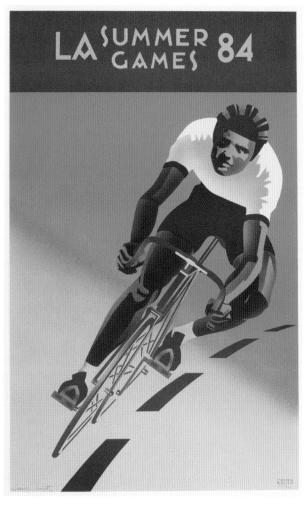

Plate 105
Los Angeles 1984
'LA Summer Games 84'.
Print by Laura Smith
Printed by ProCreations, 1983
Colour lithograph
V&A: E.348–2006

Plate 106
Los Angeles 1984
'LA Summer Games 84'.
Print by Laura Smith
Printed by ProCreations, 1983
Colour lithograph
V&A: E.349–2006

posters', commissioned in 1983 from 12 noted Los Angeles-based designers, each of whom chose to depict a particular Olympic sport. Here the posters had to comply with the design and look of the Games, adhering to the official typography and colour palette, with no duplication of sports.[101] A functional 'Look' poster, setting out criteria for colour and design, acted as a printed guide for architects and designers creating the LAOOC look at more than 75 sites. Non-official posters added to the Games' visual diversity – for example, the set 'LA Summer Games' (1983) (plates 105 and 106) by Laura Smith, inspired by the simplified forms and immediate impact of Art Deco posters, was independently published as a limited edition of fine art lithographs.

The XV Olympic Winter Games held in the Canadian city of Calgary in 1988 continued the financial success of the Los Angeles Games, with corporate sponsorship once more bringing in large-scale revenue (which went to several legacy projects) and also raising the profile of Calgary as an important commercial centre. Broadcasting rights were again assigned to ABC television and favourites of the Games became those who combined sporting achievement with charisma, such as Alberto Tomba ('la Bomba') of Italy, who took gold in the slalom and giant slalom, and skater Katarina Witt (East Germany) with her interpretation of Bizet's *Carmen*.

The Games' official emblem, designed by Gary Pampa of Alberta, metamorphosed Canada's national maple-leaf emblem into a stylized snowflake made up of large and small letter 'Cs' (large for Canada, small for Calgary), echoing the 'Cs' of the announcement 'Come Together in Calgary' and the shapes of the Olympic rings. In an official poster (plate 107), this image was superimposed over Larry Fisher's photographic view of Calgary seen against a backdrop of the Rocky Mountains; Fisher's original version of this cityscape had been commissioned in 1985 as the basis for a mural in the Alberta Pavilion in Expo-86 (Vancouver).

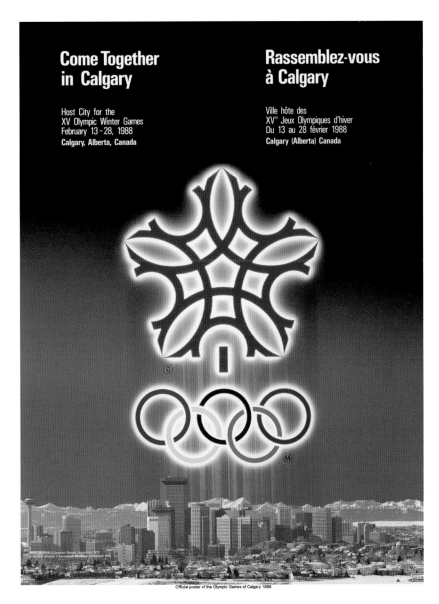

Plate 107
Calgary 1988
'Come Together in Calgary'. Official
poster featuring the Games' official
emblem, designed by Gary Pampa,
superimposed over a photograph by
Larry Fisher. Art direction: Justason +
Tavender, Calgary, c.1986
Colour offset lithograph
Olympic Museum Lausanne Collections

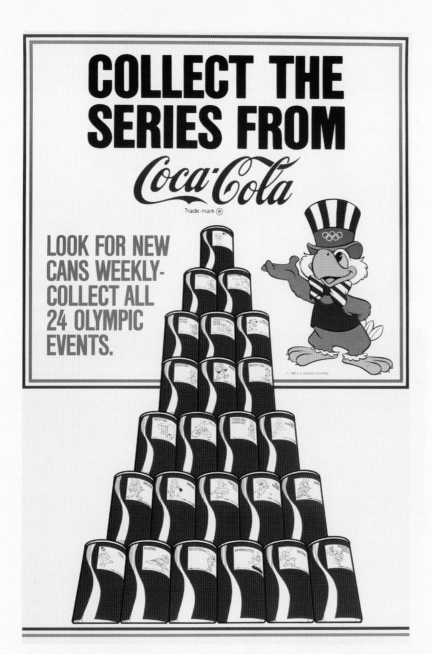

Plate 108
Los Angeles 1984
'Collect the series from Coca-Cola'
Anonymous poster advertising Coca-Cola,
an official sponsor of the Los Angeles Games
Published *c.*1982
Colour offset lithograph
V&A: E.416–2007

Commerce

Olympic Games posters, by their very nature, promote the Games to an international audience and are an important part of any publicity strategy. Before the 1960s, it was customary for each Olympic Games to produce one official poster to advertise the event, but since then organizing committees have in addition generated whole series of officially authorized posters. Some are themed to appeal to different target audiences under headings such as 'Sport', 'Culture', 'Artist' and 'Designer'. Others promote particular elements of an Olympic Games, such as the opening ceremony, the torch relay, the official emblem or the Games' mascots. Many of these posters have achieved a marketable afterlife, some as highly collectable works of art and others as prized souvenirs.

Official posters are free of overt commercial advertising. Unusually, the official poster for Amsterdam 1928 was lettered with the name of the Netherlands Railways according to the language of the country to which it was being distributed.

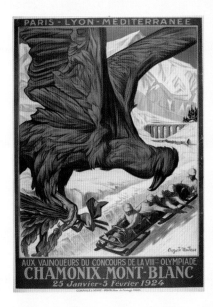

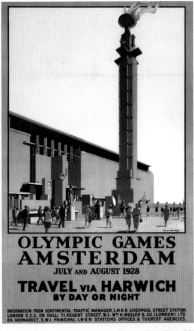

Plate 20 (p.33)
Chamonix 1924

Plate 24 (p.38)
Amsterdam 1928

Plate 47 (p.58)
BEA/London 1948

Railway companies naturally wished to generate their own commercial advertising for travel to and from the event, so the same Amsterdam Games, seen from a different perspective, were also promoted by a London and North Eastern Railway poster of the tourist genre (plate 24). A Paris–Lyon–Méditerranée railway poster advertising travel to Chamonix-Mont Blanc in 1924 (plate 20) later took on a quasi-official status when the Chamonix Winter Games were retrospectively recognized as 'Olympic'. The benefits to commercial companies of association with the Olympic Games have long been obvious (see plate 47). In the London Games of 1908, for example, the Oxo Company was cited in the official report for the free provision of its product to sustain competitors in the marathon. Today the use of the Olympic 'brand' is strictly controlled, but in the past some opportune advertising did occur. Commercial sponsorship not only funds the Games themselves but also allows the IOC to provide funds to each nation that competes.

Under the ethos of amateurism that prevailed during the first half of the twentieth century, official commercialization of the Olympic Games was shunned: the organizing committee of the Los Angeles 1932 Olympic Games, for example, 'endeavoured at all times to keep the element of commercialism out of the Games'.* Ironically it was the Los Angeles Games of 1984 that were the first to develop the full potential of

corporate sponsorship and licensing agreements to yield substantial revenues. Sam the Olympic Eagle, developed as the Games' mascot by C. Robert Moore of Walt Disney Productions and used by the LAOOC as a symbol to engage youth, was extensively applied in licensed products as well as by many sponsors and suppliers in their own promotional materials (plate 108).

Under the present code of practice, official sponsors and licensees may acquire the right to create an association with particular Games, and to use the Games' Marks (Olympic terminology, symbols, emblems (see plate 109) etc.) in authorized commercial contexts.

*Xth Olympiade Committee of the Games of Los Angeles, USA, 1932 Ltd, The Games of the Xth Olympiad Los Angeles 1932: Official Report (Los Angeles, 1933), p.220.

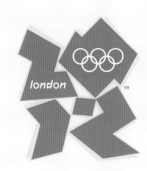

Plate 109
London 2012
Emblem
Courtesy of London
2012/International
Olympic Committee

Posters played an important role in setting the stage for the XXIV Olympiad in Seoul, the capital of South Korea, which was chosen ahead of the Japanese city of Nagoya to host the 1988 Games. The Seoul Olympic Organizing Committee (SLOOC), formed in 1981, wanted their posters to 'promote the Games and to create a festive mood' and they generated sets to suit varying needs: official, sport (photographic images representing the 27 Olympic sports), culture, event (for direct publicity) and arts (a total of 600 sets of lithographic prints by 25 leading contemporary artists). There were also posters featuring the Games' official emblem and official mascot.[102] The emblem (plate 110), designed by Professor Yang Seung-Choon of Seoul National University, was an energetic variation on the *samtaeguk* design, a popular Korean decorative motif. *Samtaeguk* itself is a variant of the circular yin-yang symbol, which represents the dynamic duality of the universe. The official mascot was a tiger (plates 111, 113), chosen as the candidate character in preference to a rabbit, a squirrel and a pair of mandarin ducks. Its designer, Kim Hyun, reinvented the formidable tiger of Korean myth and legend as a lovable cartoon tiger cub called 'Hodori', who wore a traditional *sangmo* hat with spiralling ('S' for Seoul) streamer and a set of Olympic medals. Kim Hyun produced 63 approved variations to communicate a range of Olympic themes: 'Hodori' appeared as an Olympic host, a contestant in the sporting events and a practitioner of traditional Korean arts. He was also drawn as a series of pictographs with the streamer of his hat forming different letters. Professor Cho Young-Jae of Seoul National University was chosen to design the official poster (plate 112), which expressed the Games' dual ideals of harmony and progress. The artist combined an image of the Olympic rings, using computer graphic techniques to animate them into a powerfully radiant force, with that of an Olympic torch bearer, whose onward stride symbolized mankind's progress.

The 12 culture posters were 'intended to introduce Korean culture to the world and to generate diverse images of the Games'.[103] In a distinctive Korean

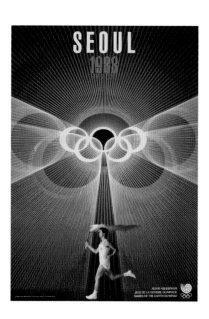

HODORI

제24회 서울올림픽대회
마스코트「호돌이」

Hodori, la Mascotte pour
les Jeux de la 24ème Olympiade
Séoul 1988
Septembre 17 – Octobre 2

Hodori, the Mascot for
the Games of the 24th Olympiad
Seoul 1988
September 17 – October 2

Plate 114
Seoul 1988
'Woman Fan Dancer'.
Culture poster by Kim Hyun, 1987
Printed in Korea
Colour offset lithograph
V&A: E.350–2006

Plate 115
Seoul 1988
'Royal Screen Pattern'.
Culture poster by
Yang Seung-Choon, 1987
Printed in Korea
Colour offset lithograph
V&A: E.359–2006

aesthetic, they variously drew upon traditional patterns, well-known paintings, architectural motifs and colourful images of Korea's visual and performing arts. Among the artists who created posters in this series was Kim Hyun, whose 'Woman Fan Dancer' design (plate 114) intriguingly played with space, pattern, colour and movement. Yang Seung-Choon's 'Royal Screen Pattern' (plate 115) was a modern evocation of the Sun, Moon and Five Peaks screen painting traditionally placed behind the royal throne of the Joseon rulers, while Ahn Chung-Un's 'Fan Dance' incorporated script from the Korean alphabet (plate 117). 'Hunting' by Zun Hoo-Yon (plate 116) interpreted a detail from a fifth-century-AD tomb mural of the Koguryŏ period – the vigorous and spirited 'Tomb of the Dancers'. The choice of an image from the pre-seventh-century northern kingdom, now North Korea, may have had significance as a unifying gesture.

The Seoul Games' ideals of harmony and progress were threatened by political problems on the home front, with student riots preceding the Games and North Korea imposing a boycott when it judged that its demands for co-host status had been insufficiently met by the IOC. Although Cuba and Ethiopia also stayed away, no other major boycotts occurred and a welcoming atmosphere was created for

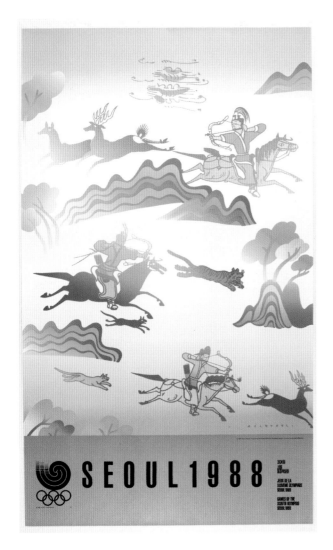

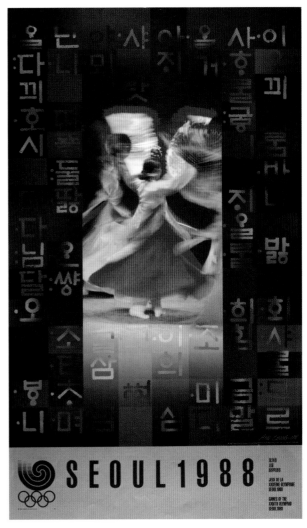

the 159 nations that competed. The Games were seen as a turning point in South Korea's progression towards integration with the international community. Tennis was included again after 62 years' absence and table tennis, to be dominated by Chinese and Korean competitors, was introduced. Sporting triumphs by American sprinter Florence Griffith Joyner ('Flo-Jo') and East Germany's Kristin Otto (six gold medals in swimming) added lustre to the Games, but the disqualification of 10 athletes for using performance-enhancing drugs – most sensationally Canadian sprinter Ben Johnson, who was stripped of his 100-metre gold medal – made shock headlines worldwide.

The choice of Albertville in France as the venue for the 1992 Olympic Winter Games was due to the driving force of two men who wished to develop the economic potential of the Savoie region for winter sports and tourism: Jean-Claude Killy, the triple Olympic champion of Grenoble, and Michel Barnier, at that time *député* for Savoie and with political influence in the area. Albertville followed in the footsteps of the earlier French venues of Chamonix and Grenoble, but even with great improvements to the town's infrastructure, competitions needed to be spread over 14 different sites. Funding was raised by sponsorship and licensing contracts

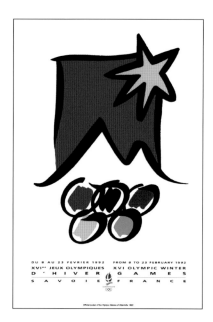

and the sale of exclusive broadcasting rights. The official poster (plate 118), produced by Agence Desgrippes & Associés (creative director Alain Doré), was a jaunty, cartoon-like design, outlining white-peaked mountains, a star-like sun and the brightly coloured Olympic rings against a backdrop of blue sky and white space. With its simplified lines and bold colouring, it had the immediate appeal of a tourist poster and its motif was widely used on brochures, publicity leaflets and official programmes. At the bottom it bore the official emblem designed by Bruno Quentin – the red and white flag of Savoie metamorphosed into the Olympic flame. Other official posters represented the Games' various venues and sporting disciplines, the mascot and the pictograms, as well as specific services.[104] The Albertville XVI Olympic Winter Games were the last to be held in the same year as the Olympic Games, following a change to the Olympic Charter in 1986, and the first Games to manifest the changes to the European political landscape following the overthrow of Communism in Central and Eastern Europe and the USSR in 1989–91. After many years of competition under the banner of the Soviet Union, the Baltic States of Estonia, Latvia and Lithuania appeared under their own flags, while other former Soviet states coalesced under the name of the Unified Team (EUN), and Germany competed as a united country once more. Cross-country skier Lyubov Yegorova (EUN) became the most successful woman athlete and ice dancers Marina Klimova and Sergei Ponomarenko (EUN) won gold medals at their third attempt.

By the 1990s, urban regeneration had become a *sine qua non* of the Olympic bid process, and it was perhaps most spectacularly achieved by Barcelona, whose successful bid for the 1992 Games led to an architectural renaissance that rejuvenated the city and transformed it into a top tourist destination. The main building projects were the Olympic facilities at Montjuïc, the Diagonal and Vall d'Hebron; the reopening of the city to its seafront through the construction of the Olympic Village (now a residential area) and the Barcelona ring roads that provided a transport network. The Montjuïc area, the low-lying hill overlooking Barcelona, was the main sporting focus, centring on the extensively refurbished Olympic Stadium (originally built for the 1929 Barcelona World Fair) and its Anella Olímpica (Olympic Ring) of venues. These included the newly built Palau Sant Jordi (named after the Catalonian patron saint) for gymnastic events, the renovated Bernat Picornell swimming pools, and the innovative telecommunications tower (1991), designed by Santiago Calatrava and built by the telephone company Telefónica to carry coverage of the Games.

Barcelona's bid also made much of the city's history and culture, and an ambitious four-year cultural programme of theatre, music, dance, film and exhibition was subsequently devised, planned by Olimpíada Cultural SA, a private company belonging to the Organizing Committee of the Barcelona Olympic Games 1992 (COOB'92). For IOC president Juan Antonio Samaranch, the choice of Barcelona in his native Catalonia was the realization of a personal dream, and as an advocate of the benefits of commerce, he welcomed the sponsorship, broadcasting and advertising deals that helped to fund this Olympiad. The Games were among the most successful of recent times, with no boycotts and more than 9,300 athletes

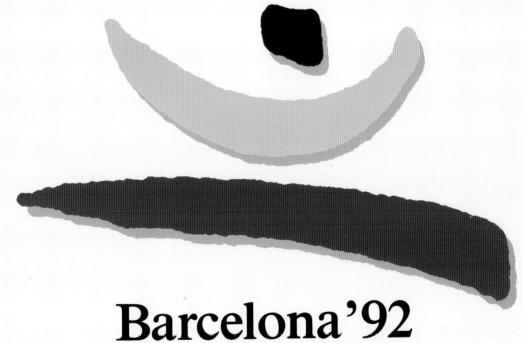

Barcelona'92

Jocs de la XXVa Olimpíada
Barcelona 1992

Juegos de la XXV Olimpíada
Barcelona 1992

Jeux de la XXVe Olympiade
Barcelona 1992

Games of the XXV Olympiad
Barcelona 1992

Plate 120
Barcelona 1992
'Barcelona '92'. Poster by Enric
Satué, one of four official posters
Published 1990
Colour offset lithograph
V&A: E.2610–2007

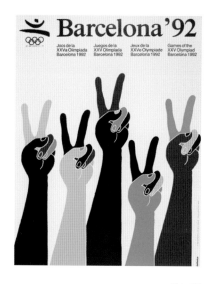

Plate 121
Barcelona 1992
'Games of the XXV Olympiad 1992'.
Poster from the designer series by
Arcadi Moradell
Published 1990
Colour offset lithograph
V&A: E.2606–2007

Plate 122
Barcelona 1992
'Cobi'. Poster by Javier Mariscal, one
of four official posters
Published 1990
Colour offset lithograph
V&A: E.2614–2007

representing 169 countries participating. The new political world order was made explicit during the opening ceremony, when the parade of teams included those of reunified Germany; of politically reformed South Africa, readmitted after 32 years, following the end of apartheid, and watched by Nelson Mandela; of newly independent Latvia, Estonia and Lithuania; of Croatia, Slovenia, and Bosnia and Herzegovina as separate nations, following the break-up of Yugoslavia; and of Cuba and North Korea, returning after 12 years. Stars of the Games were the gymnast Vitali Sherbo (EUN), who won six gold medals and had the flag of Belorussia raised at the victory ceremony, Earvin 'Magic' Johnson of the US basketball team and Britain's Linford Christie, who won the 100-metres final.

Recognizing the importance of posters in popularizing the event, identifying the host city and developing an aesthetic linked to the global image of the Games, COOB'92 launched an ambitious programme. A total of 58 posters were issued in four different collections: four official Olympic posters, painters' posters, designers' posters and photographic sports posters (28 photographs on a sporting theme chosen from 5,000 in the world's leading archives).[105] The official posters were by Josep M. Trias (emblem poster), Javier Mariscal (mascot poster), Enric Satué (plate 120) and Antoni Tàpies. Early in 1988 a jury had selected a design by Trias as the official emblem for the Games. It depicted a dynamic human figure, made up of three symbolic colours, leaping over the Olympic rings, incorporating the text 'Barcelona 92' printed in semi-bold in the classic Times New Roman typeface. A fragment of Mediterranean blue suggested the figure's head, a curve of yellow the arms outstretched in welcome and a strip of red (the colour associated with Spain) the vaulting legs. In a poster adaptation (plate 119), the figure 'flew' above a silhouetted skyline composed of famous Barcelona landmarks. The emblematic figure also influenced the design of the Barcelona pictograms, in which variations of Trias's figure were used. The poster by Mariscal, an artist whose work spans a range of media including humorous illustration, painting, sculpture, graphics and interior design, bore the image of 'Cobi', the surreal dog he had created in 1988 as Barcelona's official mascot (plate 122). The mascot's name, rendered in quirky typography, related to the acronym COOB'92 and was easy to remember in all languages. Home support for 'Cobi' was initially muted, but the mascot grew enormously in popular affection – and, as a piece of Olympic corporate identity, is recognized as one of the most successful of the modern Games.

For the designers' series, leading Spanish design companies and institutions selected 18 artists who represented the best of Catalan design. Among those selected were sculptor and painter Josep Pla-Narbona, who created a composition of sculpture-like figures moving across a blue sky like cirrus clouds (plate 123); graphic designer and illustrator Pere Torrent ('Peret'), who counts the work of Miró among his influences (plate 124); and Arcadi Moradell, whose abstract design made witty reference to the Olympic symbol (plate 121). The whole print run of the four collections (2,940,000 items) was produced under the sponsorship of Telefónica and the posters were distributed by COOB'92 free of charge. Signed limited editions in screenprint and lithography were also issued for the four official posters, and for

CoBi

Barcelona'92

Jocs de la	Juegos de la	Jeux de la	Games of the
XXVa Olimpíada	XXV Olimpíada	XXVe Olympiade	XXV Olympiad
Barcelona 1992	Barcelona 1992	Barcelona 1992	Barcelona 1992

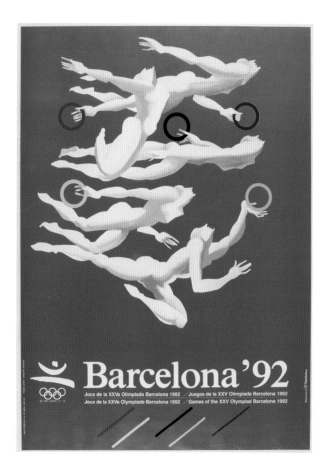

Plate 123
Barcelona 1992
'Barcelona '92'.
Poster from the designer
series by Josep Pla-Narbona
Published 1990
Colour offset lithograph
V&A: E.2609–2007

Plate 124
Barcelona 1992
'Games of the XXV Olympiad
Barcelona 1992'.
Poster from the designer
series by Peret (Pere Torrent)
Published 1990
Colour offset lithograph
V&A: E.2608–2007

the eight painters' posters by Eduardo Arroyo, Eduardo Chillida, Antoni Clavé, Jean-Michel Folon, Josep Guinovart, Robert Llimós, Guillermo Pérez Villalta and Antonio Saura. These were used as presentation gifts for VIPs.

In Lausanne in 1986 the IOC had voted to stagger the Olympic and Olympic Winter Games, so that henceforth they would be separated by two-yearly intervals; this was partly so that advertising and broadcasting deals could be more advantageously spread. To adjust to the new schedule, the XVII Olympic Winter Games were to be held in 1994, only two years after Albertville. At the IOC Congress in Seoul in 1988, the town of Lillehammer in Norway was selected to host these Games in preference to Anchorage (USA), Östersund/Åre (Sweden) and Sofia (Bulgaria). The Norwegians' innate love of winter sports, combined with a sensitivity to the environment, enabled them to transform the venue, which then had a population of only 23,870, into a top-class Olympic setting in harmony with the landscape and designed for a sustainable future. Local hero Johann Koss fittingly won three speed-skating events, setting a world record in each. Notable among the 67 nations that competed were independent teams from Georgia, Russia and Ukraine and other former republics of the Soviet Union, and South Africa, competing in Olympic winter sports for the first time since 1960.

The visual identity concept for Lillehammer aimed to emphasize Norway's distinctive features, traditions and national character, the spirit of community

Plate 125
Lillehammer 1994
Lillehammer '94. Official poster by
DesignGruppen '94
Colour offset lithograph
Olympic Museum Lausanne
Collections

among people, and the close link between people and nature. The official emblem, designed by Sarah Rosenbaum, combined a stylized image in white and cobalt blue of the aurora borealis (the natural phenomenon signifying Norway's northerly location) and a snow flurry, with the Olympic rings and the text 'Lillehammer '94' in Century Old Style typeface. It appeared on the posters and was one of the basic visual elements in a unified design programme. Some of the pictogram emblems in this programme, such as the image of a twig to convey the Lillehammer Olympic Organizing Committee's environmental profile and a 'torch man' ('Fakkelmannen') to designate the torch relay, also appeared on the official posters produced by the Committee's design programme.[106] The official poster (plate 125) had the torch bearer as the main motif with the graphic surface treated to give a rough natural effect. Pictograms, including sports symbols inspired by Norwegian rock carvings, were spread across the design.

Plate 126
Atlanta 1996
'Atlanta'.
Official poster by Primo Angeli
Published by Fine Art Ltd, St Louis, MO
Colour offset lithograph
V&A: E.307–2006

One hundred years after the modern Olympic Games were inaugurated in Athens in 1896, the centennial Games of 1996 were awarded not to a city steeped in classical tradition but to Atlanta, the populous metropolitan capital of Georgia. Some criticized the choice, believing it to be influenced by the commercial interests of corporate sponsor Coca-Cola, whose home city it was. In spite of a shocking start, when a bomb exploded in Centennial Olympic Park, it was agreed that the Games should proceed in Olympic spirit and a festive atmosphere was recreated. Enduring images were the lighting of the Olympic torch by Muhammad Ali (the former Cassius Clay) despite his affliction by Parkinson's disease, and the athletic feats of Michael Johnson (USA), who won both the 200 and 400 metres, and of his fellow countryman Carl Lewis, who took a ninth gold medal by winning the long jump.

A key element of Atlanta's bid to win the Games had been the diversity of America's peoples and nations, and this theme was carried through into the planning of the Cultural Olympiad, a four-year programme which aimed to be large and inclusive, diverse in concept, and celebratory of the rich arts and culture of the American South.[107] The encouragement of diversity also played a role in the poster programme, which the Atlanta Committee for the Olympic Games (ACOG) developed with the guidance of its Art Direction Division. Artists and graphics designers were selected to contribute to four poster series, some of which were also issued by Fine Art Limited as limited edition prints on higher-quality paper. The categories were 'Sports' (a poster for each Olympic sport by the artist Hiro Yamagata), 'Designer'

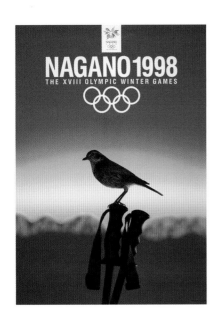

Plate 127
Nagano 1998
'Thrush'. Official poster by
Masuteru Aoba for Nagano, 1998
Printed in Japan, 1994
Colour offset lithograph
V&A: E.3184–2007

(13 images by graphic designers capturing some aspect of the Olympic spirit), 'Look Team' (by the six firms involved in the look of the Games, which included the pictograms) and 'Artist' (11 works based on artists' paintings that freely interpreted the Olympic spirit). A key requirement was that any images of competing athletes should be free of specific country markings or national flags.[108] Following this precept, the official poster (plate 126) by Primo Angeli, one of the original 'Look' designers, showed an androgynous athlete profiled against four 'Olympic' colours and patterned by the stars and flames of the Atlanta torch-mark emblem (designed by Landor Associates of San Francisco). This poster was selected as the official poster by IOC president Juan Antonio Samaranch only one week before the Games opened.

A thought-provoking statement on the theme of diversity was the poster 'Paralympics Atlanta 1996' (plate 128) by the Danish artist Per Arnoldi, commissioned by the Danish Committee for the Paralympics in aid of its involvement in the Atlanta Games of 1996. Arnoldi welcomed the invitation, believing that the Paralympic Games represented the true spirit of Olympic participation. Taking the conspicuously smooth and perfect symbol of the five linked Olympic rings, he subverted it into a different symbol made up of other geometric shapes to represent diversity. Nevertheless, these forms are still interwoven and, in Arnoldi's words, 'still clinging together for mutual acceptance and understanding'.[109]

The final Olympic Winter Games of the twentieth century were held in 1998 in Nagano, historic capital of Japan's Nagano Prefecture and set in a mountainous area of outstanding natural beauty known as the 'Roof of Japan'. These were the third Olympic Games to be held in Japan, and Nagano was the most southerly winter venue to date. As a centre for excursions and an established ski resort, it was able to adapt as athletes, team officials and thousands of spectators converged upon the area. For the Japanese athletes it was their most successful Olympic Winter Games ever; in the 68 events in seven sports, they won five gold medals and 10 medals in total. The Nagano Olympic Organizing Committee (NAOC)'s 'Vision for the Nagano Games' expressed ideals of 'respect for the beauty and bounty of nature' and 'furtherance of peace and goodwill', while the three fundamental goals were 'Participation of Children', 'Homage to Nature' and 'Festival of Peace and Friendship'.[110] Posters played a role in promoting these themes, with leading Japanese artists and designers commissioned to create five posters and seven sport-specific posters. In addition, for the first time at the Games, a special poster was designed for the opening ceremony. This reproduced the scroll painting 'Winter Landscape' by the fifteenth-century master Sesshu, an image felt to represent the ceremony's three keywords: 'Simple', 'Dignified', 'Spiritual'. In keeping with NAOC's desire for a Games in harmony with nature, the poster designated afterwards as official (plate 127) was a photomontage entitled 'Thrush' by Masuteru Aoba, combining the themes of sport, winter and nature. Aoba, a graduate of the Kuwasawa Design School, established the Masuteru Aoba Design Office in Tokyo in 1969 and has won many international awards for advertising, graphic and poster design.

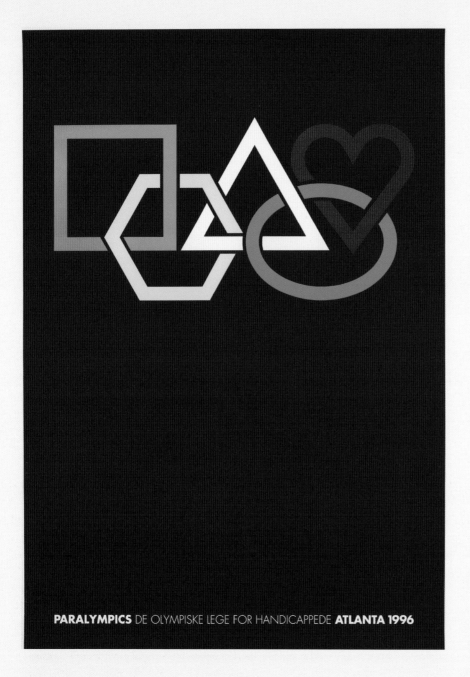

Plate 128
Atlanta 1996
'Paralympics Atlanta 1996'.
Poster by Per Arnoldi, commissioned
by the Danish Committee for the
Paralympic Games of 1996, 1995
Printed by Saloprint
Colour offset lithograph
V&A: E.361–2006

PARALYMPICS DE OLYMPISKE LEGE FOR HANDICAPPEDE **ATLANTA 1996**

Diversity

The image of the young, physically 'perfect', white male athlete dominated the early years of the Olympic Games. Gradually this archetype has been displaced, reflecting not only the growing internationalism of the Games, particularly since the 1950s, but also changing attitudes to gender, race, class, age and ability. The sense of exclusion from the official Games felt by particular groups in society has led to the founding of a number of alternative Games, which in turn has influenced the way the established Games are portrayed.

Although the initiator of the modern Olympic Games, Pierre de Coubertin, did not originally believe that women should take part in open contests before the public, and the issue was the subject of much debate,* women did compete in the early Games from the II Olympiad in a limited number of sports. In the Paris 1900 Games this included golf and tennis

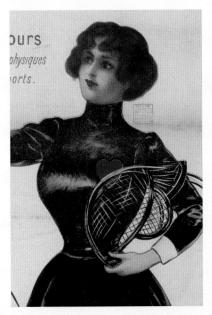

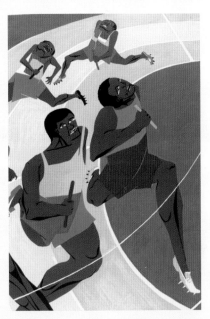

Plate 3 (p.12), detail
Paris 1900

Plate 79 (p.86), detail
Munich 1972

Plate 129
**'Olimpiada Popular Barcelona
19-26 de Juliol 1936'**
Poster by F. Lewy ('LY'), 1936
Colour lithograph
Courtesy of Jordi Carulla

– but not, in spite of being splendidly represented on a poster (plate 3), fencing. Women were not allowed to compete in athletic events until Amsterdam 1928. It was only in 1948 that there was a clearly marked increase in the participation of women, famously personified by Fanny Blankers-Koen, who won four gold medals at the London post-war Games. In spite of such sporting triumphs, women have rarely been depicted on Olympic posters.

The depiction of black athletes on official posters has been similarly rare but, making a pictorial statement for the Munich 1972 Games, the African-American artist Jacob Lawrence memorably portrayed black relay runners in the tense final moments of their race (plate 79). At a much earlier date, an inspiring vision of diversity and egalitarianism was presented by posters for the People's Olympiad, the alternative Games planned for Barcelona in 1936 (see p.47 and plate 129).

The Gay Games, a sporting and cultural event hosted by the gay and lesbian community, were started in San Francisco in 1982 by gay-rights activist Tom Waddell. His guiding principle was that 'to do one's personal best is the ultimate goal of all human achievement' and he competed at the 1986 Gay Games despite his ongoing battle with HIV/AIDS.

The idea of Paralympic Games was conceived when, in 1948, neurologist Sir Ludwig Guttmann organized a sports competition at Stoke Mandeville Hospital in England for patients with spinal injuries; he passionately believed that access to sport helped to build physical strength and self-respect. Olympic-style games for athletes with spinal cord injuries were organized for the first time in Rome in 1960. In Toronto in 1976 other disability groups were added and the idea of merging together different disability groups for international sports competitions developed. The Paralympic Games have always been held in the same year as the Olympic Games and, since the 1988 Seoul Games, they have also taken place at the same venues. Per Arnoldi's poster relating to the Paralympic Games in Atlanta in 1996 symbolizes their unique contribution to Olympic participation and endeavour (plate 128). Most recent initiatives, such as the 'Special Olympics' for people with a learning disability and the 'Senior Olympics', have further broadened our understanding of human sporting achievement.

* See Arnd Kruger, 'Forgotten Decisions: The IOC on the Eve of World War I', in Olympika: The International Journal of Olympic Studies (1997), vol.VI, pp.92–3.

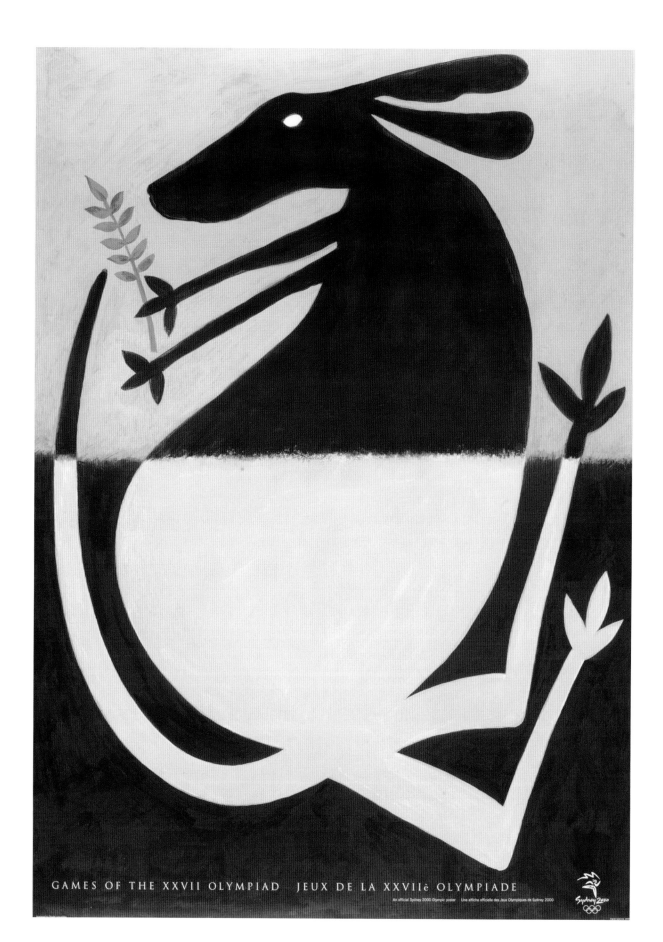

GAMES OF THE XXVII OLYMPIAD JEUX DE LA XXVIIè OLYMPIADE

An official Sydney 2000 Olympic poster Une affiche officielle des Jeux Olympiques de Sydney 2000

Sydney 2000

Plate 130
Sydney 2000
"'Peace Roo'.
Games of the XXVII Olympiad'.
Official Design Poster no.1
by David Lancashire
Printed by Ink Group Publishers,
Sydney, 1999
Colour offset lithograph
V&A: E.353–2006

This Millennium

A keenly fought contest took place for the right to host the historic millennium Games of 2000, the Games of the XXVII Olympiad, but at an election held in Monte Carlo in 1993 the final vote went to Sydney in New South Wales, ahead of Beijing, Berlin, Istanbul and Manchester. The Games therefore came to Australia for the second time, and proved an exuberant occasion, with 10,651 competitors from 199 nations participating.

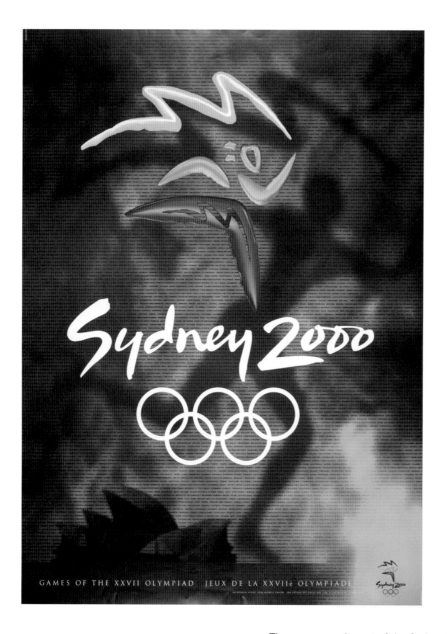

Plate 131
Sydney 2000
'Sydney 2000'.
Emblem poster by FHA Image Design
Published 1999
Colour offset lithograph
V&A: E.308–2006

The core commitment of the Sydney bid was to deliver 'the athletes' Games', recognizing them as the stars, while emphasizing Australia's love of sport and admiration for sporting achievement. Memorable moments included the lighting of the Olympic flame by Cathy Freeman, an Aboriginal Australian who later went on to win a gold medal in the 400 metres, and Britain's Steve Redgrave winning his fifth consecutive gold medal for rowing. Features of Sydney's bid were the concentration of Olympic venues in the Sydney Olympic Park at Homebush Bay (a transformed development area) and in the Sydney Harbour Zone; also the location of all the athletes and team officials together in one Olympic Village. Within the cultural programme a four-year arts festival was planned that focused on Australia's indigenous and multicultural heritage. The Sydney Organizing Committee for the Olympic Games (SOCOG) also worked closely with the Sydney Paralympic Organizing Committee to plan the XI Paralympic Games that were held in the same year.

Following the trend towards increasingly sophisticated and integrated poster schemes, SOCOG committed itself to a wide-ranging official poster programme, aiming to reflect a diversity of styles by commissioning designers from a wide range of creative and cultural backgrounds. The programme had four main components: 'Art' (eight fine art prints produced in limited editions of 99, available in boxed presentation sets); 'Children's Art Programme' (chosen from thousands of entries submitted by schoolchildren); 'Sport Posters' (eight sports posters produced in limited editions of 2,000 on archival paper, made for presentation purposes rather than for general commercial sale); and 'Design Posters' (whose eight designers/ illustrators were nominated and commissioned by SOCOG's selection committee of design experts). The last three categories were all produced by the Ink Group, Sydney. Within the 'Design' series were imaginative works by Ken Cato, Mimmo Cozzolino and Phil Ellett, Andrew Hoyne, David Lancashire (plate 130), Michael Leunig, Mambo Graphics Pty Ltd, Barrie Tucker (plate 132) and Lynda Warner (plate 133). In addition to the above categories, there were poster sets advertising SOCOG's arts and cultural events and further series of licensed sports posters.

SOCOG also commissioned an official mascot poster, designed by Mark Sofilas and Matthew Hatton, which depicted the characters 'Millie' (Millennium), 'Syd' (Sydney) and 'Ollie' (Olympics), and an official emblem poster, for which the brief was to create a highly collectable poster 'which reflects the Australian attitude, movement and originality'.[111] The chosen image by FHA Image Design (plate 131), design consultants for the look of the Games, featured the Games' emblem of an athlete, sometimes known as 'Millennium Man', made up of freely drawn boomerang shapes. The flare from the figure's torch echoed the 'sails' of the Sydney Opera House, which was shown below, and the blue background suggesting the waters of Sydney Harbour was lettered with the names of the participating nations.

Plate 132
Sydney 2000
'"Citius Altius Fortius"
["Faster Higher Stronger"].
Games of the XXVII Olympiad'.
Official Design Poster no.5
by Barrie Tucker
Printed by Ink Group Publishers,
Sydney, 1999
Colour offset lithograph
V&A: E.351–2006

Plate 133
Sydney 2000
'Games of the XXVII Olympiad'.
Official design poster no.3
by Lynda Warner
Printed by Ink Group Publishers,
Sydney, 1999
Colour offset lithograph
V&A: E.352–2006

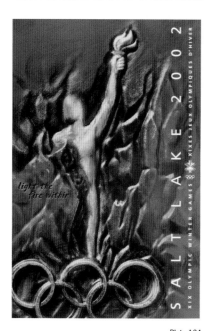

Plate 134
Salt Lake 2002
'Salt Lake 2002'.
Poster by Axiom Design
(Justin Reynolds and Scott Sorenson)
Published by Fine Art Ltd, c.2000
Colour offset lithograph
Olympic Museum Lausanne Collections

Plate 135
Salt Lake 2002
'Salt Lake 2002'. Poster by Axiom
Design (creative director Brent Watts),
commissioned by the
Salt Lake Organizing Committee
Published by Fine Art Ltd, 2001
Colour offset lithograph
Olympic Museum Lausanne Collections

Salt Lake City's winning bid for the XIX Olympic Winter Games of 2002 was the venue's sixth attempt – the first was made for the 1932 Games that went to Lake Placid – but certain bid tactics came under investigation. Vigorous promotion, especially to the American market, resulted in financial success for these Olympic Winter Games, while the opening ceremony, inaugurated by President George W. Bush, played to the home audience with LeAnn Rimes's rendition of 'Light the Fire Within' (theme song of the Games), the Mormon Tabernacle Choir performing the 'Star-Spangled Banner' and tenor Daniel Rodriguez (a NYPD officer who witnessed the Twin Towers outrage in 2001) singing 'God Bless America'. In the sporting arena, expanded to 78 events, Australian skater Steven Bradbury won gold after all his main competitors crashed in the finals of the short-track event, 'skeleton' (head-first tobogganing) returned as a medal sport for the first time since 1948 and the emerging 'extreme' sport of snowboarding caught the public eye.

The visual and written vocabulary for the Games was developed by Creative Services, essentially the Games' in-house advertising and design agency, and was applied to design, publications, advertising, photography and film. Together with the 'Look of the Games' and 'Ceremonies' functions, Creative Services worked under the management of the Creative Group to explore the application of the common theme of 'Light the Fire Within' and the development of the visual identity of 'fire and ice' (this last symbolizing the contrast of Utah's desert-to-mountain landscape). The image for the official poster chosen by the Salt Lake Organizing Committee (plate 135), designed by Axiom DC (creative director Brent Watts), evolved out of the design concept for the Games' medals and portrayed a torch-bearing athlete breaking free like a flame from a mountain of ice and rock. Within the lettering was emblazoned the crystal emblem – a composite snowflake in the orange, red and blue of the Games' colour palette. Retrospectively, the IOC conferred official status on an earlier promotional poster, conceived by Justin Reynolds of Axiom (plate 134), which used the same 'fire and ice' palette in its photomontage of a flag (bearing the approved symbols) billowing against the backdrop of Mount Superior in the Wasatch range.

For Athens the staging of the 2004 Olympiad was viewed as a homecoming and a celebration of Greece's ancient heritage, and also as a showcase for a thriving modern country. The torch relay took on extra significance as the Olympic flame was carried around the Peloponnese and the islands of Argosaronikos for seven days before beginning a global journey of a further 35 days, so that people around the world could share in the return of the Games to their national birthplace. Athletes competed on the plains of Olympia, runners followed the legendary course of the messenger Pheidippides from Marathon to Athens, and ceremonies took place in the ancient white marble Panathinaiko Stadium. Meanwhile, the centrepiece for the Games was the modern Athens Olympic Sports Complex (1991), revitalized by the Spanish architect Santiago Calatrava with the addition of suspended arched roofs, entrance plazas and canopies, a central axis, an undulating Wall of Nations and an arcaded structure reminiscent of an ancient agora or marketplace. Over 11,000 athletes from 201 nations competed in a sporting event that had a notional

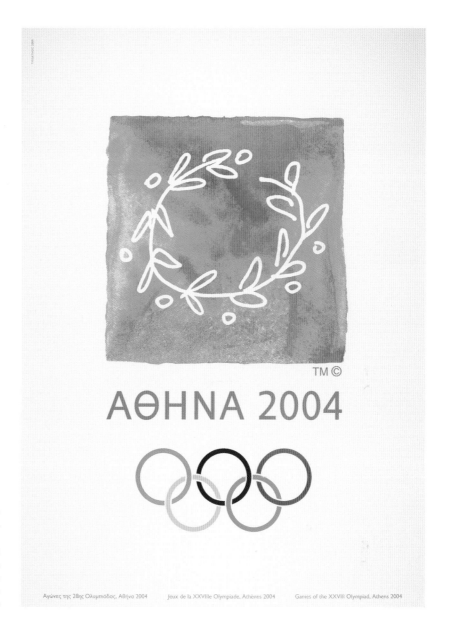

Plate 136
Athens 2004
'ΑΘΗΝΑ 2004' (Athens 2004).
Poster featuring the emblem designed
by Wolff Olins in collaboration with
Red Design Consultants
Colour offset lithograph
V&A: E.230–2006

television audience of 3.9 billion viewers. Stars of the Games were Moroccan Hicham El Guerrouj, who won the 1,500 and 5,000 metres, and Britain's Kelly Holmes who triumphed in the women's 800 and 1,500 metres.

The Athens 2004 'Look' of the Games played to the themes of Greece's ancient civilization and modern progress: the sport pictograms, for example, were inspired by the forms of ancient Cycladic figures, while site decoration and street banners were in a four-colour palette drawn from natural colours found in the Greek landscape. The official emblem, which was also the subject of a poster (plate 136), was a simple, freely drawn image of an ancient *kotinos* or olive wreath, executed in the Greek national colours of blue and white. Designed by pioneering British brand consultancy Wolff Olins in collaboration with the Greek company Red Design Consultants, this logotype sought to express the spirit of the original Games, avoiding the contemporary emphasis on commerce and merchandising, and evoking ancient times, when victors were crowned with olive wreaths – a custom reinstated

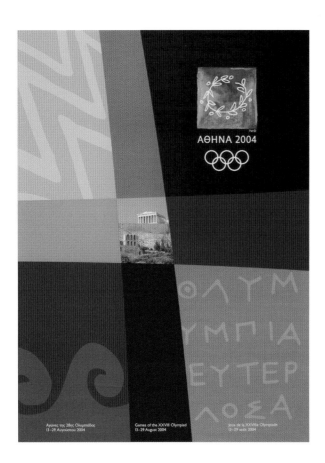

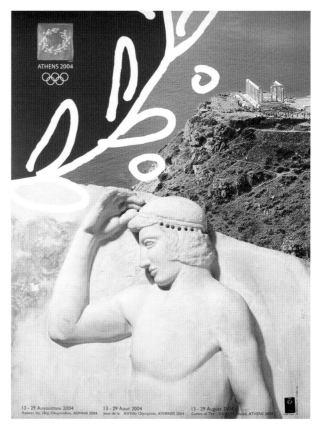

Plate 137
Athens 2004
'AΘHNA 2004' (Athens 2004).
Poster designed by the Image and Identity
Department of the Athens
2004 Organizing Committee for the
Olympic Games Communications Division
Colour offset lithograph
Olympic Museum Lausanne Collections

Plate 138
Athens 2004
'AΘHNA 2004'. Anonymous poster
reproducing a relief of about 460 BC
found near the Temple of
Athena in Sounion
Printed by Editions M. Toubis SA, Athens
Colour offset lithograph
V&A: E.418–2007

at the 2004 Games. Its colours suggested the shimmering Aegean Sea or sky. The emblem was chosen by committee from 690 entries sent in by 242 participants from 14 different countries. From the moment it was revealed in 1999, it became a key element of the image and identity programme, finding its way on to medals, stamps, pins, posters (plates 137 and 138) and other ephemera. The poster programme also included a limited edition of 28 posters commissioned from established Greek artists, and a sports series.

For the industrial city of Turin, with its enclosed location at the foot of the Italian Alps, progress was on the agenda when it seized the opportunity of hosting the 2006 Olympic Winter Games, seeing this as a way of opening itself to new audiences and re-presenting itself as a dynamic and avant-garde cosmopolitan centre. Over 2,500 athletes from 80 nations competed, with the Austrians dominating Alpine skiing and the South Koreans short-track speed skating. Once Turin had been selected by the IOC, the Turin Olympic Organizing Committee (TOROC) asked Iconologic, an Atlanta-based design company which had designed the look of the Games for Atlanta 1996, to work with them to develop the look of the Turin Games. Iconologic (lead designer Elise Thomason) created a graphic system, beginning with the sport pictograms, to symbolize the different sports that made up the Olympic Winter Games. These bold and fluid compositions were a homage to the aerodynamic sleekness of Italian design and were incorporated throughout, into banners, medals, entry tickets, uniforms and venue sites, so becoming integral to Turin's Olympic landscape. They were also used as images for a series of posters (plate 140) published by Bolaffi SpA, Italy. However,

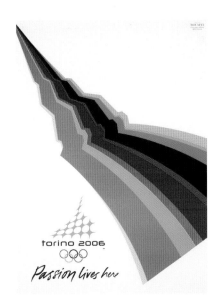

Plate 139
Turin 2006
'Torino 2006.'
Official poster by Armando Testa
(design agency)
Published by Bolaffi SpA
Colour offset lithograph
V&A: E.3644–2007

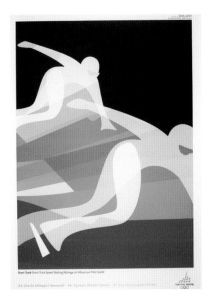

Plate 140
Turin 2006
'Short Track Speed Skating'.
Poster by Iconologic
(lead designer Elise Thomason)
Published by Bolaffi SpA
Colour offset lithograph
V&A: E.419–2007

the official poster for Turin 2006, a stylized view of the Mole Antonelliana, Turin's landmark building, tilted into a downhill ski slope, was designed by the Italian design agency Armando Testa (plate 139).

From the moment at the IOC meeting in Moscow on 13 July 2001, when Beijing was selected as the host city for the 2008 Games, with the recommendation that the 'Beijing Games would leave a unique legacy to China and to sports', the world looked with mounting excitement at what China would achieve. The Beijing Organizing Committee for the Games of the XXIX Olympiad (BOCOG) was established on 13 December 2001 to organize both the XXIX Olympiad and the XIII Paralympic Games, and by spring 2007 ambitious plans in tune with China's burgeoning economy were well under way. The incorporation of high-profile international practices was a key element in the architectural vision for the Games: among the venues designed were the National Aquatics Centre, the Olympic Village, the National Indoor Stadium, the Main Press Centre, the Fencing Hall, the International Broadcast Centre, a Media Village and the Games' chief venue, the National Stadium. Known as the 'Bird's Nest', this stadium, one of the world's largest enclosed spaces with a spectator capacity of 100,000, was designed by Swiss architects Herzog & de Meuron (architects for Tate Modern), with contemporary Chinese artist Ai Weiwei as the artistic consultant, to provide a dramatic stage for Beijing's opening and closing ceremonies and track and field competitions.

In advance promotion for the Games, the official emblem was chosen after an open competition that elicited nearly 2,000 designs. 'Chinese Seal – Dancing Beijing', which also featured on a poster (plate 141), was developed by the Beijing Armstrong International Corporate Identity Co. Ltd (AICI) in collaboration with the Beijing Organizing Committee. It depicted a dancing human figure resembling the Chinese character 'jing', so referring to the host city's name Beijing (north capital). The figure, arms outstretched in a welcoming gesture, was delineated in white on red (a symbolic colour for China) within the form of a Chinese seal; above the Olympic symbol appears the text 'Beijing 2008' in bold cursive brushstrokes evoking

第 29 届奥林匹克运动会组织委员会
Beijing Organizing Committee
for the Games of the XXIX Olympiad

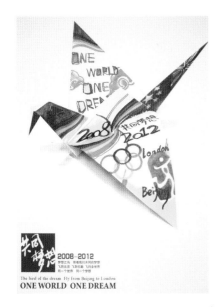

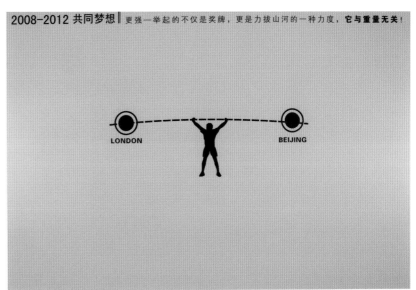

Posters for a poster competition organized in 2005 by the Cultural and Education Section of the British Embassy in Beijing and the Beijing Industrial Design Promotion Organization, 2005

Plate 142
'Bird of Dream'.
Poster by Wu Zheiwei.
Colour offset lithograph
V&A: FE.25–2006

Plate 143
'Stronger'.
Poster by Liu Wenrong.
Colour offset lithograph

Plate 144
'Ultimate Dream'.
Poster by Lu Jing.
Colour offset lithograph
V&A: FE.20–2006

(opposite page)
Plate 141
Beijing 2008
"'Chinese Seal – Dancing Beijing".
Beijing 2008'. Emblem poster by
Beijing Armstrong International
Corporate Identity Co. Ltd.
Colour offset lithograph
V&A: E.231–2006

Chinese calligraphic characters. In this vigorous design, well-known elements from traditional Chinese culture are represented together with a symbol of the Olympic ideal, to provide a dynamic visual identity for the Games.

Poster projects before the Games included a display of about 300 Olympic-themed posters, designed by college students around China, held in the Beijing Jintai Art Gallery in 2003 as part of the celebrations to mark the second anniversary of the city's successful Olympic bid. Another initiative was a poster competition organized in 2005 by the Cultural and Education Section of the British Embassy in Beijing and the Beijing Industrial Design Promotion Organization, inspired by the Games' theme, 'One World One Dream', and linking the common goals of Beijing 2008 and London 2012 (plates 142–4).

The graphic identity of the Vancouver 2010 Winter Olympic and Paralympic Games began with the selection of the emblem *Ilanaaq*, the Inuktitut word for 'friend'. It was a contemporary interpretation of the *inukshuk*, a stacked rock in human form, of the kind that the Inuit people of Canada's Arctic had constructed over time to act as guideposts across the vast territory of the North. The emblem, symbolizing hope and friendship, was designed by Rivera Group of Vancouver and selected by an international jury from 1,600 entries submitted in competition. Following the unveiling of this emblem, a pre-Games graphic identity (developed by Karacters Design Group) used colours and shapes to convey Canada's dramatic coast, forests and mountain peaks, while abstract urban graphics and digitally inspired elements were employed to represent the country's modern cities and technological innovation. Vancouver 2010's internal design team is now working on the development of the Look of the Games, which will present an evolution of the pre-Games Look, and will incorporate new elements such as pictograms, mascots and the Games theme.

Regenerating the urban environment, stimulating economic growth and improving infrastructure remain prime motivations for would-be Olympic venues. Directly or indirectly, posters have been variously used to promote such aims, both to elicit support at home and as statements of intent in the bidding process. The bid by London to host the 2012 Olympic Games (the XXX Olympiad) began in 2003, gathering momentum in 2004, with London narrowly beating Paris by 54 votes to 50 at the IOC meeting in Singapore on 6 July 2005, after bids from Madrid, Moscow and New York had been eliminated. This will be the third time that the Games have come to the city. A series of six 'Back the Bid' posters designed by M&C Saatchi was an integral part of the campaign, the concept founded on the idea that the Games would represent a giant leap forward for London and the UK. Each photomontage features an athlete who transforms a London landmark into a component of a sporting activity, so that Tower Bridge, for example, represents a

plate 146

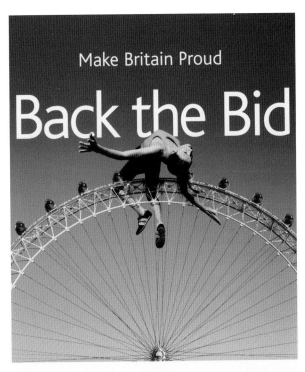

plate 147

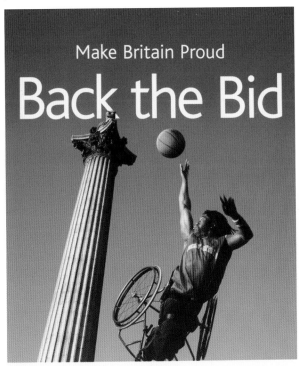

plate 148

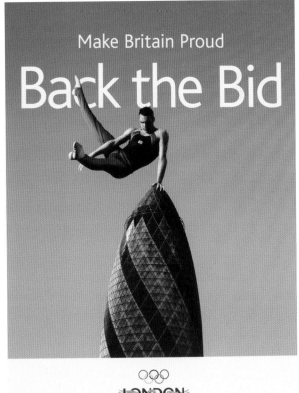

plate 149

hurdle (plate 146) and the London Eye a high jump (plate 147), while Paralympic athlete Ade Adepitan, a member of the British wheelchair basketball team, aims his shot at Nelson's Column (plate 148). The campaign's use of such well-known London locations as the London Eye – at the time of its building (it opened in March 2000) the biggest observation wheel in the world – and the Swiss Re Building – known as 'the Gherkin' (plate 149) – both encouraged home support and associated London's Olympic bid with architectural flair and urban enterprise. The posters, in many formats, were displayed across the capital, from vast outdoor city-centre sites to schools and doctors' surgeries.

Once the 2012 Games were awarded to London, the London Organising Committee (LOCOG) defined their ambition to create a Games for everyone, with everyone invited to take part in and enjoy the world's most exciting sporting event. The brand was launched on 4 June 2007, when the London 2012 emblem (plate 150) was first revealed, provoking an extraordinary public reaction. Design critics filled the pages of newspaper arts columns and design magazines with their views.[112] The emblem was conceived as simple yet distinct, bold and buzzing with energy, in the spirit of the Games; its shape was based on the universally understandable numerals '2012'. It is intended to be used across a range of applications, from mobile phone screens to projections onto the sides of buildings, and may appear as some kind of poster, though perhaps not in a conventional format.

The fact that this work of graphic design has the power to stimulate passionate debate testifies to people's engagement with the Olympic Games, with the aesthetics of design and with the way that a city represents itself both to itself and to the world. These are surely the same reasons why, for over a century, posters have been powerful agents in creating awareness, building expectation and providing a visual celebration of the Olympic Games, and why – in some form or other – they are likely to continue to do so in the future.

Plate 150
London 2012
Emblem by Wolff Olins (est.1965; designers: Patrick Cox, Luke Gifford)
Courtesy of London 2012/ International Olympic Committee

Endnotes

1 Pierre de Coubertin in Pierre de Coubertin, Timoleon J. Philemon, N.G. Polites and Charalambos Anninos, *The Olympic Games: B.C. 776–A.D. 1896. Second Part, The Olympic Games in 1896* (Athens, 1897), p.2.

2 Ibid., p.4.

3 Ibid.

4 Ibid., p.8.

5 Lines from Thomas Heywood (Poem XXXIV), 'A Panegerick to the Worthy Mr. Robert Dover', ll.21–23, quoted in Francis Burns (ed.), *Robert Dover's Cotswold Olimpick Games: 'Annalia Dubrensia' (1636) and Other Poems* (Chipping Campden, 2004), p.48.

6 Pierre de Coubertin, 'Les Jeux Olympiques à Much Wenlock', *La Revue Athlétique* (25 December 1890), vol.1, no.12, pp.705–13.

7 Eugene P. Andrews, 'A First-Hand Account of the First of the Modern Olympic Games', *Cornell Alumni News* (December 1972).

8 S.P. Lampros, N.G. Polites, Timoleon J. Philemon and Pierre de Coubertin, *The Olympic Games: B.C. 776–A.D. 1896* (Athens, 1896–7).

9 Pierre de Coubertin in Coubertin et al., *The Olympic Games, B.C. 776–A.D. 1896. Second Part*, p.1.

10 Ibid.

11 Ministère du Commerce, de l'Industrie, des Postes et des Télégraphes, *Exposition Universelle Internationale de 1900 à Paris, Concours Internationaux d'Exercices Physiques et de Sports. Rapports*, 2 vols (Paris, 1901–2).

12 Ibid., vol.II (Paris, 1902), p.9.

13 The Louisiana Purchase was the acquisition by the United States of about 530 million acres of territory from France in 1803.

14 British Olympic Council, *The Fourth Olympiad being the Olympic Games of 1908 celebrated in London* (London, 1909), pp.20–21.

15 See minutes of the British Olympic Council for 6 June 1907, 24 October 1907 and 17 June 1908.

16 Described by Richard Stanton in *The Forgotten Olympic Art Competitions* (Victoria, BC, 2000), pp.1–16.

17 Don Anthony 'Britain and the Greeks', *Olympic Review* (February–March 1996), vol.XXV, no.7, pp.66–7.

18 Swedish Olympic Committee, *The Fifth Olympiad: The Official Report of the Olympic Games of Stockholm 1912*, ed. Erik Bergvall, trans. Edward Adams-Ray (Stockholm, 1913), pp.264–7.

19 The Archives of the Stockholm Olympics 1912 in the National Archives of Sweden, Stockholm, contain documents concering Hjortzberg's poster, as well as a previous draft proposal that he submitted (a watercolour drawing), which is very different from the final official poster.

20 This coloured chalk design is in the collection of the Swedish Central Association for the Promotion of Sport, Stockholm.

21 Swedish Olympic Committee, *The Fifth Olympiad*, pp.266–7.

22 Ibid., p.266.

23 Ibid.

24 Ibid., pp.806–11.

25 Stanton, *The Forgotten Olympic Art Competitions*, pp.30–33.

26 Extracts from letter to Kristian Hellström, Secretary of the Swedish Olympic Committee, 31 January 1911. In IOC Archives (translation from French by the author).

27 The poem is quoted in full in the Swedish Olympic Committee, *The Fifth Olympiad*, pp.809–11.

28 The decisions of this congress are described by Arnd Krüger in 'Forgotten Decisions: The IOC on the Eve of World War I', *Olympika: The International Journal of Olympic Studies* (1997), vol.VI, pp.85–98.

29 The poster is no. 144 in Dick Dooijes and Pieter Brattinga, *A History of the Dutch Poster 1890–1960* (Amsterdam, 1968).

30 Information taken from 'The History of the Netherlands Olympic Committee (1912–1993)', compiled by Ton Bijkerk, Ruud Paauw and Theo Stevens, http://www2.sport.nl/boek.php3?hfdlabel=english_version_history_noc.

31 See Roland Renson and Marijke den Hollander, 'Sport and Business in the City: The Antwerp Olympic Games of 1920 and the Urban Elite', *Olympika: The International Journal of Olympic Studies* (1997), vol.VI, pp.73–84.

32 Karle Scheerlink dated the original drawing for the poster to 1914 or earlier, since the same image (without the text) was used for the cover of the brochure 'Aurons-nous la VIIième Olympiade à Anvers en 1920?', printed in Antwerp by J.E. Buschmann in 1914: see K. Scheerlinck and R. Lucas, 'Antwerpen Geplakt: Vooroorlogse Antwerpse affichekunst', catalogue for exhibition held at the Archief en Museum voor het Vlaamse Cultuurleven in Antwerp, 1993 (cat.25, p.100). There is no evidence of Van Kuyck's name on the poster, which is signed 'Walter Van der Ven & Co., Anvers'. The brochure cover illustration is lettered with the initials *MVDV*.

33 Robert F. Wheeler, 'Organized Sport and Organized Labour: The Workers' Sports Movement', *Journal of Contemporary History*, special issue: Workers' Culture (April 1978), vol.13, no.2, p.196.

34 The Union of DTJ – Dělnická Tělovýchovná Jednota (Workers' Gymnastics Association) – was a socialist organization that had its origins in Prague in 1892, became an association in 1903 and 20 years later had more than 11,000 associations and 117,000 members.

35 See Christopher Wilk, 'The Healthy Body Culture', in *Modernism: Designing a New World* (London, 2006), pp.250–94.

36 From Pierre de Coubertin, 'Mens Fervida in Corpore Lacertoso', Foreword to *Les Jeux de la VIIIe Olympiade Paris 1924. Rapport Officiel* (Paris, 1924).

37 Netherlands Olympic Committee, *The Ninth Olympiad being the Official Report of the Olympic Games of 1928 celebrated at Amsterdam* (Amsterdam, 1928), p.217.

38 III Olympic Winter Games Committee, *Official Report of the III Olympic Winter Games* (Lake Placid, 1932), pp.96–9.

39 Quoted in David Clay Large, *Nazi Games: The Olympics of 1936* (New York and London, 2007), p.54.

40 Xth Olympiade Committee of the Games of Los Angeles, USA, Ltd, *The Games of the Xth Olympiad Los Angeles 1932: Official Report* (Los Angeles, 1933), pp.749–65.

41 Ibid., pp.213–14, p.220 (illus.).

42 Organisationskomitee für die XI. Olympiade Berlin 1936 EV, *The XIth Olympic Games Berlin, 1936: Official Report* (English-language version), vol.1 (Berlin, 1937), p.352.

43 Ibid., p.355.

44 Attendances described in Large, *Nazi Games*, p.136.

45 Brothers-in-law James Pryde (1866–1941) and William Nicholson (1872–1949), who adopted the pseudonym The Beggarstaffs for their commercial work.

46 Organisationskomitee für die IV. Olympischen Winterspiele 1936 Garmisch-Partenkirchen EV, *IV Winterspiele Garmisch-Partenkirchen. Amtlicher Bericht* (Berlin, 1936), pp.145, 147.

47 Organisationskomitee für die XI. Olympiade Berlin 1936 EV, *The XIth Olympic Games Berlin, 1936*, p.124.

48 Ibid.

49 See Antony Beevor, *The Battle for Spain: The Spanish Civil War 1936–1939* (London, 2006), p.67.

50 See Foreword by Paul F. Sanders and J.J. Voskuil to the catalogue for the *D-O-O-D* exhibition, held in Amsterdam, August 1936.

51 Quotation translated from Martti Jukola's original text in his *Huippu-urheilun historia* (*The History of Elite Sports*) (Porvoo, Finland, 1935), p.187.

52 Organising Committee for the XIV Olympiad, *The Official Report of the Organising Committee for the XIV Olympiad* (London, 1948), p.220.

53 For a discussion on the origin of these words, see David C. Young, 'On the Source of the Olympic Credo', *Olympika: The International Journal of Olympic Studies* (1994), vol.III, pp.17–25.

54 Organising Committee for the XIV Olympiad, *The Official Report of the Organising Committee for the XIV Olympiad*, pp.145, 154–5.

55 Ibid., pp.112–13.

56 Probably the statue in the British Museum, a Roman marble copy of a bronze original, one of two marble copies with the head positioned towards the ground instead of towards the discus; the other is in the Vatican Museum.

57 A non-illustrated catalogue was sold at 1s 6d and an illustrated souvenir with 97 illustrations at 3s 6d.

58 Organizing Committee for the VI Olympic Winter Games, *Olympic Winter Games Oslo 1952* (Oslo, c.1952), pp.78–9.

59 Organizing Committee for the XV Olympiad Helsinki 1952, *The Official Report of the Organizing Committee for the Games of the XV Olympiad Helsinki 1952* (Helsinki, 1955), p.113.

60 See Stanton, *The Forgotten Olympic Art Competitions*, pp.209–57.

61 Comitato Olimpico Nazionale Italiano, *VII Olympic Winter Games: Official Report* (Cortina d'Ampezzo, 1956), pp.210–11.

62 Swedish Equestrian Federation, *The Official Report of the Organizing Committee for the Equestrian Games of the XVIth Olympiad* (Stockholm, 1959), p.17 (illus.).

63 The Richard Beck Archive is housed in the Powerhouse Museum, Sydney, registration number 92/1256.

64 Organizing Committee for the Games of the XVI Olympiad, Melbourne, 1956, *The Official Report* (Melbourne, 1958), p.142.

65 Beatriz García, 'The Concept of Olympic Cultural Programmes: Origins, Evolution and Projection', university lecture published by Centre d'Estudis Olímpics (Barcelona, 2002), p.7.

66 Organizing Committee, *VIII Olympic Winter Games Squaw Valley, California 1960: Final Report*, ed. Robert Rubin (Sacramento, 1960), pp.67–9.

67 Organizing Committee of the Games of the XVII Olympiad, *The Games of the XVII Olympiad, Rome 1960: The Official Report of the Organizing Committee* (Rome, 1960), vol.1, pp.299–301.

68 Cited in Colin Naylor (ed.), *Contemporary Designers* (second edition, London and Chicago, 1990), p.821.

69 The image appears to be based on a capital, now supporting a bronze pine cone, in the Vatican Museum, most recently said to be from the Baths of Severus Alexander. Most of the central athlete's raised arm and head are missing in the original.

70 Organisationskomitee der XI. Olympischen Winterspiele Innsbruck 1964, *Offizieller Bericht der XI. Olympischen Winterspiele Innsbruck 1964*, ed. F. Wolfgang and B. Neumann (Vienna, 1967), p.325.

71 Cited in Wei Yew (ed.), *The Olympic Image: The First 100 Years* (Edmonton, Alberta, 1996), p.176.

72 Organizing Committee for the Games of the XVIII Olympiad, *The Games of the XVIII Olympiad Tokyo 1964* (Tokyo, 1964), vol.1, p.473.

73 Ibid., p.353.

74 From biographical information held in the files of the Documentation Section, Olympic Museum, Lausanne.

75 *Official Report of the Organizing Committee of the Games of the XIX Olympiad* (Mexico, 1969), vol.2, pp.297 et seq.

76 In letter from Eduardo Terrazas and Beatrice Trueblood published in *Eye* (Spring 2006), vol.15, no.59, p.74.

77 See Armin Vit, 'Wyman's Way', *Creative Review* (June 2006), pp.42–7.

78 *Webesteem* (2004), no.9.

79 Discussed in Emma Booty's interview with Lance Wyman in *Design Week* (26 October 2006), vol.21, no.43, pp.20–21.

80 Lance Wyman speaking at the D&AD President's Lectures, Logan Hall, London, 22 November 2006.

81 Organizing Committee for the XIth Olympic Winter Games Sapporo 1972, *Official Report* (Japan, 1973), p.340.

82 From his speech at the memorial service on 6 September 1972, recorded in Organizing Committee for the Games of the XXth Olympiad, *Die Spiele: The Official Report of the Organizing Committee for the Games of the XXth Olympiad* (Munich, 1972), vol.1, p.38.

83 Ibid., p.257.

84 Ibid., p.258.

85 Ibid.

86 Ibid., p.270.

87 See Markus Rathgeb, *Otl Aicher* (London and New York), 2006, pp.61–7.

88 See Brigitte Beil, 'The Graphic Image of the XX Olympic Games', *Graphis* (1972), vol.28, no.160, pp.148–61.

89 Rathgeb, *Otl Aicher*, p.83.

90 Ibid., pp.94–5.

91 Ibid., p.94.

92 Organizing Committee for the XIIth Winter Games 1976 at Innsbruck, *Final Report* (Innsbruck, 1976), p.393.

93 Le Comité Organisateur des Jeux Olympiques (COJO), *Games of the XXI Olympiad, Montréal 1976: Official Report* (Ottawa, 1978), vol.1, pp.320–23.

94 Bruce Kidd, 'The Culture Wars of the Montreal Olympics', *International Review for the Sociology of Sport* (1992), vol.27, no.2, p.157.

95 *Official Report of the Organizing Committee of the Games of the XXII Olympiad, Moscow 1980* (Moscow, 1981), vol.2, p.360.

96 Ibid., p.372.

97 Organizing Committee of the XIVth Winter Olympic Games 1984 at Sarajevo, *Final Report* (Sarajevo, 1984), p.136.

98 See Frayda Feldman and Jörg Schellmann, *Andy Warhol Prints: A Catalogue Raisonné 1962–1987* (third edition, revised and expanded by Frayda Feldman and Claudia Defendi, New York, 1997), no. II.303, pp.128, 271.

99 Detailed in Karen R. Goddy and Georgia L. Freedman-Harvey (eds), *Art and Sport: Images to Herald the Olympics* (Los Angeles, 1992), pp.38–42.

100 Los Angeles Olympic Organizing Committee, *Official Report of the Games of the XXIIIrd Olympiad Los Angeles, 1984* (USA, 1985), vol.1, p.297.

101 Ibid., p.300.

102 Seoul Olympic Organizing Committee, *Official Report* (Seoul, 1989), vol.1: 'Organizing and Planning', pp.640–49.

103 Ibid., p.644.

104 Organizing Committee of the XVI Olympic Winter Games of Albertville and Savoie, *Official Report of the XIV Olympic Winter Games of Albertville and Savoie* (Albertville, 1992), p.297.

105 COOB'92 *Official Report of the Games of the XXV Olympiad Barcelona 1992* (Barcelona, 1992), vol.3, pp.333–7.

106 Lillehammer Olympic Organizing Committee, *Official Report of the XVII Olympic Winter Games Lillehammer 1994* (Lillehammer, 1995), vol.2, p.150 (illus.).

107 Atlanta Committee for the Olympic Games, *The Official Report of the Centennial Olympic Games* (Atlanta, 1997), vol.1: 'Planning and Organizing', p.146.

108 Ibid., p.140.

109 In a letter to the author, 19 July 2007.

110 Organizing Committee for the XVIII Olympic Winter Games, Nagano 1998, *The XVIII Olympic Winter Games: Official Report* (Nagano City, 1999), vol.1, p.11.

111 Recorded in the documentation for the poster in the Powerhouse Museum collection.

112 For example, CR blog, '2012: Pro or Con', *Creative Review* (July 2007), vol.27, no.7, pp.38–9.

Appendix A

'Edition Olympia 1972'

Five series of posters were issued jointly by the Organizing Committee for the Games of the XX Olympiad and the publishing house F. Bruckmann KG, Munich. The 'Edition Olympia' series were announced from 1968 to 1972 in the pages of *Gebrauchsgraphik* and its successor, *Novum Gebrauchsgraphik*, journals of advertising art published by F. Bruckmann. Details of the articles are listed in the Bibliography.

First series, issued in 1969–70:
Hans Hartung
Oskar Kokoschka
Charles Lapicque
Jan Lenica
Marino Marini
Serge Poliakoff
Fritz Winter

Second series, issued in 1970:
Horst Antes
Shusaku Arakawa
Eduardo Chillida
Piero Dorazio
Allen Jones
Pierre Soulages
Victor Vasarely

Third series, issued in 1971:
Josef Albers
Otmar Alt
Max Bill
Allan D'Arcangelo
David Hockney
R.B. Kitaj
Tom Wesselmann

Fourth series, issued in 1972:
Valerio Adami
Alan Davie
Friedrich Hundertwasser
Jacob Lawrence
Peter Phillips
Richard Smith
Paul Wunderlich

Fifth series, issued in 1972:
Gernot Bubenik
Günter Desch
Alfonso Hüppi
Kleinhammes
Werner Nöfer
Wolfgang Petrick
Gerd Winner

Acknowledgements

The Board of Trustees of the Victoria and Albert Museum is most grateful to the following benefactors, through whose generosity a number of Olympic Games posters were recently acquired for the Museum: the American Friends of the V&A in honour of Diana Qasha, Ruth Artmonsky, Mark Birley through the Bath and Racquets Club, Delancey, Mr and Mrs Clifford Gundle, Preston Fitzgerald, Lt Cdr Paul Fletcher (Ret'd), Mrs Joan Hampson, Mr and Mrs Stephen McClelland, Lady Purves, and Graham and Jane Reddish. It is also grateful to the following donors of Olympic posters and ephemera: Per Arnoldi, Bruce Kidd, Jack Ladevèze, Lynn Parker, Tony Scanlon and the Wenlock Olympian Society.

I acknowledge with gratitude the encouragement, support and guidance of all those who have helped in the preparation of this book. I thank the following organizations which have been supportive: the International Olympic Committee (IOC); the Olympic Museum, Lausanne, with special thanks for her outstanding help to Stéphanie Knecht, Document Information Officer, as well as to Frédérique Jamolli, Curator, Patricia Reymond, Collections Manager, Sabine Christe, Archivist, Nicolas Meystre, Library, Anouk Ruffieux, Administrative Manager and Celine Le Bail, Trainee; the London Organising Committee of the Olympic Games (LOCOG), especially Fran Hegyi, Cultural Programme Adviser, and Alastair Ruxton, Senior Manager; the Beijing Organizing Committee for the Games of the XXIX Olympiad (BOCOG); the British Council Beijing, with particular thanks to Meijing He, Networks Manager, China-UK Connections through Culture team, and Zhao Li, Arts Manager; the Capital Museum, Beijing; Robert Dover's Games Society, especially Dr Francis Burns; and the Wenlock Olympian Society, particularly Chris Cannon, Helen Cromarty and Peter Thompson.

I gratefully acknowledge the help of the following people who have offered expertise, guidance and generous help with research into various Olympic Games posters: Brita Belsvik, Informasjonsleder, Norges Olympiske Museum, Lillehammer; Robert J. Christianson, Beverley Cook and Julia Hoffbrand, Curators, Later Department, Museum of London; Liz De Fazio, Museum Director, Lake Placid Winter Olympic Museum; Andrew Forrest; Jean-Charles Giroud, Directeur adjoint, Bibliothèque de Genève; Ali Gardiner, Paul Maaker and Elaina J. Spring, Vancouver 2010 Winter Games; Carolien Glazenburg, Department of Graphic Design, and Willem van Beek, Library, Stedelijk Museum Amsterdam; Claire Grangé, Directrice, Maison des Jeux Olympiques d'Hiver, Albertville; Olof Halldin, National Library of Sweden; Valérie Huss, Musée Dauphinois, Grenoble; Bruce Kidd, OC, PhD, Professor and Dean, Faculty of Physical Education and Health, University of Toronto; Dr Ian Jenkins, Senior Curator, and Victoria Turner, Curator, Department of Greece and Rome, the British Museum; Danielle Léger, Spécialiste de collections, Bibliothèque et Archives nationales du Québec; Glennda Leslie, Archivist, Administration Services, City Clerk's Office, the City of Calgary; Robert Lucas, Letterenhuis, Antwerp; Angela Luke; Thomas Lundgren, Förste arkivarie, Avdelningen för enskilda arkiv,

Riksarkivet, Stockholm; Gunilla Lydén, the Swedish Central Association for the Promotion of Sport, Stockholm; Clare Miles; Connie Nelson, Executive Director, Alf Engen Ski Museum Foundation, Utah; Markus Rathgeb, Department of Media Design, BA – University of Corporate Education, Ravensburg; Professor Roland Renson, FaBeR/Faculty of Kinesiology and Rehabilitation Sciences, Catholic University of Leuven, Leuven; Paul Riley; Doris Ruckenstuhl, Austrian Cultural Forum, London; Tony Scanlon; Dick Smith; Richard Stanton; Dominic Sutherland; Marta Sylvestrová, Curator, and Petra Ciupková, Assistant of Department, Moravian Gallery (Moravska Galerie), Brno; Vesa Tikander, Sports Library of Finland; Sarah Tisdall; Nicolette Tomkinson, Christie's Vintage Poster Department; Anne-Marie Van de Ven, Curator, Decorative arts & design, Powerhouse Museum, Sydney; Patricia Salas Velasco; Bob Wilcock, Vice-Chairman of the Society of Olympic Collectors.

The following artists and designers have generously provided information and insight into their work: Adrian Adams (Creative Director, JABA Multimedia Design, Adelaide); Per Arnoldi; Luke Gifford and Adam Throup (Wolff Olins); April Greiman; Adolfo Mexiac; Laura Smith; Elise Thomason; Barrie Tucker (The Barrie Tucker Company, Nairne SA); Brent Watts (Axiom Design); and Lance Wyman.

Within the V&A, I wish to thank V&A Publishing, especially Mary Butler and Mark Eastment for encouraging the project, and Anjali Bulley for guiding it through. I warmly thank the V&A Exhibitions and Loans Department, headed by Linda Lloyd-Jones, especially Elizabeth Capon, Poppy Hollman, Sarah Sonner, Sarah Terkaoui and Penny Wilson. In the Word & Image Department I gratefully acknowledge Julius Bryant (Keeper), Gill Saunders (Senior Curator of Prints) and all members of the Prints team, whose generous support was crucial. The wonderful voluntary assistance of Clare Fletcher, Rosie Miles, Lynn Parker and Raika Wokoeck was invaluable. For their expertise I thank Beth McKillop (Director of Collections and Keeper), Ming Wilson, Anna Wu and Hongxing Zhang of Asian Department, and Megan Thomas and Eric Turner of Metalwork. Staff of Paper and Books Conservation, headed by Alan Derbyshire, conserved many objects to a tight deadline; Victoria Button skilfully coordinated the project. Paul Robins of the Photographic Studio executed the excellent photography with dispatch.

I thank all those who have commented on the text, including David Crowley, Catherine Flood, Carsten Holbraad, Liz Miller, Gill Saunders and Ruth Walton, and those who helped with various translations: Lizzie Guyatt, Nico de Jong and Antje Schroeder. I am very grateful to Lesley Levene for her sympathetic and meticulous editing and to Will Webb for his elegant design.

In conclusion, I thank any individuals or institutions who in any way have contributed to this work, but whom I may have inadvertently omitted to mention. I am nonetheless grateful.

Margaret Timmers

Bibliography

Websites

Major sources of information on official Olympic Games posters are the Official Olympic Reports issued by the organizing committees of successive Games. Specific reports are referred to in the text, but all available reports can be found through the website of the LA84 Foundation at: http://www.la84foundation.org/5va/reports_frmst.htm.

The LA84 Foundation Sports Library houses a comprehensive collection of sports information. Its extensive digital collection of sports publications is available at: http://www.la84foundation.org/5va/over_frmst.htm.

Information on numerous aspects of the Olympic Games, including posters, is to be found on the official website of the Olympic Movement at: http://www.olympic.org.

Publications

'Australian Style for Olympic Posters', *Olympic Review* (April–May 1999), vol.XXVI, no.26, pp.32–3

Barlow, Debbie, 'The History of the Official Olympic Posters', unpublished thesis, London, 27 April 1979, copy held in the IOC Library, Lausanne

Bayer, Herbert (foreword), *The Graphic Design of Yusaku Kamekura* (New York, 1973)

Barnicoat, John, *A Concise History of Posters* (London, 1972)

Beil, Brigitte, 'The Graphic Image of the XX Olympic Games', *Graphis* (1972), vol.28, no.160, pp.148–61

Beil, Brigitte, with a foreword by Hans Kuh, 'The Visual Image for the XXth Olympic Games Munich 1972', *Novum Gebrauchsgraphik* (July 1972), vol.43, no.7, pp.2–56

Berlioux, Monique, *Olympism through Posters* (Lausanne, 1983)

Burns, Francis, *Heigh for Cotswold! A History of Robert Dover's Olimpick Games* (Chipping Campden, 2000)

Carulla, Jordi, and Carulla, Amau, *La Guerra Civil en 2000 Carteles: República-guerra Civil-posguerra* (Barcelona, 1997)

Chronicle of the Olympics (London, New York, Sydney and Moscow, 1996; updated edition 1998)

Cole, Beverley, and Durack, Richard, *Railway Posters 1923–1947* (York, 1992)

Colomé, Gabriel, and Sureda, Jeroni, *Sport and International Relations (1913–1939): The 1936 Popular Olympiad*, part of the collection Working Papers, Studios Olímpicos (CEO–UAB) (Barcelona, 1994)

Drevon, André, *Les Jeux Olympiques Oubliés: Paris 1900* (Paris, 2000)

Durry, Jean, with a foreword by Juan-Antonio Samaranch, *Pierre de Coubertin, the Visionary* (Paris, 1996)

'Edition Olympia 1972', *Gebrauchsgraphik* (September 1968), vol.39, no.9, p.62

'Edition Olympia 1972', *Gebrauchsgraphik* (March 1969), vol.40, no.3, p.61

Frison-Roche, R., 'Chamonix 1924', *Olympic Review* (December 1982), no.182, pp.729–36

Furbank, Muriel, Cromarty, Helen, and McDonald, Glyn, *William Penny Brookes and the Olympic Connection* (Much Wenlock, 1996)

Gallo, Max, with essays by Carlo Arturo Quintavalle and Charles Flowers, *The Poster in History* (New York and London, 2001; originally published Milan, 1972, with previous edition in English, 1974)

García, Beatriz, 'The Concept of Olympic Cultural Programmes: Origins, Evolution and Projection', university lecture delivered in 2001, published by the Centre d'Estudis Olimpics (Barcelona, 2002)

Giroud, Jean-Charles, *A Century of Swiss Winter Sports Posters* (Geneva, 2006)

Goddy, Karen, and Freedman-Harvey, Georgia (eds), *Art and Sport: Images to Herald the Olympic Games* (Los Angeles, 1992)

Haddon, Celia, *The First Ever English Olimpick Games* (London, 2005)

Hilton, Christopher, *Hitler's Olympics: The 1936 Berlin Olympic Games* (Stroud, 2006)

Kidd, Bruce, 'The Culture Wars of the Montreal Olympics', *International Review for the Sociology of Sport* (1992), vol.27, no.2, pp.151–62

Kuh, Hans, 'Edition Olympia 1972: Poster Designs', *Gebrauchsgraphik* (January 1970), vol.41, no.1, pp.14–15

Kuh, Hans, 'New Posters of the Edition Olympia 1972', *Gebrauchsgraphik* (October 1970), vol.41, no.10, pp.20–23

Lampros, S.P., N.G. Polites, Timoleon J. Philemon and Pierre de Coubertin, *The Olympic Games: B.C. 776–A.D. 1896* (Athens, 1896–7)

Large, David Clay, *Nazi Games: The Olympics of 1936* (New York and London, 2007)

Levin, Ray, 'Olympic Poster Art', *Art Magazine* (Toronto), Special Olympics Issue (Summer 1976), vol.7, no.28, pp.8–11

Mandell, Richard D., *The Nazi Olympics* (Urbana, 1987; first published 1971)

Margadant, Bruno, *Das Schweizer Plakat/The Swiss Poster/L'affiche suisse 1900–1983* (Basel, Boston and Stuttgart, 1983)

Mason, Stanley, 'Towards an International Symbology – Tokyo 1964', *Graphis* (1964), vol.20, no.116, pp.514–17

Matthews, George R., *America's First Olympics: The St Louis Games of 1904* (Columbia, 2005)

Miller, David, *Athens to Athens: The Official History of the Olympic Games and the IOC 1896–2004* (Edinburgh, 2003)

Moriarty, Catherine, Rose, June, and Games, Naomi, *Abram Games, Graphic Designer: Maximum Meaning, Minimum Means* (Aldershot, 2003)

Müller, Norbert (ed.), *Pierre de Coubertin: Textes Choisis*, 4 vols (Zürich, 1986)

Münchner Stadtmuseum, *Ludwig Hohlwein 1874–1949: Kunstgewerbe und Reklamekunst/ Herausgegeben von Volker Duvigneau und Norbert Götz* (Munich, *c.*1996)

Naylor, Colin (ed.), *Contemporary Designers* (second edition, Chicago and London, 1990)

Pahud, Jean-François, 'Olympic Games Poster Retrospective', *Olympic Review* (April 1985), no.210, p.258

Pfeiffer-Belli, Erich, 'The 4th Poster Series of the Edition Olympia, 1972', *Novum Gebrauchsgraphik* (August 1972), vol.43, no.8, pp.18–21

Preuss, Holger, *Economics of the Olympic Games: Hosting the Games 1972–2000* (Petersham, New South Wales, 2000)

Rathgeb, Markus, *Otl Aicher* (London and New York, 2006)

Renson, Roland, and Hollander, Marijke den, 'Sport and Business in the City: The Antwerp Olympic Games of 1920 and the Urban Elite', *Olympika: The International Journal of Olympic Studies* (1997), vol.VI, pp.73–84

Rippon, Anton, *Hitler's Olympics: The Story of the 1936 Nazi Games* (Barnsley, 2006)

Rotzler, Willy, 'Mexico 68 – Graphics of the Olympic Games', *Graphis* (1968), vol.24, no.140, pp.514–19

'Salt Lake 2002: 2002 Games Poster Unveiled', *Olympic Review* (August–September 2001), vol.27, no.40, p.47

Sarhandi, Daoud, and Rivas, Carolina, 'This is 1968… This is Mexico'/Graphic Design/Olympic Identity', *Eye* (Summer 2005), vol.14, pp.24–37

Segel, Harold B., *Body Ascendant: Modernism and the Physical Imperative* (Baltimore and London, 1998)

Stanton, Richard, *The Forgotten Olympic Art Competitions* (Victoria, BC, 2000)

Timmers, Margaret (ed.), *The Power of the Poster* (London, 1998)

Umminger, Walter, 'From Athens to Mexico: Posters of the Olympic Games', *Olympic Review* (June 1971), no.45, pp.334–9

Weill, Alain, *The Poster: A Worldwide Survey and History* (Boston, 1985)

Wheeler, Robert F., 'Organized Sport and Organized Labour: The Workers' Sports Movement', *Journal of Contemporary History*, Special Issue: Workers' Culture (April 1978), vol.13, no.2, pp.191–210

Wilcock, Bob, *The 1908 Olympic Games, the Great Stadium and the Marathon: A Pictorial Record* (London, 2008)

Wilk, Christopher, 'The Healthy Body Culture', in Christopher Wilk (ed.), *Modernism: Designing a New World 1914–1939* (London, 2006), pp.249–95

Wivel, Mikael (introduction), *Per Arnoldi 250 Plakater etc.* (Copenhagen, 2003)

Vit, Armin, 'Mexico68 Olympics: Wyman's Way', *Creative Review* (June 2006), vol.26, no.6, pp.42–7

Yew, Wei (compiler and ed.), *The Olympic Image: The First 100 Years* (Alberta, 1996)

Picture Credits

© 1984 Olympics, Jayme Odgers and April Greiman/ Courtesy of the Victoria and Albert Museum: Plate 103

© ADAGP-Paris/Courtesy of the Victoria and Albert Museum: Plate 82

© The Josef and Anni Albers Foundation/VG Bild-Kunst, Bonn and DACS, London, 2008/Courtesy of the Victoria and Albert Museum: Plate 72

© Courtesy of Per Arnoldi/Courtesy of the Victoria and Albert Museum: Plate 128

© ARS, NY and DACS, London, 2008/Courtesy of the Victoria and Albert Museum: Plate 79

© Artists-Athletes Coalition/Courtesy of the Victoria and Albert Museum: Plates 90-93

Arxiu Fotogràfic de l'Arxiu Històric de la Ciutat de Barcelona: Plate 34

© Bettmann Corbis: Plate 66

Courtesy of Merrill C. Berman: Plate 35

© Adolfo Mexiac Calderõn/Courtesy of the Victoria and Albert Museum: Plate 65

Courtesy of Jordi Carulla: Plates 33, 129

© DACS, London/VAGA, New York, 2008/Courtesy of the Victoria and Albert Museum: Plate 101

© Estate of Abram Games/Courtesy of the Victoria and Albert Museum, London: Plate 47

© David Hockney/Courtesy of the Victoria and Albert Museum: Plates 16, 104

© Alfonso Hüppi/Courtesy of the Victoria and Albert Museum: Plate 76

Collection of Peter Jacobs: Plate 86

© Allen Jones/Courtesy of the Victoria and Albert Museum: Plate 77

© Estate of R.B. Kitaj/Marlborough Fine Art/ Courtesy of the Victoria and Albert Museum: Plate 78

© Ralph Lavers/Courtesy of the Victoria and Albert Museum, London: Plate 38

© The Estate of Roy Lichtenstein/DACS 2008/Courtesy of the Victoria and Albert Museum: Plate 102

© Lewis Mulatero/Courtesy of the Victoria and Albert Museum: Plate 129

Museum of London: Plate 10

National Railway Museum, York: Plate 24

Official Reports of the Olympic Games: Plates 30, 31, 55

Courtesy of the Olympic Museum Lausanne Collections: Plates 3, 8, 17, 25, 45, 48, 50, 51, 54, 58, 59, 88, 89, 94, 99, 107, 118, 125, 134, 135, 137, 145

Courtesy of London 2012/International Olympic Committee: Plates 109, 150

Poster photo archives, Poster Please inc., New York: Plate 6

Courtesy of Dick Smith: Plate 1

© Laura Smith/Courtesy of the Victoria and Albert Museum: Plates 105, 106

© Richard Smith/Courtesy of the Victoria and Albert Museum: Plate 81

Twentieth Century Fox Film Corporation: Plate 22

© Estate of Victor Vasarely/Courtesy of the Victoria and Albert Museum: Plate 83

Courtesy of the Victoria and Albert Museum / © IOC: Plates 4, 5, 7, 9, 12-15, 18-21, 23, 26-9, 32, 36, 37, 39-44, 46, 49, 52, 53, 56, 57, 60-64, 70, 71, 73, 74, 80, 85, 87, 95-8, 108, 110-117, 119-124, 126-7, 130-33, 136, 138-141, 143-44, 146-9

© 2008 Andy Warhol Foundation for the Visual Arts/Artists Rights Society (ARS) New York/DACS, London/Courtesy of the Victoria and Albert Museum: Plate 100

Wenlock Oympian Society: Plate 2

© Estate of Tom Wesselmann/Courtesy of the Victoria and Albert Museum: Plate 84

Courtesy of Bob Wilcock, Society of Olympic Collectors: Plate 11

© Lance Wyman, Eduardo Terrazas, Pedro Ramirez Vázquez/Courtesy of the Victoria and Albert Museum: Plates 67, 68

Courtesy of Lance Wyman: Plate 69

© Zabalaga-Leku, DACS, London, 2008/Courtesy of the Victoria and Albert Museum: Plate 75

Figures in *italics* refer to illustrations.